What you see in this book lives in the intricate world constructed around the songs, and which the songs inhabit. It is the material that gives birth to and nourishes the official work.

By official work I mean the song or the book or the score that is released into the hands of the fans. The fans become its custodians. They own it. Yet beyond the song there is an enormous amount of peripheral stuff – drawings, maps, lists, doodles, photographs, paintings, collages, scribblings and drafts – which are the secret and unformed property of the artist.

These are not to be seen as artworks so much as the wild-eyed and compulsive superstructure that bears the song or book or script or score along. They are a support system of manic tangential information.

I hope that you find some value in them. To me, these pieces have a different creative energy to the formed work: raw and immediate, but no less compelling.

Nick Cave

STRANGER THAN KINDNESS

NICK CAVE

HarperOne
An Imprint of HarperCollinsPublishers

HarperOne

Developed by Nick Cave and Christina Back

Essay 'God Is in the House' copyright © Darcey Steinke, 2020

Contexualisation texts copyright © Darcey Steinke and Janine Barrand

Originally published as *Stranger Than Kindness* in the United Kingdom in 2020 by Canongate Books.

First HarperOne hardcover published in 2021.

FIRST EDITION

Library of Congress Cataloging-in-Publication Data has been applied for.

ISBN 978-0-06-304808-9

21 22 23 24 25 CNG 10 9 8 7 6 5 4 3 2 1

MIX
Paper from responsible sources
FSC
www.fsc.org FSC® C008047

SHATTERED HISTORY

by Nick Cave

ONE

You are born. You build yourself piece by piece.
You construct a narrative. You become an individual,
surrounding yourself with all that you love. You are
wounded too, sometimes, and left scarred. Yet you
become a heroic and unique embodiment of both
the things you cherish and the things that cause you
pain. As you grow into this living idea, you become
instantly recognisable; among the billions of faces
in the world, you become that which you think you
are. You stand before the world and say, 'I am here
and this is who I am.'

TWO

But there is an influence at work. A veiled, magnetic force. An unnamed yearning drawing you toward a seismic event; it has always been there, patiently waiting. This event holds within it a sudden and terrifying truth. You were never the thing that you thought you were. You are an illusion, as the event shatters you into a multitude of pieces.

THREE

The pieces of you spin apart, a million little histories, propelling themselves away at a tremendous rate. They become like the hurtling stars, points of retreating light, separated only by your roaring need and the distant sky itself.

FOUR

You scramble for the pieces of your shattered history. There is a frantic gathering up. You seize the unknowable fragments and begin to put yourself back together again. You reassemble yourself into something that seems absolutely foreign to you, yet fully and instantly recognisable.

FIVE

You stand anew, remade. You have rebuilt yourself. But you are different. You have become a we, and we are each other: a vast community of astonishing potential that holds the sky aloft with our suffering, that keeps the stars in place with our limitless joy, that situates the moon within the reaches of our gratitude, and positions us in the locus of the divine. Together, we are reborn.

Nick Cave as a toddler in Warracknabeal, c. 1960
Photograph by Colin Cave

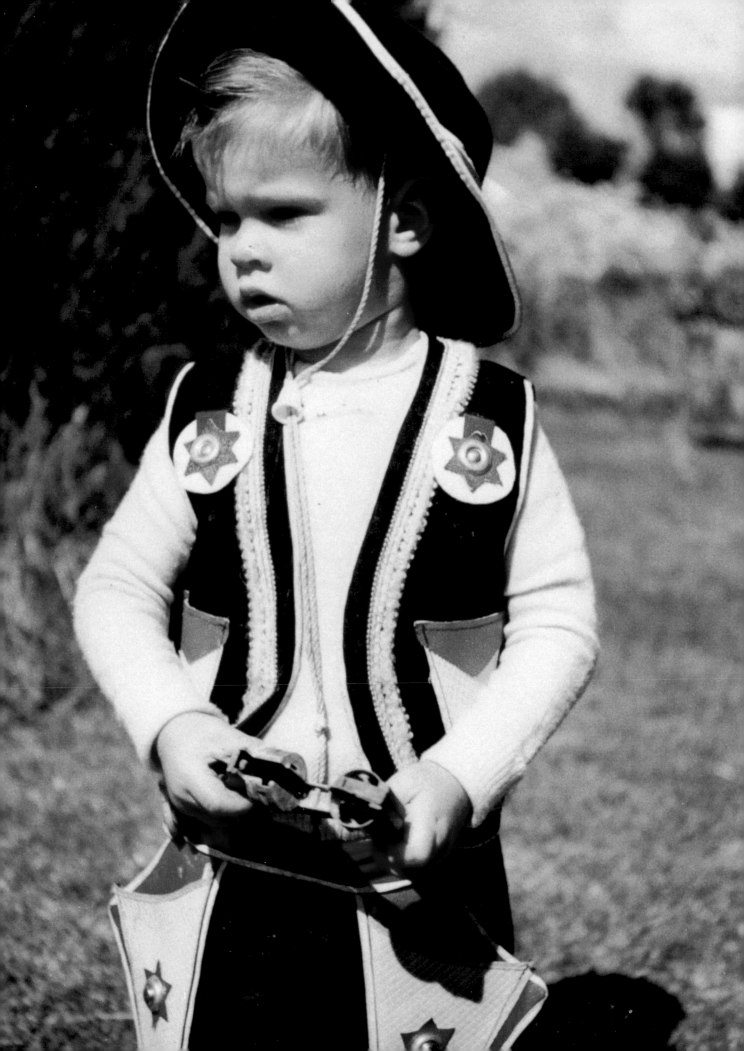

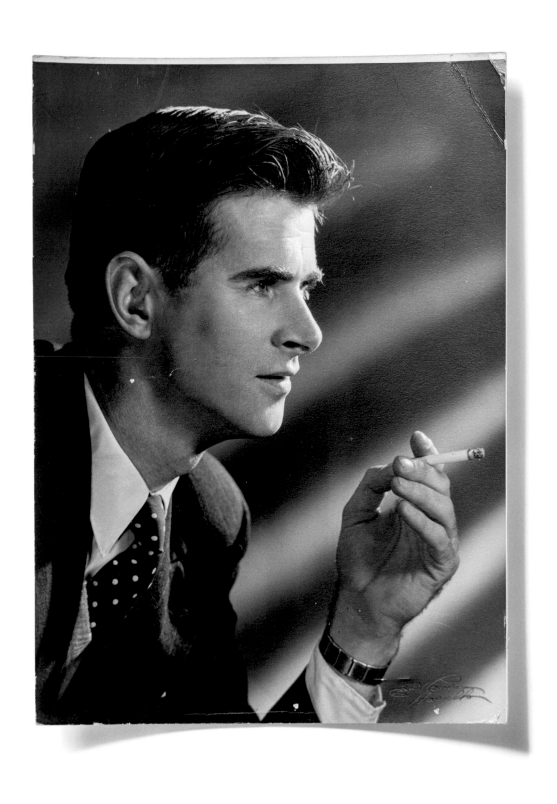

Colin Cave, c. 1956
Photograph by Ernest Cameron
For further reading see page 257

Lolita by Vladimir Nabokov, 1980
(first published in 1955)
For further reading see page 257

Following page:
Christmas card featuring choir boys
of the Holy Trinity Cathedral, Wangaratta, 1965
For further reading see page 257

Christmas Greetings

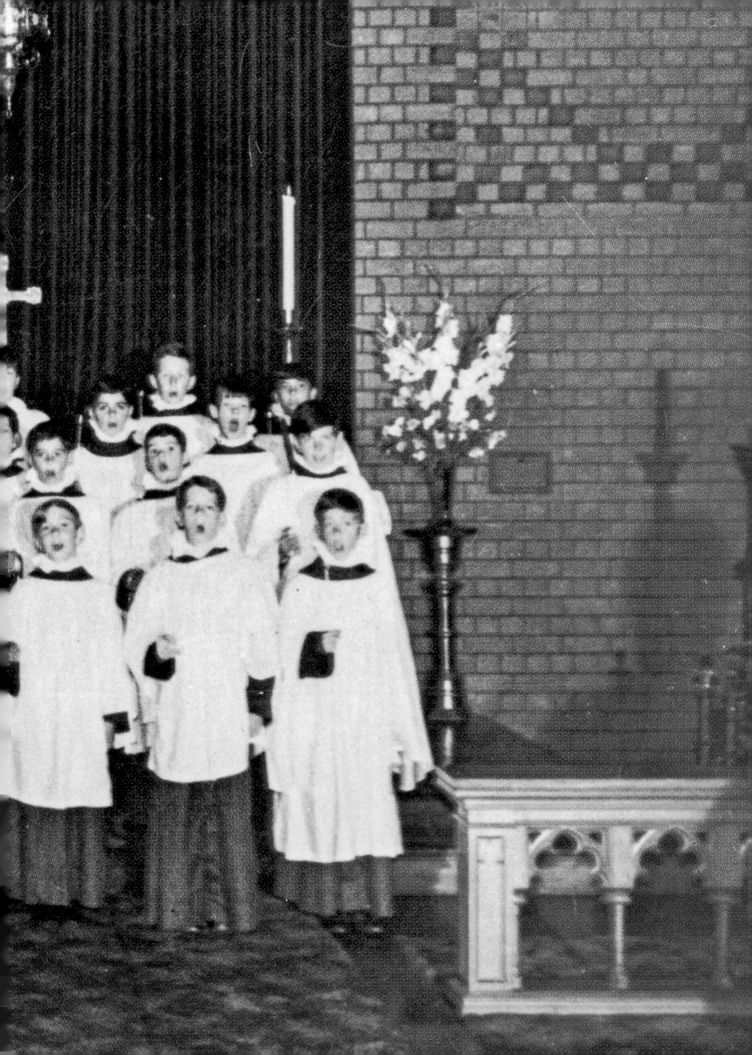

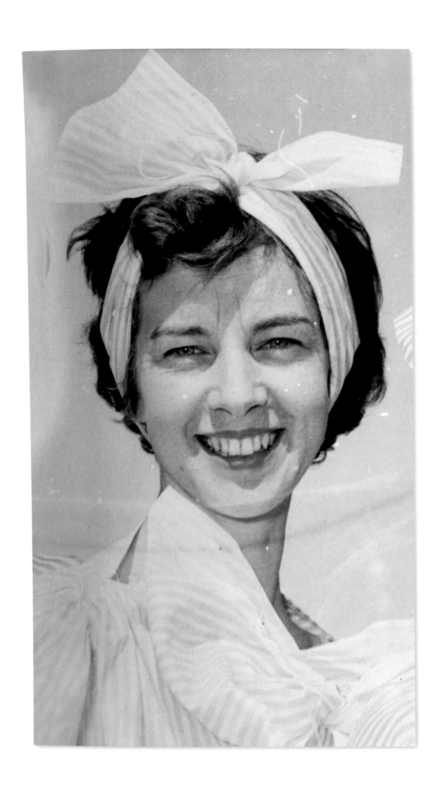

Dawn Cave, 1958
Photographer unknown
For further reading see page 258

Previous page:
Still image from
City with a Future - Wangaratta, 1965
Directed by Gordon Williams
For further reading see page 257

Morcom House
CAULFIELD GRAMMAR SCHOOL
217 GLEN EIRA ROAD, EAST ST. KILDA, VIC., 3183
Telephone: 53 2461
 53 3009

1

Sunday

Dear Mum, Dad, Pete and Julie.

How is every-thing at home. I hope you are all very well.

On Friday night we had an activities night where we played "Grid Iron", no rules. When Saturday morning came I was rather aching so I didn't play to well against Scotch College in Rugby (32-0). One bad thing I lost one of my football socks _but_ I am buying another pair cheaply from "Aussie Dessposals". They are 83¢ and I will buy them soon. Sorry.

On Friday night we (me and Micheal Spinks) went to "Aussie Disposals" and there were 2 blue cotton jackets for 90¢.

P.S. Julie - do you want a few stickers?

Morcom House
CAULFIELD GRAMMAR SCHOOL
217 GLEN EIRA ROAD, EAST ST. KILDA, VIC., 3183
Telephone: 53 2461
 53 3009

2

This is what they look like.

— stud buttons
— stud buttons.
zip up front

So we bought on each. They are second hand but I use them for everything. They are really great.

Most of the boarding house has been pretty sad about things. There was a boy (day boy) who was a friend of all the boarders last year died. He was really brainy and intelligent and left school last year to go to University. He had committed suicide. He had shot himself. You know

Morcom House
CAULFIELD GRAMMAR SCHOOL
217 GLEN EIRA ROAD, EAST ST. KILDA, VIC., 3183
Telephone: 53 2461
 53 3009

3

Bill Tuycross. He was Reeve Barns [the boy who committed suicides) best friend. Bill was the curly heared boys who showed us around the school when we came to look at it. He was under sedative from shock.

On Monday the school is taking up to see "2001 Space Odessy". All form 2's are going.

There is nothing much more to tell you except I had to have a hair cut. It was very short. I wanted to go to "Charles Luse" as he is very good but I only had $1.00 and he cost $1.10 so I had to go to some trashy ~~bar~~ barber down the road.

Well I must go, Bye Bye.
Are missing you. Nick xxxxx

Letter sent from Nick Cave to his family
while in boarding school, 1971

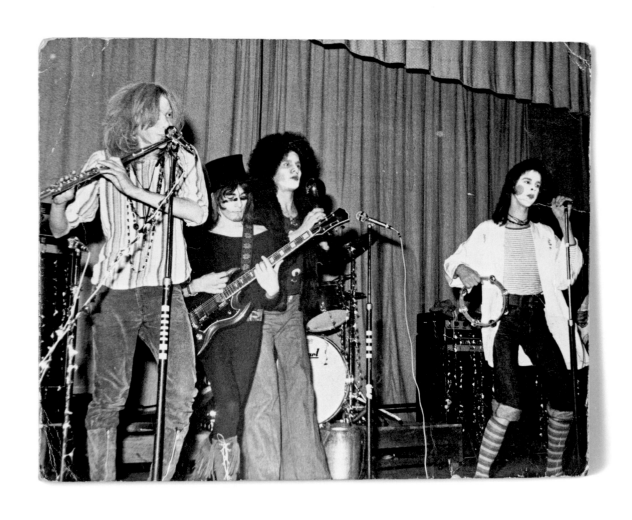

Chris Coyne, John Cocivera,
Howard (last name unknown), Phill Calvert
and Nick Cave performing at
Korowa Anglican Girls' School, c. 1975
Photographer unknown
For further reading see page 258

P.O. BOX 189 ST. KILDA , VIC, 3182

FROM THE HEADMASTER

CAULFIELD GRAMMAR SCHOOL
217 GLEN EIRA ROAD, EAST ST. KILDA, VIC, 3183
Telephone 53 0451

25th June, 1975.

Mr. C.F. Cave,
6 Airdrie Road,
NORTH CAULFIELD, 3161.

Dear Mr. Cave,

I have become somewhat concerned about aspects of Nicholas' attitude and conduct in the School.

Reports have been coming to me from members of staff of difficulties they have been meeting in gaining Nicholas' full co-operation. They have on occasions observed a lack of proper respect for their authority and a disinclination to accept instructions. Work, too, has been neglected.

I should add that, in this situation Nicholas is not acting alone, but is involved with a group of friends who support and encourage this contrary spirit in each other.

Matters reached a minor climax last week and I am now hopeful that, as a result of action taken, Nicholas has begun to understand the foolishness of his attitude and the fact that it is he who will suffer most if he persists in this pattern of conduct. There are signs that this is so.

You will, I am sure, prefer that I should inform you of the situation at this stage. I hope, of course, that the present improvement will be sustained and that the necessity will not arise for more serious action to be taken. To this end I know that we can count on your help and influence.

Yours sincerely,

B.C. Lumsden,
Headmaster.

Letter from Caulfield Grammar School
to Colin Cave, 1975

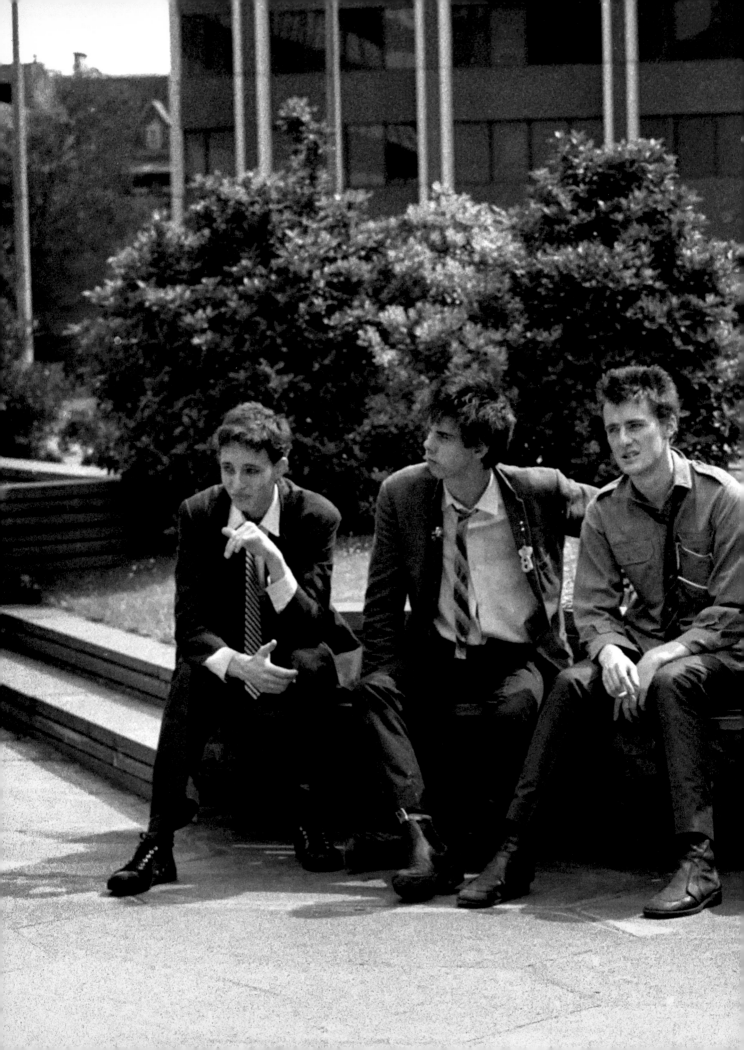

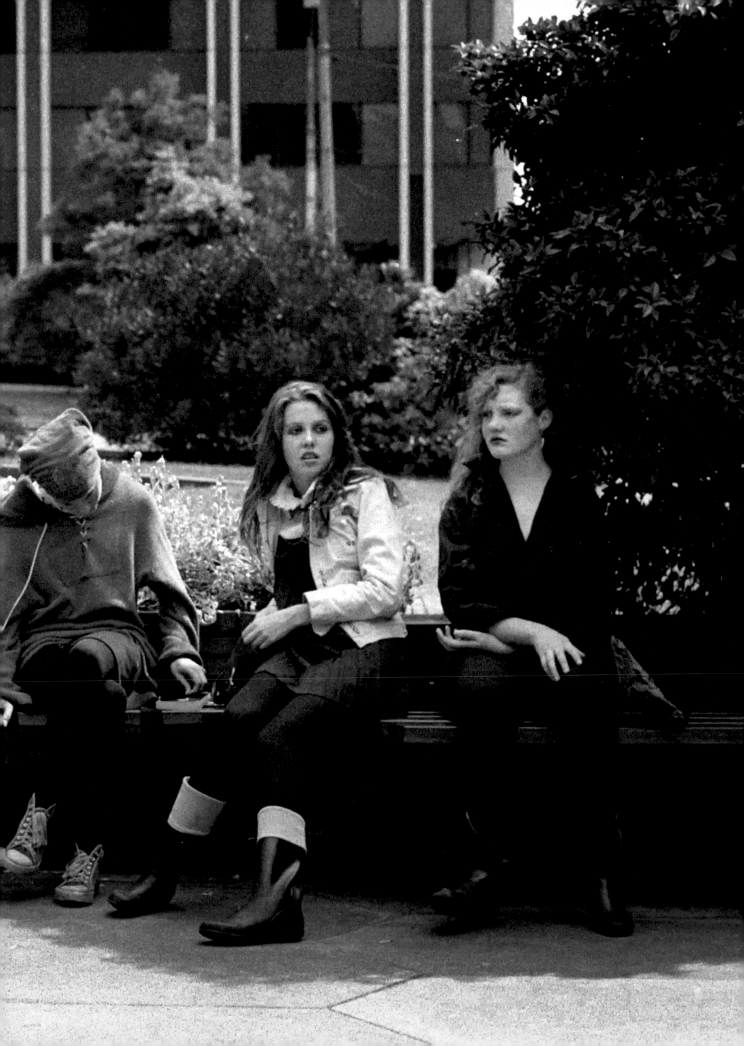

Nick Cave at The Saints concert,
Tiger Room, Melbourne, 1977
Photograph by Rennie Ellis
For further reading see page 258

Previous page:
Rowland S. Howard, Nick Cave, Ollie Olsen, Megan
Bannister, Anita Lane, Bronwyn Adams, Nauru
House, Melbourne, 1977
Photograph by Peter Milne
For further reading see page 258

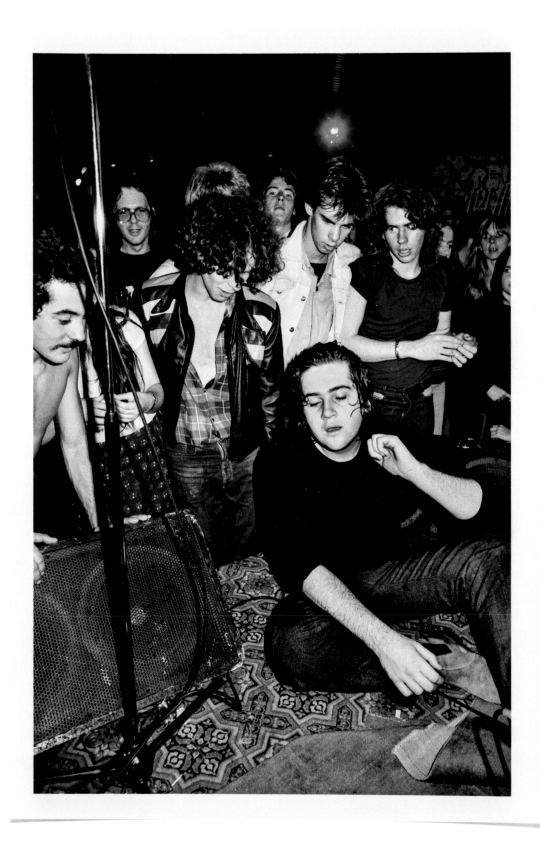

Song List

Learnt

She's not the chosen one
A.K.A
You and/or Her
Shivers
Broken Hands

Unlearnt

Whatever it Means
The Wrong Person
Grand Illusions
My Secret.
Mad about the boy.
Taste my Fresh Blood
My Actress?

To Finish

Thin Boys
Remember(No)
Into the Other Room

Song list, The Boys Next Door, 1978
For further reading see page 259

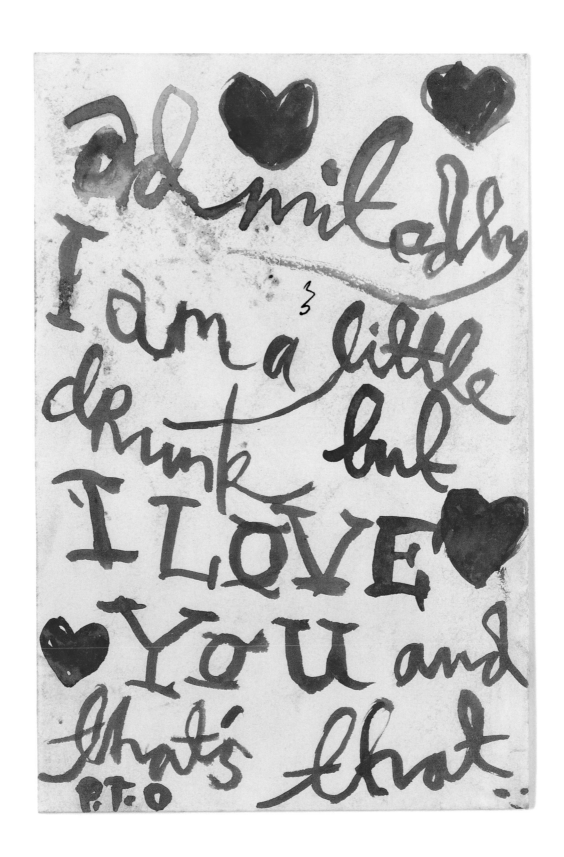

Letter from Nick Cave to Anita Lane, 1980

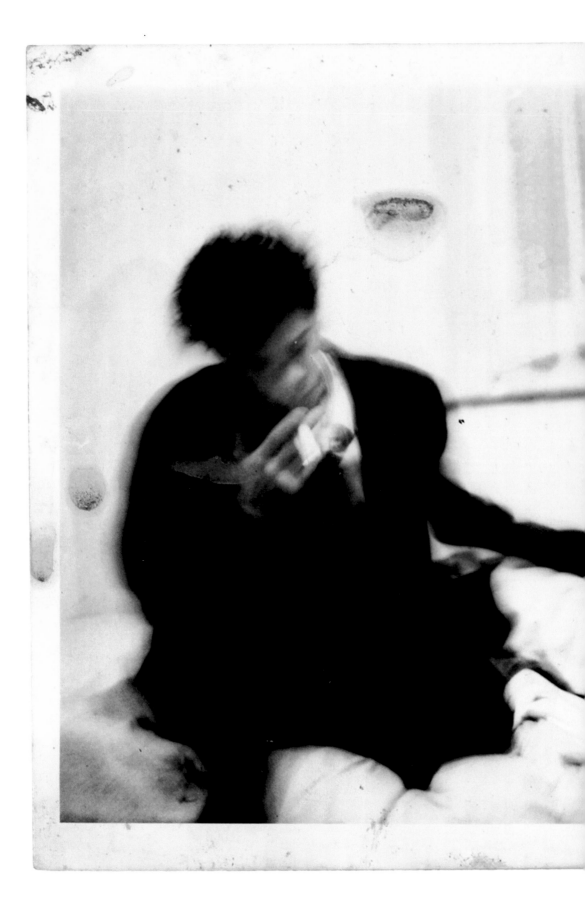

Nick Cave and Anita Lane, c. 1980
Photographer unknown
For further reading see page 259

34

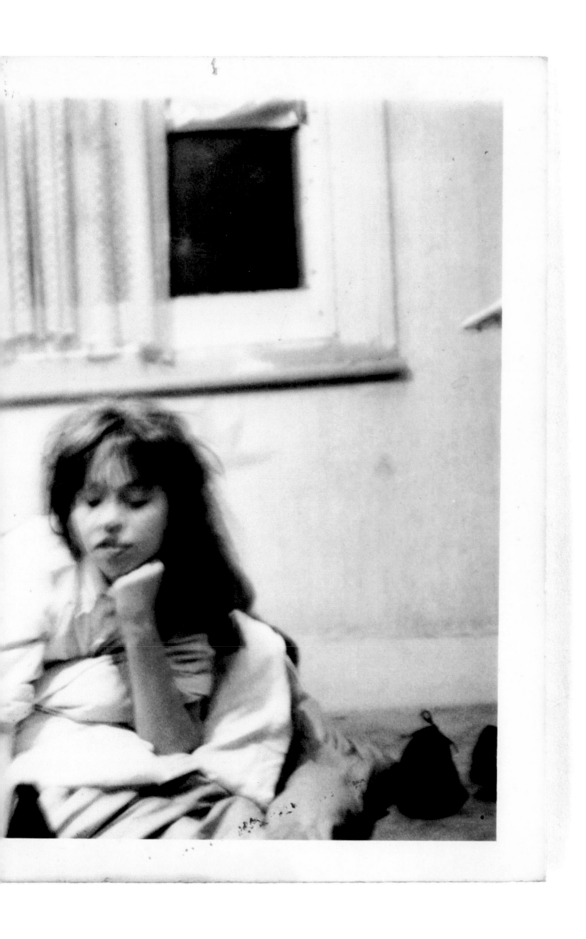

things I am not happy ~~withxwhith~~
with,within the boys next door (in no particular
order)
1. micks guitar/synth playing
2. the synth as an instrument
3. the choice of ~~recordedx~~songs to record
4. my visual performance
5. 50% of our material
6. the lack of interband comunication
7. phils contribution as a drummer
8. the way the set lists are organised
9. the way in which we accomadate for the
 tastes of our audience
10.

List by Nick Cave, c. 1978
For further reading see page 259

Shopping List
clothes:
(Kensington Mart)
— 7. floral shirts + ties
socks + 4 pants
3 pieces & suit
Shoes — boots
— Dryclean suit
black coat
wash clothes
for Anita
hair
hairdye C1
combs
cut it
books s. hand Calder + over
meths
records records s. hand
Crucifix
Purse + Mother

books:
decent Dictionary
Encyclodia
Book of Mythical Gods
Schopenhauer ?)
Beckett Trilogy company etc
Ezra pound collection
postcards Pierre Nicks Jue + Axel
Bjön, Mütten Gudrun
Air Tickets Suzanne Bettina
Beata + Manon + Christine

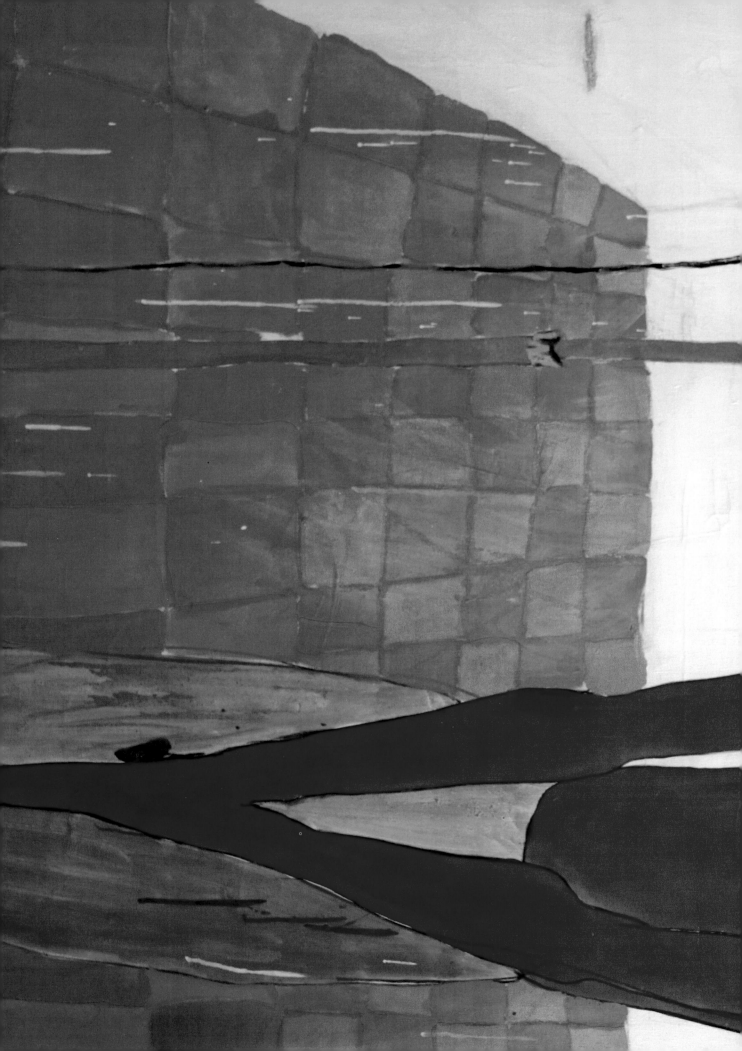

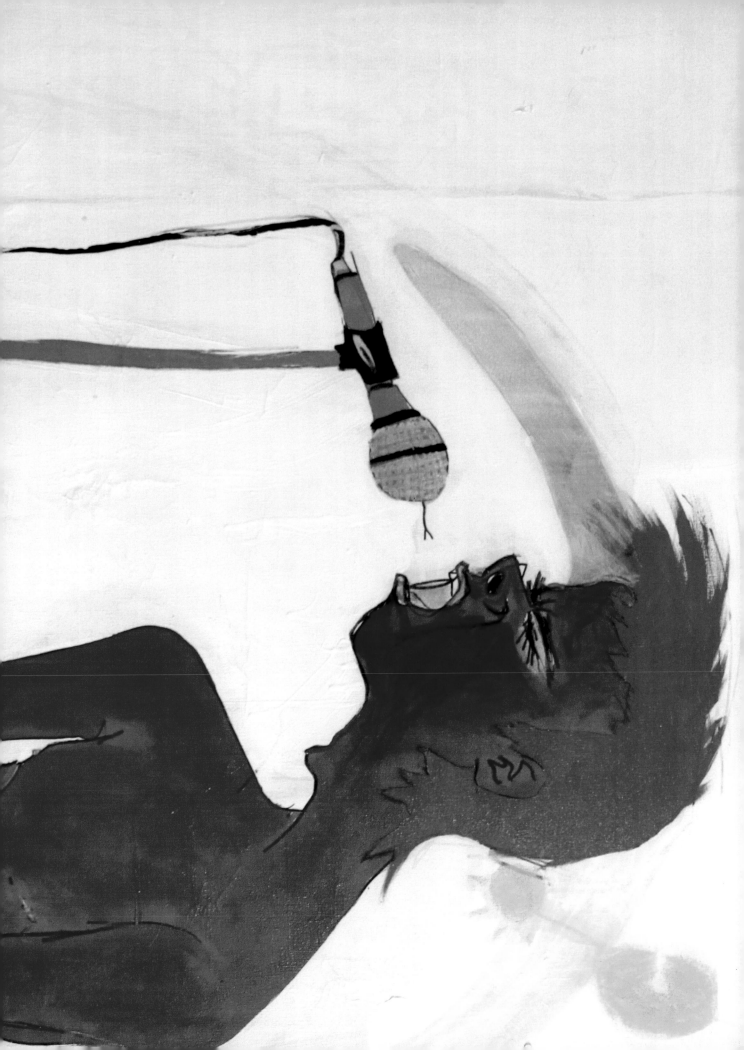

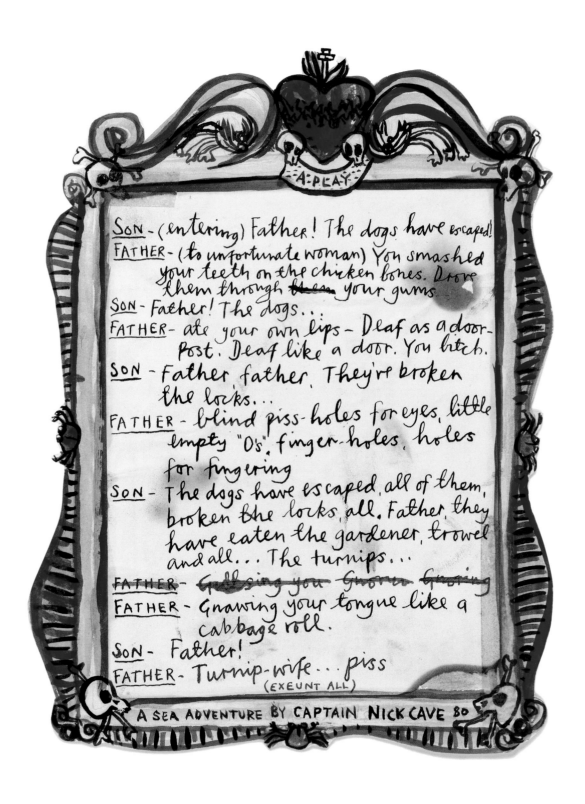

Script for *A Sea Adventure* by Nick Cave, 1980

Previous page:
Painting entitled *Horn of Plenty*
by Anita Lane, 1977
For further reading see page 260

Happy Birthday

It was a very happy day
they all had fun, fun, fun
There was icecream and jelly
and a punch in the belly
andi the cake got all over the walls
and how his face glowed
It's a bike! What a surprise!
A big bike! What a big surprise!
A red bike! What a red surprise!
Whoooooooooooooo! A surprise!!
But the best thing there
was the wonderful ~~Dog~~ Dog-chair
it could count right up to ten!
Woof woof woof woof woof woof woof...

It's another happy day
He was born eleven years ago
This years it's long trousers
and a really smart tie
Just think..Five more years and he'll be shaving!
And how his little face glowed
It's a Ninja suit! What a surprise!
and a Samuria sword! What a metal surprise!
He'll remember this day for the rest of his life
But..the best thing there x
You guessed it! The Dog-chair!
It could count right up to ~~eleven~~ eleven
Woof woof woof woof woof woof woof woof....
And it ran 'round and 'round the room
.....until it got dizzy.

Song lyrics for 'Happy Birthday' by Nick Cave, 1980
First released as a free giveaway single at The Boys Next
Door's farewell concert in 1980
For further reading see page 260

Wallet owned by Nick Cave, c. 1985

List

(red) $25
knuckles

*1. Ring + Onyx Ring + crucifix
2. Black Trousers — Tailor
3. Winklepickers — Venus
4. Money to mal princess
*5. Jacket + Shirts etc. — op —
*6. Books — Artaud reader
 Brecht ∧ Verse
 Pinget (Marcus) complete
7. Xerox select players
 (impressive press, sinopsis))
 ring Mr. Kerle. Mitch, sound
 Anita, costume
 Tony Clark, B.Drop?
 Look into
 Youth Thtre
8. Dentist 10 a.m — 11 a.m (Good, bad, T.V)
9. Dinner w/ Pete + Almax
10. Pixote?
11. K. West — Money — Ring

12. Clip-belt for ⌗ buckle

OWED 185
S. — $100 + 25 + 60
LIZ — $0025
GARY/SIMON — $25
BRONWYN $25
HARRY $15
ROWLAND $20
KEN $50 (ROW, RACT) $50×2
LISA $25

OWING
HELEN — $100
COSTA — $60
SATURDAY
*Ring Ken West (Gig + Money $75
 + plays
*Ring Arpad Mihaly
*Ring Marcus (20 mls)
*Sigma Codeine Linctus
Para codeine Linctus
cnr Riversdale / @ kentine

* Ring C. Carr.. Bio + Articles
THURSDAY • Flat

* B/W Herringbone pants fixed
* Money to Rowland (2:30 p.m.)
* S/Check Order by 2:00 pm.
 • Visit Chris Whelan
* GIG • Ring Arpad after 3:00
 P.M.

FRIDAY

Makeup for nita w/ Lee
write synopsis + bio.
* Material - trousers ▦

SATURDAY

• Buy Grmm.
• Buy Costa

SUNDAY

GUEST LIST.
Pierre + Margie
Liegh + Dwayne
Tony Clarke
Simon/Brot.
Nicks Costa l
Carol Pinxt
Helen + Debbie

Following page:
Still image from the music video
for 'Nick the Stripper', 1981
Directed by Paul Goldman
For further reading see page 260

THIS PLACE IS
WITH THE DEVI
THE DEVIL IN
AND THE DEVIL
AND I'LL MEET Y
IF YOU WEAR TH
(I'LL HAVE ONE MOR
WHERE MY HEA
AND PRAYERS
PRAYERS

Lyric for *Prayers On Fire* by Nick Cave, c. 1981
Featured on the artwork for *Prayers on Fire*
by The Birthday Party, 1981

48

HELL TO ME
IN MY BED
HIS BOTTLE
IN MY HEAD
IN HEAVEN AGAIN
DRESS AGAIN
DRINK, MY FRIEND)
IS KEPT ON ICE
URST INTO FLAMES
ON FIRE

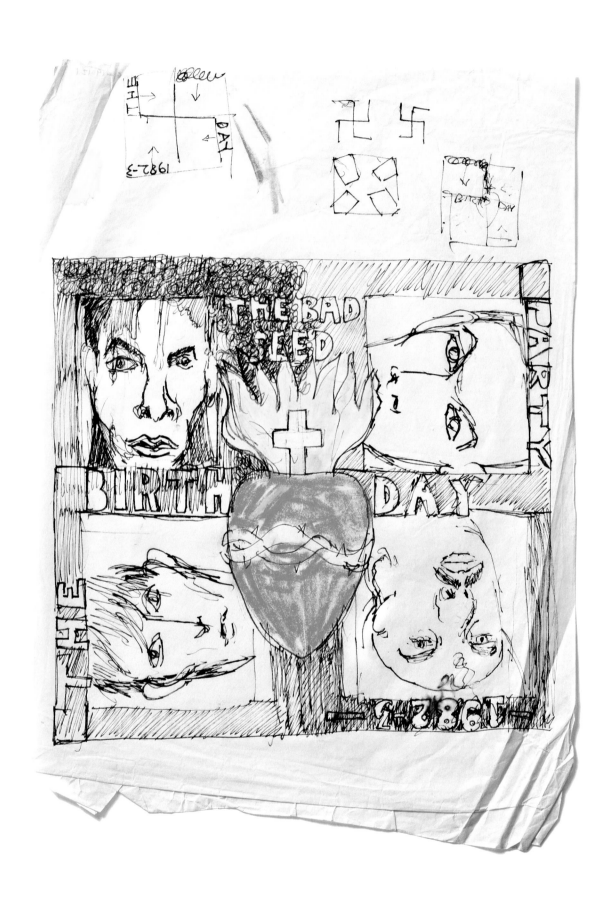

Design sketch for *The Bad Seed*
by Nick Cave, 1982-83
For further reading see page 260

Song lyrics for 'Wild World' by Nick Cave, 1982-83
Released on *The Bad Seed* by The Birthday Party, 1983

TRUCK LOVE —
enter the villian JOE — HIS MASTER IS THE PAST...

Dead Joe by Nikolas Cave and Anita Lane

Ho-ho-ho ho-ho-o-o-o Dead Joe -o-oh! x2
ENTER ?... Into the volcano... Into the CAR-smash crash
the VILLIAN where you can't tell the boys from the girls anymore
+ all the cash for the modern prodigy
Boys my polished planks of mahogany
+ Joe — I wanna go the ho ho Joe -o Dead Joe -oh
Ho-ho ho-ho-ho-ho-ho Dead Joe
Exit Darkie Joe — nugget on the sheets

... Its only death, sir

 prints FLOOR
Dead Joe / sook on the sheets
welcome to the CAR - smash
where you can't tell the boys from the girls anymore
and its only Death, sir — only death sir
Joe lies is gooey in a ditch / punch punch punch, sir
oh, the nun is a shrew is a nun is shrew
who steals the gold from the teeth of our neighbour
O-o-o-o-oh, No-o-o-o-o-o Dead Joe -oh

② Dammed up /

✱ Its only death, sir, but we wanna go-o-oh
 Dead Joe-oh!

Song lyrics for 'Dead Joe'
by Nick Cave and Anita Lane, 1982
Released on Junkyard by The Birthday Party, 1982

Did g... that Sonnys Burning
Oh! look how Sonnys Burning
lighting Like some bright erotic star
ting up the p...
+ raising the
flame on: flame on
Someday I think I'll cut him down

Oh! can you see how Sonnys burning
yer! someday I think I'll cut him down
but, ... it gets so cold in here
and he gives off such an evil heat
flame on: flame on
:Crackle and spit your ... to me

Oh! witness Sonny burning
warming the damp and rotten seeds
that bloom into the demon-flowers
now ... fire + flora both consume me
flame on: flame on
Sonnys burning pits into me
flame on: flame on
Now evil heat is running thru me
flame on: flame on
Sonny forever to me
was such a good friend
flame on: flame on
can't seem to cut him down
flame on: flame
cant seem to cut him down
flame

flame on: flame on.
Sonny is burning and me
and me and me and me

Song lyrics for 'Sonny's Burning' by Nick Cave, 1982
Released on *The Bad Seed* by The Birthday Party, 1983

Bluebeard
 Swampland.

1. Lawd ahm gunna die
 ya no ahm gunna die
+ Lawd, Ah no not wot ah did
but God nos ah pay fa it
So, cum mah excushionahs
oh, cum mah bounty-huntahs
yah, cum mah County-killahs
for ah canna run no more
 runnin' thru dah swampland
- thru mud + quixanne
Lucy, ah lost YAH SILVER rockette
 SWAMPLAND DONE TOOK IT
 mah blud turns black wit fear
 mah blud turns black wit fear
* an Lucy ah loved yah til dah enn
 They're huntin' me larka dog
 down in Swaaaaamp laaand

2. Blind wit cat-a-racks of hate
they cum wit gun + club + stump
wit rope + gas-o-leen
wit dogeys rabid-mean; against
 strainin' against dah chains
 + ah canna run no more
Is that Nancy Jacksons dress
Is that mah name written on it
Is that mah D. Warrant
 written in her blood
an

Blind wit cat-a-racks of Hate rabid- an blind
2. Death cum they cum wit gun an nife
wit rope an gas-o-leen
wit dogeys PULLING mean
Strainin' on dah chains ah canna run no mo'

Is that lil Nancy Jacksons dress?
Is that mah Death warrant? Is that mah name
 wen ya see dah FIRE on Hangmans Hill Lucy WRITTEN IN BLUD?
 THAT AINT SOME OF ARK THEY'RE BURNING

 Forget yah evah luved me
 an' take dah cad-a-lack an' drive
* Lucy, theres a monstah livin in these harts
 an ah won't live to see dah sun rise
 in swaaaamp laaahd

<u>jennifers veil</u>

So you've come back for Jennifer

y'no she ~~wearas~~ hides her face behind a veil

I'm warning you Frankie, leave on the next train,

Your Jennifer, she just aint the same

Hey! ~~Don't~~ ^{quit} wave that thing 'round, *oh cum back!*

Come back! and give me a chance to explain

Your Baby will never cry again,

 CHORUS

So don't try to reach out, and don't let the ~~xxi~~ ships flag ^{down} ~~drop~~.

Poimt the figure-head at the storm

and drive ^{Her} ~~it~~ hard upon.

Don't stop. and Don't Stop

And don't let the veil drop

(another ship ready to sail, The rigging is tight like

Jennifers Veil)

 2)

She drew the curtain, on her face,

~~ever since came~~
~~the day~~ they burnt the ol' place down.

And, why is she searchin', thru the ashes,

why, only Jennifer knows that now.

? ✗ AND THE OFFICER ↑ ↑ WITHOUT A WORD / *left all his junk an' just moved out.*
 CHORUS

So ~~don't~~ try to reach out and ~~don't pull~~ ^{let} the ships flag down,
point the figure^{head} at the glass
smash! smash! into shards

Don't stop and don't touch

and don't let the veil drop

(another ship out to sea, the ~~rigging is loose~~
 ^{behind}
~~loose like~~ Jennifers veil)

Song lyrics for 'Jennifer's Veil' by Nick Cave, 1983
Released on *Mutiny!* by The Birthday Party, 1983

GOD IS IN THE HOUSE

by Darcey Steinke

I — Pilgrims

Twenty years ago, I lived for a year in a house across from William Faulkner's Rowan Oak in Oxford, Mississippi. My office was in the attic, a room bigger than my whole apartment in Brooklyn. My desk sat in front of a window and at intervals ladybugs with rust backs and black spots streamed out of the window frame. They'd gather in a shifting pile and then crawl out across the glass onto the green vine wallpaper. I often thought, by the way they swooped and curved, that they might form letters, then words and finally a sentence from a wild god.

This never happened. Instead I watched Spanish moss hanging like long scarves from the giant cedar in my yard and, behind the tree on the road, buses filled with senior citizens come to tour Faulkner's Greek Revival house in Bailey's Woods. Sometimes the pilgrims were from other countries: busloads of Irish and French people on vacation. I watched them de-bus, walk the driveway covered in small blonde stones, pass the boxwood hedge maze and the giant magnolias with their thick, shiny leaves and creamy-petalled flowers. Inside they'd find portraits of Faulkner's ancestors as well as dark wooden Victorian furniture. In the writer's office they'd gape at the outline for *A Fable* written directly on the walls and Faulkner's Underwood typewriter sitting next to a tin of pipe tobacco on his desk. I most cherished the items and details that brought Faulkner back to scruffy life: a crappy plastic shoe rack beside his bed and, in the kitchen, pencilled phone numbers written around the black rotary phone.

Every night at twilight, I walked with my three-year-old daughter over to Rowan Oak. She would chase rabbits around the boxwoods and, as it got darker, try to catch fireflies. Sometimes we'd find offerings on the steps: a red rose, a white rose, a pair of fake false teeth, a tiny plastic coffin.

The pilgrims came in every season. Most compelling to me were not the busloads of people but the seekers who came on foot, alone or in pairs. I assumed they'd travelled to Oxford by Greyhound bus and walked all the way from the bus station across town. Some were in ordinary clothes but the majority of them, and this at first surprised me, wore black. I would look up from my legal pad to find a tall young man in a black velvet jacket, tight black trousers and knee-high black lace-up boots. I remember a girl in black leather trousers, a blouse with large bell sleeves, a black ribbon around her neck. Another young woman wore black lace gloves to her elbows, a long black dress and Doc Martens.

'I OFTEN THOUGHT, BY THE WAY THEY SWOOPED AND CURVED, THAT THEY MIGHT FORM LETTERS, THEN WORDS AND FINALLY A SENTENCE FROM A WILD GOD'

Of all the young pilgrims I saw that year the one who most stays in my mind is a Japanese boy in black high-top tennis shoes, black jeans and a Nick Cave & The Bad Seeds t-shirt. He walked fast and with a look of stricken anticipation. I had the feeling his journey had been arduous and that his longing was close to overwhelming him.

I didn't see the boy leave Rowan Oak; I'd had to pick up my daughter at pre-school, grade papers, make our dinner. When we walked over later in the near dark we found on the steps, in the usual offering spot, a copy of Nick Cave's novel *And the Ass Saw the Angel* in Japanese.

I have spent a lot of time in the intervening years thinking of those black-clad kids, moving diligently and with joy under the draped moss, past banks of kudzu toward their particular mecca. I understand why they were drawn to Rowan Oak and to Faulkner: his lyric prose, his cast of suffering and deeply human characters, but most of all what Albert Camus called Faulkner's 'strange religion'. A religion that knifed open metaphysical questions and split the human heart. 'What goes on up there,' Cave writes in *And the Ass Saw the Angel*, 'what measure the affliction? What weight the iron? Is it a chance system? ... or —anti-creation, something seasonal, something astrological?'

What is God? What does it mean to bear witness? Where do the dead go? Does the divine world exist? Does it fit with the human world or are they separate? What does it mean to be good? Cave's characters, like Faulkner's, often blend the earthly and the heavenly. 'No God up in the sky' Cave sings, 'no devil beneath the sea/Could do the job that you did, baby,/ of bringing me to my knees.' Cave's songs often undermine and negate religious adoration and instead, though we may be too blissed out to realise it, confront us with lush far-reaching theological questions.

John Keats claimed that the best writers all had a love of questions, of paradox, of what he called 'Negative Capability, that is, when a man is capable of being in uncertainties, mysteries, doubts, without any irritable reaching after fact and reason.'

Both Faulkner's and Cave's characters reside in paradox, filled with doubt, longing, questions, frustration. Faulkner's paradoxical religious outlook 'invested brothels and prisons with the dignity of the cloister'. And Cave is '"agitating" for a *broader* definition of the human, one that incorporates lapses into the human, incompleteness, a certain dilapidation and impoverishment of the soul'. Both see human/god relationships as complicated, fraught. Apophatic theological belief is found, if at all, piecemeal, murky, a grasping through darkness, never in the light.

'All the best people,' my friend recently said to me at our red wine lunch, 'are dinged up a little.' What makes a living person or a fictional character unique is not perfection but their flaws and scars.

God's redemptive gift of grace can be experienced in Cave's songs by anyone, the more dinged up the better: a killer on death row ('The Mercy Seat'), a john ('Jubilee Street'), even a man who may or may not have murdered his entire family ('Song of Joy'). Like Faulkner's 'strange religion', Cave is not interested in easy born-again redemption. Those black-clad young people were not pilgriming toward fixed meaning, certain divinity, systems of truth. No. They were drawn like particles toward a magnet, like an electrified atom of authentic mystery, to a raw – almost bloody – sensitivity, to an awareness 'in which life itself is lived more intensely and with a meaningful direction'.

William James, the nineteenth-century philosopher, speculated that belief was a form of magnetic energy that pulled the believer almost unconsciously in one direction or another. 'It is as if a bar of iron, without touch or sight, with no representative faculty whatever, might nevertheless be strongly endowed with an inner capacity for magnetic feeling; and as if, through the various arousals of its magnetism by magnetic comings and goings in the neighborhood, it might be consciously determined to different attitudes and tendencies. Such a bar of iron,' James continues, 'could never give you an outward description of the agencies that had the power of stirring it so strongly; yet of their presence, and of their significance for its life, it would be intensely aware through every fibre of its being.'

On Sundays Faulkner intermittently attended the Episcopal church in Oxford, but according to local legend he also, after all-night drinking binges, rode his horse wildly around the town square while the rest of Oxford sat in church. And Faulkner, as well as Nick Cave, casts a spell on you, like a prehistoric shaman, who meshes the reader in numinous symbols and sacred horror.

My favourite Faulkner character, Addie Bundren from *As I Lay Dying*, speaks only after she is dead. Many of Cave's most unforgettable characters, from The Birthday Party's 'She's Hit' to the *Murder Ballads'* 'Henry Lee' and 'Where the Wild Roses Grow', to *Ghosteen*, are voiced only after they are gone. Addie haunts her family, who must carry her dead body in a pine coffin into town. Before she dies, one of her sons describes her eyes. 'Like two candles when you watch them gutter down into the sockets of iron candle-sticks.' Addie's female body is an affront and a challenge to masculine culture. Outwardly she has conformed to traditional gender construction, though her inner life is complete rebellion.

She has had an affair with the minister, Whitfield, and her child with him is her favourite son Jewel. Addie's friend Cora abides by traditional Christian standards, while Addie is punk rock, rejecting the Christian ideal of human suffering as the price one pays for the privilege of eternal life. 'The duty to the alive, to the terrible blood. The red bitter blood boiling through the land.'

Cave's song 'Nobody's Baby Now' has always reminded me of Addie, a seeking soul, who turns away from both human convention and restrictive religion to face an implacable God. 'I've searched the holy books/Tried to unravel the mystery of Jesus Christ, the saviour/I've read the poets and the analysts/Searched through the books on human behaviour/I travelled the whole world around/For an answer that refused to be found/I don't know why and I don't know how/ But she's nobody's baby now'. Later lines from the song could be spoken by Addie's son Jewel. 'And through I've tried to lay her ghost down/ She's moving through me, even now.'

In *And the Ass Saw the Angel*, the hero Euchrid Eucrow speaks, like Faulkner's Addie, out of silence. While Addie speaks from beyond the grave, Euchrid is a deaf mute, the only surviving twin born to an alcoholic mother into a mythical landscape with hints of the American Deep South as well as rural Australia. 'Tall trees born into bondage rising from a ditch and crabby dog-weed, carrying a canopy of knitted vine upon their wooden shoulders.' Euchrid is 'jettisoned from the boozy curd of gestation' into the Ukulite Congregation, a group of Amish/Mormonlike zealots. In his silent world Euchrid is 'the loneliest baby boy in the history of the world ...'

The God of the novel is the Old Testament God, and interactions with him bring Euchrid fear and trembling rather than peace. And as Cave has written, 'I believed in God, but I also believed that God was malign and if the Old Testament was testament to anything, it was testament to that.'

Euchrid is shunned, beaten up and despised by the Ukulite faithful but also by anyone else he comes into contact with. His lamentations contain some of the most beautiful writing in the book. 'Ah was deemed unworthy of the organ of lament. Ah am not one to bemoan mah lot. But even Christ himself was moved to loosen the tongue of his wounds.' And in Lamentation 3: 'Even now as ah inch under, something rushes at me. Something of the hellish reason-evangelists hooded scarlet came, turned vigilante with bloody deed done.'

Euchrid is kin to John Harper in the 1955 film *The Night of the Hunter*. Both are boys living in a world of false prophets and over-heated faith. Harper must protect his little sister Pearl against a widow-killing convict with the words HATE tattooed on the fingers of one hand and LOVE on the fingers of the other. After Powell murders their mother, the children climb

'HELL IS A GREAT DEAL MORE FEASIBLE TO MY WEAK MIND THAN HEAVEN'

into a boat and float into an uncanny night journey on glittering black water. It's hard to tell if the river is redemptive, or that doomed transitional waterway, the River Styx.

'Hell,' Flannery O'Connor wrote in *A Prayer Journal*, 'is a great deal more feasible to my weak mind than heaven.'

And the Ass Saw the Angel does not let up on injustice and hellish atrocities. Still, it's Cave's rich atavistic language, idiosyncratic and imaginative, that is ultimately redemptive. 'Language itself,' Cave has said, 'can have a hugely beneficial effect on you in the same way music can.' Rebecca, a character in the novel, comes 'through her back door, wearing only a night dress and carrying her spirit lamp, she crept like a bird into the night'. And Euchrid's empathy for the earth is acute and beautiful. 'All about me the world seemed in need of attention.'

'A proof of God is in the firmament, the stars ...' Faulkner once wrote, 'proof of man's immortality, that his conception that there could be a God, that the idea of a God is valuable, is in the fact he writes the books and composes the music and paints the pictures. They are the firmament of mankind.'

'Slippery as religious experience,' writes Maud Casey in her book *The Art of Mystery*, 'mystery involves an undoing that yields wonder.'

'For me,' Cave told an interviewer for *BOMB* magazine, 'belief comes from the place that inspiration comes from, from a magical space, a place of imagination.'

'Faulkner wrote about twelve ministers,' the religious scholar Charles Reagan Wilson wrote, 'three heavy drinkers, three fanatics, and three slave traders, two adulterers and two murderers.'

God, as they say, works in mysterious ways.

My grandfather, the Reverend Arthur Ferdinand Steinke, neither drank nor killed anyone, though he was foreboding and very Old Testament. His church had a tall white steeple and a metal cross on the brick façade. He was a sombre Lutheran minister who loved to wear his black Martin Luther cape and slouchy hat. A fire-and-brimstone preacher, as he got up into his eighties he didn't talk much but he still loved to preach. Even when he had to be helped up the steps into the pulpit, his voice boomed, his face reddened, and he sweated. His sermons often spun out into diatribes about how the Christian faith should use the symbol of the electric chair rather than the cross, which chimes eerily with the imagery in Cave's song 'The Mercy Seat'. Sometimes my grandfather fell into a time warp, telling women to get over their addictions to nylon stockings, and men to new car tyres. His signature sermon was one in which he held up a silver dollar and asked someone in the congregation to

'ALL I HAD TO DO WAS WALK ON STAGE AND OPEN MY MOUTH AND LET THE CURSE OF GOD ROAR THROUGH ME'

come and claim it. Nobody would, not the ageing male ushers, not the church ladies in their pastel Sunday suits, not the young mothers or the teenagers. We were all terrified of him. After ten excruciating minutes he began berating us for our lack of faith.

What does it mean to be Old Testament? To identify with its punitive and inchoate God? The Old Testament seems to have given Cave permission; extreme texts can open up a writer to a freer and more expressive way of working. 'When I bought my first copy of the Bible, the King James version,' Cave writes in his introduction to *The Gospel According to Mark*, 'it was to the Old Testament that I was drawn, with its maniacal, punitive God, that dealt out to His long-suffering humanity punishments that had me drop-jawed … at the very depth of their vengefulness.'

In his early years Cave channelled the Godhead of the Old Testament. 'All I had to do was walk on stage and open my mouth and let the curse of God roar through me. You could smell his mad breath.' In Cave's imagination the Bible became a magic book, enchanted but also dangerous. You could 'see the yellow smoke curl from its many pages, hear the blood-curdling moans of despair.'

So much of the power in Cave's lyrics is in the way he declaims them. In his black suit, the microphone in his right hand, and his left pointing out over his congregation, Cave stalks the stage, sometimes falling on his knees to touch the hands raised up in hallelujah. What makes his presence so mesmerising is that while he evokes a tent preacher, he is also sexual, gothic, and his message, unlike an Old Testament preacher, damns no one; it is nuanced, complex and empathetic.

Cave in later writings linked the nihilistic rage that permeated his early songs to blocked grief. 'I see that my artistic life has centered around an attempt to articulate the nature of an almost palpable sense of loss that has laid claim to my life. A great gaping hole was blasted out of my world by the unexpected death of my father when I was nineteen.' Cave learned to fill that 'hole' by writing.

The gnostic concept of an impotent and evil God whose melancholy and rotten creation mirrors his own badness seems to be part of Cave's earliest theology. Many of the songs are staged in a mythic place much like the Southern United States. The South in this myth is Old Testament, punitive, conservative, wounded. A grim Calvinism injects the area with literal readings of the Bible, as well as an obsession with mortality.

In Mississippi, my next-door neighbour was an Italian translator who was working on court transcripts of John Calvin's trials. These took place in Geneva in the 1500s. She told me about a young woman who had accidently broken a vessel filled with olive oil and in fear of what her master might do to her had jumped into the river. Because suicide was, according to Calvin, a crime against God, she was tried and hanged. This fragile drenched ghost often comes to me all these centuries later, a slave girl, standing in front of a court filled with men. Calvin would have railed on, much like my grandfather, about the sovereignty of God and the depravity of man.

'No bolder attempt to set up a theocracy was ever made in this world,' wrote cultural critic H.L. Mencken about the South, 'and none ever had behind it a more implacable fanaticism.' What would I say if I were that slave girl persecuted by Calvin and his idea of a rule-obsessed and punitive God?

Cave's 'Big-Jesus-Trashcan' would be a good place to start. Cave snarls 'Right!' as the song begins, signalling that court is in session and it's not the sinner but the Church's crappy theology that is on trial. The sin of the Church is its failure to come to terms with human nature, to think it is better than the people it serves. 'Big-Jesus-Soulmate-Trashcan a fucking rotten business this.' There is anger but also sorrow for the sorry state of the Church. This melancholy manifests in both rage and absence. Jesus, as he is embedded in the Church, is a malevolent figure who pumps Cave 'full of trash'.

Punk, to my mind, differs from heavy metal by both its sly humour and its irony. Also its nuanced theological engagement. While much metal takes on the mask of destroyer, punk is the wailing of the destroyed. A Bible website lists scriptures that support the existence of punk rock: 2 Timothy 4:2, 'Preach the word; be ready in season and out of season; reprove, rebuke, and exhort, with complete patience and teaching'; Ephesians 5:19, 'Addressing one another in psalms

'PUNK IS THE WAILING OF THE DESTROYED'

and hymns and spiritual songs, singing and making melody to the Lord with your heart'; and my favourite, James 1:8, 'He is a double-minded man, unstable in all his ways.'

Darkness doesn't have to be nihilistic. Cave has often denied that his songs are negative, and in interview footage from the 1990s he says that rather than asking him why his lyrics are dark, people should ask Bruce Springsteen why his lyrics are happy. The mystic St John of the Cross taught that only through what he called the Dark Night could we ever understand ourselves and that the purest form of God is absence. Only by deconstructing our meta-narratives about God can we get closer to the divine mystery.

Our ideas about God, Gerald G. May writes in his book about St John, 'are only messengers. Instead, we take them for the whole of God's self, and thus we wind up worshipping our own feelings. This is perhaps the most common idolatry of the spiritual life.'

'I do not know you God,' writes Flannery O'Connor, 'because I am in the way. Please help me to push myself aside.'

In both St John's poetry and Cave's lyrics emptiness is the beginning of something; it is generative. 'You fled like the stag after wounding me,' writes St John, 'I went out calling you, but you were gone.' And Cave: 'The same God that abandoned her/Has in turn abandoned me.' The spiritual path is one of subtraction; we are slowly but conclusively emptied out.

'The kind of sadness that is a black suction pipe extracting you,' writes Anne Carson, 'from your own navel and which Buddhists call/"no mind cover" is a sign of God.'

'The religions which have a conception of this renunciation,' writes theologian Simone Weil, 'this voluntary effacement of God, his apparent absence ... these religions are true religion.'

Weil says: 'Grace fills empty spaces but it can only enter where there is a void to receive it and it is grace itself that makes this void.'

'Big-Jesus-Trashcan' attempts, like all punk, to harness the life force, or rather, the band becomes a conduit for that wild force. This power is not strictly positive – it's a mad energy that pushes up tulip tendrils, moves babies out of mothers, gives poets ideas but also fuels anger, violence, even bloodshed. The life force is as much part of a seed sprouting as it is a body chemically breaking down after death.

For Cave, it's this same wild rush of spirit that also fuels rock's beginnings. These myths in Cave's telling are both enchanted and ominous. In 'Big-Jesus-Trashcan' Elvis makes an appearance: 'wears a suit of gold (got greasy hair)'. In the next line Cave sets up a sort of competition with Elvis, an anxiety of influence that will continue throughout all the years of his songwriting: 'But God gave me sex appeal.'

Elvis is the Jesus of rock and roll. Of course we have the earlier myth of Robert Johnson meeting the Devil at a crossroads, as retold in the song 'Higgs Boson Blues' on Cave's album *Push The Sky Away*. Johnson seems to sell his soul so that musical divinity in the form of the blues, rock's predecessor, can enter the world. It's the African American blues men and women who are both the founders and the saints of rock's Church. But Elvis is Jesus. Stanley Crouch, a critic, has called Jesus's last line on the cross – 'My God, my God, why hast thou forsaken me' – the greatest blues line of all time. Like Jesus's, each part of Elvis's life has been fetishised, mythologised, made into scripture.

'Myth,' Cave writes in his poem *The Sick Bag Song*, 'is the true history.' In his song 'Tupelo', Cave both retells and electrifies the myth of Elvis's birth. First thunder and hard rain, then Cave calling out like a wild prophet. 'Looka yonder!' Cave exhorts us, 'A big black cloud come!/O comes to Tupelo'. A storm preceeds the birth of rock's messiah, the birth that will bring into the world, through song, pockets of

'MUSIC COULD BE AN EVIL THING, A BEAUTIFUL, EVIL THING'

eternity. The supernatural aspects of this new king's coming are accompanied not only by biblical rain but also a cessation of natural processes: hens can't lay, cocks can't crow, horses are freaked out, women and children have insomnia. Unlike the usual soft-focus sentimental myth of Elvis's birth along with his dead twin in the shotgun shack in Tupelo, Cave includes a new character, the Sandman. Not the gentle fairy who sprinkled sand in children's eyes so they can sleep but instead a version of E.T.A. Hoffmann's Sandman, who throws sand into children's eyes so that their eyes fall out and he can collect them to feed to his own children on the dark side of the moon.

It wasn't Elvis, but one of Cave's other idols who first initiated him into the extreme pleasures and darkness of rock. 'I lost my innocence,' Cave told an interviewer in the *Guardian*, 'with Johnny Cash. I used to watch the Johnny Cash Show on television in Wangaratta when I was about 9 or 10 years old. At that stage I had really no idea about rock'n'roll. I watched him and from that point I saw that music could be an evil thing, a beautiful, evil thing'.

The 'King' in 'Tupelo', like Jesus, is born in a modest abode, on a concrete floor 'with a bottle and a box and a cradle of straw'. The dead twin is placed 'In a shoe-box tied with a ribbon of red'. Death and life are tied, like happiness and grief, beauty and ugliness are intertwined and can never separate. The song ends hinting at the weight that will haunt Elvis: 'He carried the burden outa Tupelo.' Not unlike Christ carrying the sins of the world.

What do we know of Elvis's actual life in Tupelo? We know his mother Gladys had a difficult pregnancy and had to quit her job at the garment plant where she worked. We know that Elvis's twin Jesse was born dead, but was never forgotten by either the Presley family or Elvis's fans, Cave included. Gladys told Elvis: 'When one twin dies the other got his strength.'

We know that even at age two, Elvis was drawn to music. At the Pentecostal church where his mother took him, Elvis regularly escaped from the pew and ran up to the choir, standing in front of them, eyes large with wonder, trying to sing along with the hymns. He got his guitar from the local hardware store at age eleven and in seventh grade started to take it to junior high, keeping it in his locker and playing for his friends at lunchtime and recess.

In Cave's telling, Elvis's birth is messianic and Elvis himself, who famously slept with a large statue of Christ on his bedside table, was drawn to Jesus. He was known to both acknowledge and deny his kinship to Christ. After a Las Vegas concert in 1972, a woman ran up to the stage carrying a crown on a red pillow, telling Elvis it was for him, because he was the king. Elvis smiled and took her hand, 'Honey, I'm not the king. Christ is the king. I'm just a singer.' Nearer the end of his life he told his spiritual adviser Larry Geller about a mystical experience he had in the desert. 'I didn't only see Jesus's picture in the clouds – Jesus Christ literally exploded in me. Larry, it was me! I was Christ ...'

We also know that Elvis, from a young age, practised meditation. He told one of his early girlfriends, June, that if you look up at the moon and let yourself go totally relaxed and don't think about anything else, just let yourself float in the space between the moon and the stars, that 'If you relaxed enough ... you could get right there next to them.' Elvis told June that he never spoke about this mystical experience because people think you are crazy 'if they can't understand you'.

'There was a floating sense of inner harmony,' Peter Guralnick writes in his biography of Elvis, 'mixed with a ferocious hunger, a desperate striving linked to a pure outpouring of joy, that seemed to just tumble out of the music. It was the very attainment of art and passion, the natural beauty of the instinctive soul.'

'I spend my days pushing Elvis Presley's belly up a series of steep hills,' writes Cave in *The Sick Bag Song*. And later: 'I like the image of pushing Elvis Presley's belly up a hill – the Sisyphean burden of our influences.'

In The Red Hand Files, the website where Cave answers questions posed by his fans, one asks 'What does Elvis mean to you?' In his reply, Cave focuses on Elvis as performer. 'This narrative of suffering and rebirth is played out again and again within our own lives, but I believe it is captured most beautifully, within the musical performance itself.'

Cave points to the last ten minutes of the film *This Is Elvis*, in which the singer blunders the lyrics to 'Are You Lonesome Tonight'. 'It is one of the most traumatic pieces of footage I have ever seen.' Afterwards Elvis, humiliated, bows his head, then his voice 'steeped in sorrow' begins 'All My Trials'. As the concert ends the camera lingers on Elvis's face: 'tear-streaked … his head hung in sorrowful acceptance; and his caped arms outstretched in triumph. These are the stages of Christ's passage upon the cross, the anguish, the sufferance and the resurrection.'

————

After moving to Memphis, Elvis attended both white and black gospel concerts with his parents. As a teenager he hung around Beale Street, mesmerised by the black singers. He also attended the Assembly of God church with his girlfriend Dixie Locke. The church started as a tent revival, then moved to a storefront and finally into a church building. Elvis told a reporter how the 'holy rollers' inspired him. 'They would be jumping on the piano, moving every which way. The audience liked 'em. I guess I learned from those singers.'

Whenever a guest came to visit my daughter and me in Mississippi, we'd go see Al Green at his Full Gospel Tabernacle Church an hour away in Memphis. In the parking lot we always found the bass player's van, covered with plastic rocket ships which hinted at his other gig in a funk band. One of my friends on hearing the music start up whispered into my ear, 'My god, the dirty organ!' It was not unusual for one of the Staple Singers to drop in, the choir backing her up. Every Sunday Al Green sang out from the pulpit. His youthful shining face sent me and the other members of the congregation into a euphoric trance. My daughter Abbie never got over those services. When we moved back to Brooklyn, where we sometimes attended the Episcopal church, she called the service 'stupid' and begged to be taken back to 'real church'.

'[Elvis] reminded me of the early days,' DJ Tom Perryman said about seeing the singer perform, 'of where I was raised in East Texas and going to these Holy Roller Brush Arbor meetings: seeing these people get religion.'

Acts 2:19: 'Suddenly a sound came from heaven like a rush of a mighty wind and it filled all the house where they were sitting. And there appeared to them tongues of fire, distributed and resting on earth.' These flames allowed Jesus's traumatised disciples, just days after his crucifixion, to speak in languages that they did not know, languages that are both nonsensical and holy.

Rock's debt to the blues tradition is well catalogued but the influence of the so called 'holy rollers' of the Pentecostal Church is either unacknowledged or minimised. Many of rock's innovators, including Elvis, Jerry Lee Lewis, Sister Rosetta Tharpe, Little Richard and James Brown, were raised in, and created by, the musical traditions of the southern Pentecostal Church.

After the service at Al Green's church we'd visit Graceland. In Graceland, light seems to come at you from all directions, as if the sun has liquefied and flowed into the floor, walls and ceiling. I recognised in the glittery decor a longing for transcendence that is often labelled as tacky. The mirrored bar in the downstairs TV room was like a fenestral opening, the kind I spent most of my childhood searching for, that soft spot in reality that linked this world to the next. I liked the modest colonial kitchen. I could easily picture a bummed out and overweight Elvis wondering what it was all about as he raided the refrigerator. It's this transfiguring light integrated with sadness that makes Graceland so powerful. Elvis's endless hobbies – shooting guns, racquetball, horseback riding – all seemed like desperate attempts to fill up a faltering life.

Elvis is an icon, but not in any contemporary sense, not a one-dimensional computer icon. Neither is he an icon in the sense that Princess Di is an icon, someone who represented a particular kind of lifestyle. Elvis was an icon in the traditional sense of icons of the Greek Orthodox Church. These icons depict Christ, Mary or a saint shown against a gold background, which signified a source of illumination, independent of them. In iconography gold paint is built up from the base and the figure emerges from this globe of light. The gold light signified the mystical Other, the life force, a higher power, God.

'As much as we twist and turn,' Cave writes in *The Sick Bag Song*, 'they [influences] are never really transcended. They are seared into our souls like a brand.'

III — Of Weal and Woe

Elvis's story ends with sadness, loneliness and abandonment. He died 'reading a book on the Shroud of Turin,' writes David Rosen in the *Tao of Elvis*, 'sitting on the American throne he fell forward, ending his life in a prayerful position on the thick bathroom carpet.'

'The different kinds of vice,' wrote Simone Weil, 'the use of drugs, in the literal or metaphorical sense of the word, all such things institute the search for a state where beauty is tangible.'

In an interview in the 1980s Cave, clearly high, nods off. On his unrolled shirt sleeve, the interviewer sees specks of blood. Another journalist reports that at a Birthday Party show near the end of the band's time together, Cave frequently falls down; bandmates kick him to get up. 'Throughout the gig Cave looked like a corpse reanimated with a thousand-volt shock.'

Self-destruction, addiction, debasement, anorexia, even cutting, these are medical and psychological conditions but they are also spiritual. The fragile human sways under the weight of the world's expectations, under the weight and responsibility of their own humanity. There is suffering and estrangement but also the possibility of opening up to grace.

'Well,' Dylan said, in 1991, as he accepted the Grammy for Lifetime Achievement, 'my daddy, he didn't leave me much, you know he was a very simple man, but what he did tell me was this, he did say, son, he said,' there was nervous laughter from the audience, 'he said, you know it's possible to become so defiled in the world that your own father and mother will abandon you and if that happens, God will always believe in your ability to mend your ways.'

————

Cave, in The Red Hand Files, answers a question about evil. He believes 'that we are spiritual and transcendent beings, that our lives have meaning, and that our individual actions have vast implications on the well-being of the universe'. What we do, how we act, affects

'THE FRAGILE HUMAN SWAYS UNDER THE WEIGHT OF THE WORLD'S EXPECTATIONS, UNDER THE WEIGHT AND RESPONSIBILITY OF THEIR OWN HUMANITY'

not just those near us but the universe itself. 'This acknowledgement of our capacity for evil, difficult as it may be, can ultimately become our redemption.'

Evil is just as human as empathy or love. While we try to cast evil as the other, evil is us. Evil is kin to debasement, but while debasement is a singular state, evil is an attempt to transfer our debasement and pain to another through violence.

'The thief and the murderer,' wrote T.H. Huxley, 'follow nature just as much as the philanthropist.'

'Song of Joy' on the album *Murder Ballads* follows this equation of abasement forced onto another in the form of bloodshed. The speaker tells the story of meeting his wife Joy: 'I had no idea what happiness a little love could bring'. But then he wakes one morning to his wife crying. She 'became Joy in name only'. He is the father of the family, he and Joy have three daughters, and also the destroyer of the family. In acute detail he lays out how he *found* his wife bound with electrical tape, a gag in her mouth, stabbed and stuffed into a sleeping bag. His little girls are also dead. The song seems connected to the famous 1970 MacDonald murders in which a doctor killed and then denied killing his entire family. 'I like the way the simple, almost naïve tradition of the murder ballad,' Cave has said, 'becomes a vehicle that can happily accommodate the most twisted acts of deranged machismo.' 'Song of Joy' evokes in this listener Freud's *unheimlich*, the uncanny or the unhomely. The horror concealed in the domestic has spurted out. The safe area of the home has been made unholy. Cave understands what the listener needs. That need is not always for beauty and love but sometimes for violence and blood. We are closer than we would like to admit to human predator and human prey. Horror, while rarely realised, is real. The Devil has won this particular round and Cave, rather than offering an unsatisfying redemption, keeps the story inside human misery and struggle. In 'Song of Joy' the listener serves the religious function of witness. The speaker is a monster, but we know that the Latin root of monster is *reveal*. The 'monstrum', writes professor of religion Timothy Beal, 'is a message that breaks into this world from the realm of the divine.'

Johnny Cash, a singer with a powerful influence on Cave who also did a memorable cover of Cave's 'The Mercy Seat', also depicted evil in his songs. In 'Folsom Prison Blues', the speaker is a murderer. 'I shot a man in Reno just to see him die.' Cash often said that while God was #1, the Devil was #2. 'I learned not to laugh at the devil.' As a boy Cash remembered walking in the woods and seeing a blazing fire in the distance between the tree trunks. 'That must be the hell I've been hearing about.' Cash saw his life as a battle. 'I'm not obsessed with death,' he wrote, 'I'm obsessed with living. The battle against the dark one and the clinging to the right one is what my life is about.'

'What is that sweet breath behind my ear, I hear you say?' writes Cave in *The Sick Bag Song*. 'It is the Muses and Johnny Cash blowing us along our way.'

'To me,' Cash wrote, 'songs were the telephone to heaven and I tied up the line quite a bit.' Many of Cash's songs have the tension of the psalms, an older telephone to God. The psalms, particularly the lament psalms, vibrate with doubt, misery and passion. Cave admires how 'verses of rapture, or ecstasy and love could hold within them apparently opposite sentiments – hate, revenge, bloody-mindedness – that were not mutually exclusive. This has left an enduring impression upon my songwriting.' Cave's chorus from 'Mercy' is psalm-like. 'And I cried "Mercy"/Have mercy upon me/And I got down on my knees'. From Psalm 13: 'How long wilt thou forget me O Lord? for ever? how long wilt thou hide thy face from me?' Lines from 'I Let Love In' – 'Lord, tell me what I done/

'EVIL IS JUST AS HUMAN AS EMPATHY OR LOVE'

Please don't leave me here on my own/Where are my friends?/My friends are gone' – parallel the sense of absence found in Psalm 74: 'We see not our signs: there is no more any prophet: nether is there among us any that knoweth how long.'

Cave's theology, like all true faith, is both fuelled by doubt and ever transforming. His songs, like psalms, are not nihilistic, but act as a counterweight to the wilful optimism of our culture, a culture that denies the darkness that we are all, in this life, called to face. In both Cave's lyrics and the psalms, darkness is not easily transformed into light. No. Darkness is shared and solace is offered in fidelity, in a relentless solidarity. 'Darkness,' the theologian Walter Brueggemann has written, 'is where new life is given.'

On stage Cave's persona has been likened to a sinister old-time preacher. Critics early in his career questioned what one called his 'deranged preacher shtick'. Many of his songs, like 'City of Refuge', have a camp meeting, revivalist energy. 'In the days of madness/My brother, my sister/When you're dragged toward the Hell-mouth/You will beg for the end/But there ain't gonna be one, friend/For the grave will spew you out/It will spew you out.' Cave often gives what seems to be a sermon in the bridge of songs, but this, I would argue, is as it should be. Cave is not adding a mask, a shtick to the idea of the rock star; he is instead harkening back to the original *Front Man*, the preacher who fronted the choir.

Another religious archetype that Cave sometimes evokes is the circuit rider, a preacher dressed in black, on horseback with a Bible in his saddlebag. Circuit riders moved from revival to revival.

African American worshippers set up camp behind the raised platform and whites in front. Sunrise was welcomed by a trumpet call and preaching continued throughout the day. Many preachers, like Peter Akers, used their whole bodies as they spoke. Akers often fell to his knees (a knee drop!) and pressed his face in supplication to the platform.

Sinners who wanted to repent were welcomed to the front of the platform, a space known alternatively as the mercy seat, the mourner's bench, the glory pen and the anxious seat. When enough mourners had come forward the preacher left the pulpit and moved into the pen where he continued to exhort, invite and counsel mourners. It's hard not to think of rock performers, like Cave, playing to the first few rows of fans pressed up to the stage. Many of the mourners at camp meetings (and concerts) were women. Revivals were one of the few places antebellum women could act out. They cried, screamed, jerked and fell down. Redemption was cathartic, even sex-positive. One Alabama girl wrote in a letter to a friend that she had gained 'many boyfriends' at the camp meeting and that the girls had enjoyed themselves 'more than ever before'. Peter Cartwright wrote in his memoir about the suddenness of female conversion, how bonnets and combs would fly and a young women's hair 'would crack almost as loud as a wagon whip'.

At night, thousands of lights filled the camp meeting grounds, bonfires, candles, flickering lamps attached to tree branches and fire altars, raised tripods blazing with enormous flames. The night revival is akin to the rock concert where lighters make stars in the dark. The concert is a secular happening, but also a holy one. Cave evokes in both song and performance what has been lost in religious practice, at least among his liberal, secular followers: the vastness of God, an otherworldly and theatrical grandeur.

'A PREACHER DRESSED IN BLACK, ON HORSEBACK WITH A BIBLE IN HIS SADDLEBAG'

'I can remember the time when I used to sleep quietly without workings in my thoughts,' writes Mary Rowlandson, who was captured by Native Americans in 1675, 'but now it is other ways with me. When all are fast about me, and no eye open, but HIS who ever waketh, my thoughts are upon things past, upon the awful dispensation of the Lord towards us, upon HIS wonderful power and might ... I remember in the night season, how the other day I was in the midst of thousands of enemies, and nothing but death

before me ... Oh! The wonderful power of God that mine eyes have seen, affording matter enough for my thoughts to run in, that when others are sleeping mine eyes are weeping.'

————

In 1998, Cave wrote an introduction to *The Gospel According to Mark.* In it he reflects on his evolving self and how this coincided with his discovery of the New Testament: 'But you grow up. You do. You mellow out. Buds of compassion push through the cracks in the black and bitter soil. Your rage ceases to need a name. You no longer find comfort watching a whacked-out God tormenting a wretched humanity as you learn to forgive yourself and the world.' Cave's theology continues to morph. 'Religions,' philosopher John Gray writes, 'seem substantial and enduring only because they are always invisibly changing.'

In the New Testament, Cave explained on the radio, 'I slowly reacquainted myself with the Jesus of my childhood, that eerie figure that moves through the Gospels, the man of sorrows, and it was through him that I was given a chance to redefine my relationship with the world. The voice that spoke through me now was softer, sadder, more introspective.'

Who is Cave's Jesus? He is first and foremost a story-teller, an artist even, a being whose imagination was both laser-like and unrestrained.

'YOU NO LONGER FIND COMFORT WATCHING A WHACKED-OUT GOD TORMENTING A WRETCHED HUMANITY AS YOU LEARN TO FORGIVE YOURSELF AND THE WORLD'

Jesus did not teach his followers a set of principles but showed them a way of life. Cave's Jesus is not moralistic; instead he encourages a faith that is in close relation with a God who does not like complacency or stability, who is perpetually on the move, who pushes us on a journey with multiple ruptures and endless transformation.

'As I understand it,' wrote the songwriter Leonard Cohen, 'into the heart of every Christian, Christ comes, and Christ goes. When, by his Grace, the landscape of the heart becomes vast and deep and limitless, then Christ makes His abode in the graceful heart and His Will prevails. The experience is recognized as Peace. In the absence of this experience much activity arises, divisions of every sort. Outside the organizational enterprise, which some applaud and some mistrust, stands the figure of Jesus, nailed to a human predicament, summoning the heart to comprehend its own suffering by dissolving itself in a radical confession of hospitality.'

'Christ, it seemed to me,' says Cave, 'was the victim of humanistic lack of imagination, was hammered to the cross with the nails of creative vapidity.'

'In his spiritual reality too,' Josef Pieper writes in his book *Only the Lover Sings*, 'man is constantly moving on – he is essentially becoming; he is on the way. For man to be means to be on the way – he cannot be

'SONG ITSELF IS A KIND OF MOVEMENT, A BECOMING, A SLICE OF ETERNITY SLIPPED INTO NORMAL TIME TO DILATE AND EXPLODE OUR FIXEDNESS'

in any other form, movement is intrinsic to a pilgrim, not yet arrived, regardless of whether he is aware of it or not, whether he accepts it or not.'

Song itself is a kind of movement, a becoming, a slice of eternity slipped into normal time to dilate and explode our fixedness. A song, like a book or a film, 'must be the axe for the frozen sea inside us'.

In the last chapter of *Varieties of Religious Experience*, William James lays out the fundamental tenets that frame all faiths. 1: 'There is *something wrong about us* as we naturally stand.' 2: '*We are saved from the wrongness* by making proper connection with the higher powers.' The conundrum that many of Cave's songs explore is that divine connection, no matter how much we crave it, is often unstable, unbelievable, even inhuman. While God is not indifferent, he/she/they is hard to reach. A better strategy than forcing oneself up towards the Godhead is to connect with the divine in humans. 'God don't need me,' a black minister says in Faulkner's novel *A Fable*, 'I bears witness to him of course, but my main witness is to man.'

In 'The Witness Song', Cave's focus is human love. The speaker and his female partner both dip their hands into a fountain of healing water. Both claim to be healed, then admit that the holy water has not healed them. It's as if the rebuking of God's supernatural ability brings them closer together. What haunts the speaker as the song ends is not a Christian trope but the gesture the women makes as she leaves. 'And she raised her hand up to her face/And brought it down again/I said "that gesture, it will haunt me"'.

The lover in 'Do You Love Me?' is a stand-in for the celestial sphere and all its creatures. 'I found God and all His devils inside her/In my bed she cast the blizzard out/A mock sun blazed upon her head/ So completely filled with light she was.' Cave searches for a faith that is not cookie-cutter or one size fits all,

'MY SONGS ARE CONVERSATIONS WITH THE DIVINE THAT MIGHT, IN THE END, BE SIMPLY THE BABBLING OF A MADMAN TALKING TO HIMSELF'

but deeply personal in its symbols, myths and theology. He pushes his own life through the Christian grid and usually finds his own life with all its uncertainty, rupture and sadness more real, if not completely satisfying.

In many songs Cave struggles toward a radical Christian theology that is on a human scale. The speaker in 'Into My Arms' does not believe in an interventionist God or angels, but human love. And in 'Brompton Oratory', the speaker tells us that the beauty of intimacy with his lover is almost impossible to endure, and in its sensations it rivals the foremost Christian ritual. 'The blood imparted in little sips/The smell of you still on my hands/As I bring the cup up to my lips.'

There is no God without human beings; the human imagination makes God. Doubt in our imagined divinity is, in part, what fuels faith. 'I have always found great motivating energy,' Cave writes in The Red Hand Files, 'in the idea that the thing I live my life yearning for, let's call it God, in all probability does not exist … my songs are conversations with the divine that might, in the end, be simply the babbling of a madman talking to himself.'

IV — Angelology

Angels probably don't exist either. These spiritual beings, according to the fifteenth-century philosopher Marsilio Ficino, are created when a person acts with a pureness of intent. Every angel is the embodiment of a single emotion or impulse. 'The action transcends its physical place, time and individual connection and rises into the angel world: an angel is created.'

The single most vibrant dream of my life concerned angels. I was a new mother, at thirty-three, when I woke in the dark and went out into the hallway. On the landing I found a door that led to the fourth floor of my house. Why hadn't I realised before that my house had four not three floors? I went up the stairs into a huge, high-ceilinged room, panelled with dark wood, and on the far wall was a three-storey fireplace, filled with enormous pink and orange flames. The fire warmed the room and was its only light source. Human creatures were lying and sitting on furs spread out on the floor; each one was speaking in a high-pitched melodic language I could not understand. They were speaking but their mouths did not move. They all had light brown skin, soft, shoulder-length hair and flat-chested, androgynous bodies. Each wore a beige bodysuit. While none of the creatures looked alike they all shared the same placid expression. The love between them was obvious in how they smiled at one another and lay with their heads in each other's laps. It was not until I woke up that I realised they were angels.

What can be known about angels? I'm as valid an angelologist as anyone. From my dream I gather that angels have no specific sexual orientation and when they are not working as celestial messengers, they enjoy their downtime. In the Bible, angels are often fearsome. There is a reason that the first words they speak are 'Be not afraid!' In The Book of Judges, angels move up into heaven inside a column of fire. Gnostic texts claim that there are seventy-two angels, each responsible for the creation of a different part of the body. Angels existed long before Christianity, and Hippolytus wrote in 200 CE that the highest form of angels, prime angels, were born of a copulation between God and the Earth.

In *And the Ass Saw the Angel*, Euchrid sees his angel in the swamp. The 'angel did ease herself into mah world'. First a whisper, then a flutter, then his name is called and finally the beating of silver wings. 'Immersed in a cobalt light, she hovered before me. Her wings beat through mah lungs, fanning up nests and brittle shells and webs and shiny wings and little skeletons and skulls and skins around me.

And this visitation, she spoke sweetly to me. She did. "I love you, Euchrid," she said. "Fear not, for I am delivered unto you as your keeper."'

'Angels,' observes Michel de Certeau in his book *White Ecstasy*, 'enter the human world as the cosmology that placed them in a celestial hierarchy begins to crumble.' The less we believe in God, the more angels can escape heaven and walk with us on the earth.

'THE LESS WE BELIEVE IN GOD, THE MORE ANGELS CAN ESCAPE HEAVEN AND WALK WITH US ON THE EARTH'

The poet Rilke tells us that angels have 'tired mouths', and that they all resemble each other. Ficino explained that the sun is God and the stars, the angels. Also that while human souls are created daily, angels were all created before time began. Porphyry, around the third century CE, claimed you could attract an angel with an offering of 'fruit and flowers'. Thomas Aquinas, known as the Angelic Doctor, said that each angel was a single species, a creature unto himself.

'We are with you,' the angels tell Cave in *The Sick Bag Song*, 'but you must take the first step alone.'

'Religion,' John Gray writes in his book *Seven Types of Atheism*, 'may involve the creation of illusions. But there is nothing in science that says illusion may not be useful, even indispensable, in life. The human mind is programmed for survival, not truth.'

In Cave's mid-career songs angels are frightening and chaotic. In 'The Hammer Song', 'an angel came/With many snakes in all his hands.' The angels in 'Straight to You' are part of heaven's chaos. 'The saints are drunk and howling at the moon/The chariots of angels are colliding.' As in many of Cave's songs, while the spiritual world is vibrant and real, the speaker chooses human life, human fragility, human emotion. 'I don't believe in the existence of angels,' Cave sings in 'Into Your Arms', perhaps his most theologically brilliant song, 'but looking at you I wonder if that's true.'

Maimonides, a Jewish philosopher born in 1135, extended the idea of the angel to include wind and fire. Also human passion: everyone who goes on a mission is an angel. The angel in this way of thinking is the imagination itself.

'There is communion, there is language,' Cave sets down, 'there is God. God is a product of a creative imagination, and God is that imagination taken flight.'

'Still,' the poet Fanny Howe writes, 'hope was like a throng of singers that circle the world both here and there having died and echoed over and over. What is a song but a call from the other side?'

In the song 'Distant Sky', from *Skeleton Tree*, Cave's first album to come out after the death of his son Arthur in 2015, an angel speaks, an angel who will carry us back into God. 'Let us go now, my one true love … We can set out, we can set out for the distant skies/Watch the sun, watch it rising in your eyes … Soon the children will be rising, will be rising/This is not for our eyes.' Everything is one in the angel world. Time is not linear but simultaneous so the children both rise in the morning from their earthly beds as well as that final rising after death, the resurrection. As Rilke wrote, 'Angels (they say) don't know whether it is the living/they are moving among, or the dead.'

Before resurrection there is death and the angel of death comes as a messenger but also to coax the soul out of the body and into the open air. Gabriel will blast his trumpet to demarcate time's ending. Graves will shiver and the reawakened bodies will push up like mushrooms from beneath their mouldy beds.

William Blake's angel opens up metaphorical coffins, so the spiritually dead can run free. 'And by came an Angel who had a bright key,/And he opened the coffins and set them all free.' The Islamic angel Azrael was said to lure the soul by holding an apple from the tree of life to the nose of the dying person.

'WHAT IS A SONG BUT A CALL FROM THE OTHER SIDE?'

Libby, the wife of Bunny Munro in Cave's second novel, *The Death of Bunny Munro*, is herself a kind of death angel. Returning to their flat having been with a prostitute, Bunny, who believes he is locked out of the marital bedroom, sees his wife through the keyhole, standing by the window wearing the orange nightgown that she wore on their wedding night. She floats in his mind in 'dreamtime', the 'near-invisible' material of her nightgown hanging from her nipples.

Once inside the bedroom, he finds his wife hanging from the security grille. 'Her feet rest on the floor and her knees are buckled. She has used her own crouched weight to strangle herself.'

To Bunny Junior, their ten-year-old son, his mother is ever after a spirit. 'A slowly dissolving ghost-lady, as incomplete as a hologram. He feels, in this instance, forever suspended on the swing, high in the air, never to descend, beyond human touch and consequence, motherless …'

In Karl Ove Knausgaard's novel *A Time for Everything*, angels are corporeal beings who, ever since Christ's crucifixion, have been trapped on earth. They have thin wrists, claw-like fingers, deep eye sockets. They shake continuously and uncontrollably. They do not speak but shriek. As they move, they trail gaseous fire, like a comet.

The eighteenth-century mystic Emanuel Swedenborg often flew to heaven to converse with angels, though after these sessions he was never able to remember what the creatures told him. Humans have trouble both understanding and remembering angel speech. Angels may appear to speak but they are more likely communicating directly with their minds. 'The angels,' wrote Hildegard of Bingen, 'who are spirits, cannot speak in a comprehensible language. Language is therefore a particular mission of humanity.'

In the 1987 film *Wings of Desire*, Nick Cave plays himself, a sort of anti-angel, all sharp skeletal angles in a blood-red shirt and black open vest. He is as agitated as the angels are peaceful, emoting as he sings 'From Her to Eternity' both desire and violence. He makes the angels feel human and the humans feel like angels.

'HE MAKES THE ANGELS FEEL HUMAN AND THE HUMANS FEEL LIKE ANGELS'

The actual angels, Damiel and Cassiel, wear black trenchcoats and offer pastoral care to the people of Berlin. They see history from beginning to end; life is not linear but a continuous engagement with an ongoing present. In my favourite scene, Damiel, who will eventually choose the human over the angelic, soothes a dying man by moving his mind away from the pain caused by his motorcycle accident to the man's treasured memories: 'Albert Camus … the swim in the waterfall … first drops of rain … bread and wine … the veins of leaves, blowing grass, the colour of stones … the dear one asleep in the next room … the beautiful stranger.'

Angels, unlike humans, are not paradoxical. There is no difference between their inner and their outer. The scales are off their eyes and they see. While human subjectivity, blind spots, prejudices and ego all distort our vision, angels have no such blindness. I imagine their sight is how the visual artist Robert Irwin described the world just after he emerged

'IS IT YOU, COME TO CARRY ME THROUGH THE GATES?'

from a sensory-deprivation tank. 'For a few hours after you came out, you really did become more energy conscious, not just that leaves move, but that everything has a kind of aura, that nothing is wholly static, that color itself emanates a kind of energy. You noted each individual leaf, each individual tree. You picked up things which you normally blocked out.'

'Is it you?' Euchrid calls out at the end of *And the Ass Saw the Angel*, 'Is it you, come to carry me through the gates?'

V — The In-Between

In his foreword to *The Tibetan Book of the Dead*, the Buddhist scholar Robert Thurman enjoins us to be prepared for the transition from corporeal to spirit. The point, he tells us, is to learn to love the clear light, not 'shoot through the void and rise back up into an … embodiment'. If we don't learn to love the clear pre-dawn light we will end up inside either 'lotus or womb or egg or moist cavity' and the life cycle will start up once again.

One of the ways we can prepare, according to Thurman, is by being familiar with what heaven will look like. If we are Christian, we may see the Pearly Gates, if we're Jewish we might see angels tending the garden of Eden, harvesting manna, otherwise known as angel food. If we are science fiction devotees we might find ourselves on another planet, pink waves crashing onto an indigo shore. If we are secular, Thurman advises that we read up on life-after-death experiences. 'During the between-state,' he instructs, 'the consciousness is embodied in a ghost-like between body made of subtle energies structured by the imagery in the mind, similar to the subtle embodiment we experience in dreams.'

Raymond A. Moody collected near-death experiences in his book *Life After Life*. The steps are uncannily the same in every account: the person floats up out of their body; they see a bright light; out of the light comes a voice. After a car crash, a man watched people walk up to the wreck. 'I would try to turn around, to get out of their way, but they would just walk *through* me.'

A woman felt a sort of drifting, she heard beautiful music and floated down the hallway onto her porch and right through the screen. Another saw a spirit that looked like 'the clouds of cigarette smoke you can see when they are illuminated as they drift around a lamp'.

Since the death of his son, Cave has been in closer contact with his fans, staging so-called Conversations – events in which he answers random questions from the audience in between performing solo at the piano. He also answers fan questions on his website The Red Hand Files. In one question about the possibility of an afterlife, Cave writes how grief can engender the spirit world. 'Within that whirling gyre all manner of madnesses exist; ghosts and spirits and dream visitations, and everything else that we, in our anguish, will into existence. These are precious gifts that are as valid and as real as we need them to be.'

'Seeing the swallows flying through the summer air,' Roland Barthes writes in his *Mourning Diary*, 'I tell myself, thinking painfully of mama, how barbarous not to believe in souls, in the immortality of souls, the idiotic truth of materialism.'

There is an empty space within death culture and grief. We still haven't articulated the spiritual components of grieving. I remember after my mother's funeral how I felt at a complete loss on what to do next, how to console my flayed heart. *Ghosteen*, Cave's latest album, is a valuable study of loss and sorrow, of the time after a loved one dies when we feel stuck with one foot in this world and one, with our beloved, in the next.

'CAVE'S CALL IS TO THE IMAGINATION, TO CREATIVITY, TO THE SOUND OF THE CELESTIAL SPHERES OR WHAT WE CALL MUSIC'

Angels are everywhere on *Ghosteen*, not named directly, but they sing on nearly every song with a wordless beauty and urgency that this listener finds both painful and lovely. Cave has said that *Ghosteen* is about a disembodied spirit. Sometimes the spirit speaks as in 'Sun Forest': 'I am here/Beside you/Look for me/In the sun/I am beside you/I am within/In the sunshine/In the sun.'

On 'Ghosteen Speaks', ghost and human share not an earthly reality but a theology. 'I try to forget/To remember/That nothing is something.' The ancient idea that God is best found in the void. And the final incarnation, terrible but also full of grace: 'I am within you/You are within me.'

———

As I finish this essay, I am at my desk in my attic office in Brooklyn. My window is not swarming with lady bugs. I look out not on moss-covered cedars but a brick wall and a plastic owl that sits on the ledge to scare away pigeons. I don't watch, as I did in Mississippi, black-clad pilgrims head down the street to Rowan Oak. Though I do journey at my desk, my own sacred space, as passionately as any pilgrim. I see. I doubt. I wonder.

In Chekhov's story 'The Student', a young seminarian walking home on a cold night comes across a group of peasant women standing around a large bonfire. It is a few days before Easter. The seminarian tells the story of Peter's denial of Jesus, which brings the women to tears. As he leaves and continues walking home, he realises that it's not his storytelling abilities but the old story itself that moved the women. This gives him a jolt, a sensation of eternity. 'He even stopped for a minute to take breath. "The past," he thought, "is linked with the present by an unbroken chain of events flowing one out of another." And it seemed to him that he had just seen both ends of that chain; that when he touched one end the other quivered.'

Nick Cave's work continues to do the implicit work of re-enchanting the world, of reminding us that our longing for God is real, though our main work is to witness, minister to and love one another. This is hard, particularly when we are called to love the dead. Cave's call is to the imagination, to creativity, to the sound of the celestial spheres or what we call music. The balance of beauty and sorrow in his most recent songs reminds me of a saint's reliquary I saw at the Metropolitan Museum, in a show featuring treasures of St Sophia: a small gold chapel made out of delicate filigree, inset with blue and red jewels. And at the bottom, in a sort of golden cage, lay items that at first shocked me with their incongruity: bone fragments and a swatch of rotten cloth. The fragile remnants of a saint, a holy animal, inside an eternal frame. This is our dilemma. We are God. We are human. Both at the same time. And this is what makes our position on earth tricky, humorous, beautiful and impossible.

Darcey Steinke
Brooklyn, 2020

Notes

The Red Hand Files
by Nick Cave:
theredhandfiles.com

Pilgrims

'What goes on up there':
Nick Cave, *And the Ass Saw
the Angel* (Penguin, London,
England, 1989)

'Negative Capability': John
Keats in Maud Casey, *The Art
of Mystery* (Greywolf Press,
Minneapolis, Minnesota,
2018)

'invested brothels' and
'in which life': Thomas
Merton in Charles Reagan
Wilson, 'William Faulkner
and the Southern Religious
Culture' (University of
Mississippi Press, Oxford,
Mississippi, 1989)

'"agitating" for a
broader': Simon Reynolds,
'Of Misogyny, Murder and
Melancholy: Meeting Nick
Cave' in *Nick Cave: Sinner
Saint*, ed. Mat Snow (Plexus,
London, England, 2011)

'It is as if a bar': William
James, *Varieties of Religious
Experience* (Renaissance
Classics, United States of
America, 2012)

'Like two candles' and 'The
duty to': William Faulkner,
As I Lay Dying (Vintage
International, New York,
New York, 1930)

'I believed in God': Nick
Cave, *The Gospel According
to Mark* (Canongate,
Edinburgh, Scotland, 1998)

'Hell' and 'I do not know
you God,': Flannery O'Connor,
A Prayer Journal (FSG, New
York, New York, 2013)

'Language itself': Phil
Sutcliffe,'Nick Cave: Raw and
Uncut 2' in *Nick Cave: Sinner
Saint*, ed. Mat Snow (Plexus,
London, England, 2011)

'A proof of God': Alexander
J. Marshall III, 'The Dream
Deferred: William Faulkner's
Metaphysics of Absence',
(University of Mississippi,
Oxford, Mississippi, 1989)

'Slippery as religious':
Maud Casey, *The Art of
Mystery* (Greywolf Press,
Minneapolis, Minnesota,
2018)

Holy Jumpers

'Faulkner wrote about':
Charles Reagan Wilson,
'William Faulkner and the
Southern Religious Culture'
(University of Mississippi
Press, Oxford, Mississippi,
1989)

'I see that my': Nick Cave,
in 'The Flesh Made Word', BBC
Radio 3 Religious Services,
1996

'No bolder attempt': H.L.
Mencken, 'The Sahara of the
Bozart', *Prejudices: Second
Series* (Knopf, New York, 1920)

'are only messengers' and
'You fled like': Gerald G.
May, *The Dark Night of the
Soul* (HarperOne, New York,
New York, 2005)

'The kind of sadness':
Anne Carson, *Glass, Irony
and God* (New Directions,
New York, New York, 1996)

'The religions which':
Simone Weil, *Love in the
Void: Where God Finds Us*
(Plough Publishing House,
Walden, New York, 2018)

'greatest blues line':
Stanley Crouch in James
H. Cone, *The Cross and the
Lynching Tree* (Orbis Books,
New York, New York, 2018)

'Myth is the': Nick
Cave, *The Sick Bag Song*
(Canongate, Edinburgh,
Scotland, 2015)

'I lost my innocence': Dan
Glaister, interview for the
Guardian, 2003

'Honey, I'm not the king'
and 'I didn't only see':
David Rosen, *The Tao of Elvis*
(Harvest, Orlando, Florida,
2002)

'If you relaxed enough',
'There was a floating'
and 'They would be': Peter
Guralnick, *Last Train to
Memphis: The Rise of Elvis
Presley* (Little Brown, New
York, New York, 1994)

'When one twin', '[Elvis]
reminded me' and rock's
debt: James A. Cosby, *Devil's
Music, Holy Rollers and
Hillbillies: How America
Gave Birth to Rock and Roll*
(McFarland & Co., Jefferson,
North Carolina, 2016)

Of Weal and Woe

'reading a book': David Rosen, *The Tao of Elvis* (Harvest, Orlando, Florida, 2002)

'The different kinds of vice': Simone Weil, *Love in the Void: Where God Finds Us* (Plough Publishing House, Walden, New York, 2018)

'Throughout the gig': Michel Faber, 'A Boy Next Door' in *Nick Cave: Sinner Saint*, ed. Mat Snow (Plexus, London, England, 2011)

'The thief and': T.H. Huxley in Charles Reagan Wilson, 'William Faulkner and the Southern Religious Culture' (University of Mississippi Press, Oxford, Mississippi, 1989)

'I like the way': interview with Nick Cave in *Mojo*, January 1996

'is a message': Timothy K. Beal, *Religion and Its Monsters* (Routledge, New York, New York, 2002)

'I learned not', 'to me', 'That must be' and 'I'm not obsessed': Greg Laurie, *Johnny Cash* (Salem Books, Washington, DC, 2019)

'Darkness': Walter Brueggemann, *Spirituality of the Psalms* (Facetts, London, England, 2002)

mercy seat, the mourner's bench: Charles A. Johnson, *The Frontier Camp Meeting* (Southern Methodist University Press, Dallas, Texas, 1955)

'many boyfriends' and 'would crack': Dickson D. Bruce Jr., *And They All Sang Hallelujah*, (University of Tennessee, Knoxville, Tennessee, 1973)

'I can remember the time': Mary Rowlandson, *Narrative of the Captivity and Restoration of Mrs. Mary Rowlandson* (Project Gutenberg, 2009)

'Religions' and 'Religion': John Gray, *Seven Types of Atheism* (FSG, New York, New York, 2018)

'I slowly reacquainted': Nick Cave, in 'The Flesh Made Word', BBC Radio 3 Religious Services, 1996

'As I understand': Jim Delvin, interview on LeonardCohenForum.com, 1988

'Christ, it seemed to me': Nick Cave, *The Gospel According to Mark* (Canongate, Edinburgh, Scotland, 1998)

'In his spiritual': Josef Pieper, *Only the Lover Sings* (Ignatius Press, San Francisco, California, 1988)

'must be the axe': Franz Kafka, letter to Oskar Pollak, 1904

'There is *something*': William James, *The Varieties of Religious Experience* (Renaissance Classics, United States of America, 2012)

'God don't need': William Faulkner, *A Fable* (Vintage Books, New York, New York, 2011)

Angelology

'The action': Marsilio Ficino in Valery Rees, *From Gabriel to Lucifer* (I.B. Tauris, London, England, 2016)

'Immersed in a cobalt': Nick Cave, *And the Ass Saw the Angel* (Penguin, London, England, 1989)

'tired mouths' and 'Angels (they say)': Rainer Maria Rilke, *Duino Elegies*, translated by Edward Snow (North Point Press, Berkeley, California, 2001)

'Angels': Michel de Certeau, *White Ecstasy* in Fanny Howe, *The Needle's Eye* (Greywolf Press, Minneapolis, Minnesota, 2016)

'There is communion': Nick Cave, in 'The Flesh Made Word', BBC Radio 3 Religious Services, 1996

'Still': Fanny Howe, *The Needle's Eye* (Greywolf Press, Minneapolis, Minnesota, 2016)

'Her feet rest' and 'A slowly': Nick Cave, *The Death of Bunny Munro* (Canongate, Edinburgh, Scotland, 2009)

Emanuel Swedenborg: Gary Lachman, *Swedenborg* (Tarcher/Penguin, New York, New York, 2009)

'For a few hours': Robert Irwin in Lawrence Weschler, *Seeing Is Forgetting the Name of the Thing One Sees* (University of California Press, Berkeley, California, 1982)

The In-Between

'shoot through the void': Robert Thurman, *The Tibetan Book of the Dead* (Bantam, New York, New York, 1994)

'I would try' and 'the clouds': Raymond A. Moody Jr., *Life After Life* (HarperOne, New York, New York, 1975)

'Seeing the swallows': Roland Barthes, *Mourning Diary* (Hill and Wang, FSG, New York, New York, 2010)

'He even stopped': Anton Chekhov, 'The Student' in *The Witch and Other Stories* (Project Gutenberg, 2006)

'Mutiny! The Birthday Party'
Drawing in blood by Nick Cave, c. 1983
For further reading see page 260

(Mutiny in Heaven)

① Ah wassa born
to walk
to walk in these losers shoes
And a confess (that ah ain't gunna end it all)
a wear with os wings
Ow! ow! ow! ow!
Ah bailing out x4
Mu-tin-ee in Heaven

② This old heart is a ghetto
+ it drums a (destitute) beat
+ what was once heaven
barbee
is a slum + you know it
Ahm' bailing out x
Don't ever telephone me again x2
'cause ahve got heaven on the line
Hello? Hello? This is... this is... o-o-oh.
There's a Mu-tin-ee in Hea-ven

[ahm' bailing out 1·2·3·4 wo-o-o-ow)

③ Ah wassa born
barbee to walk
+ walk is just what ô him gunna do walk outa
One is a crowd + ahm bailing out your life
Don't ever telephone me agin x2 + mine in these losers shoes
Mu-tin-ee in Hea-ven
There's one thing that I don't need
is a hungry little hungry mouth to feed
Mu-tin-ee in Hea-ven

Song lyrics for 'Mutiny in Heaven' by Nick Cave, 1983
Released on *Mutiny!* by The Birthday Party, 1983

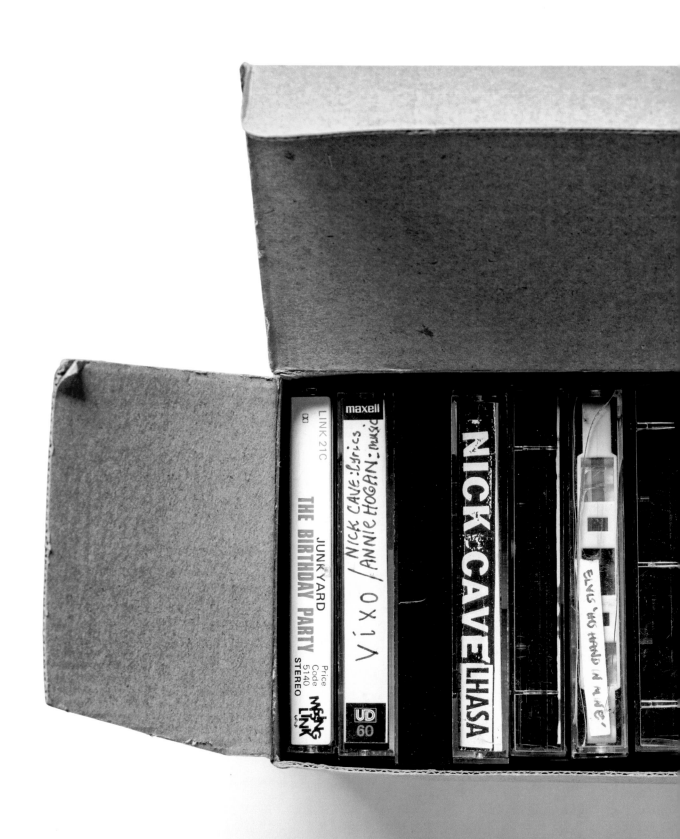

Box of cassettes
Owned by Nick Cave, 1982-85

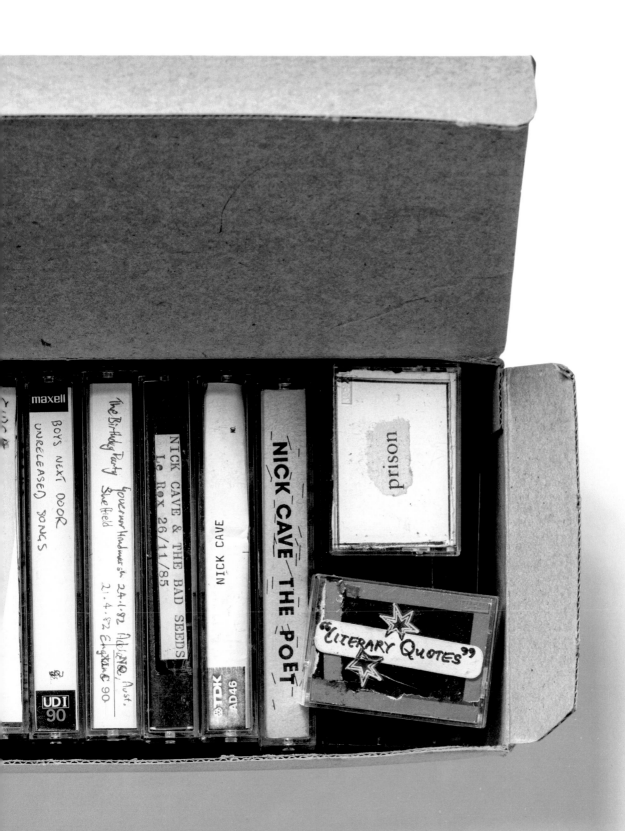

From Her to Eternity

97

Intro I wanna tell you about a GIRL.
You know, she lives in room 29
Why! That's the one right up toppa mine
I start to cry.

V1 (C) ~~Sometimes~~ I hear her walking
walking barefoot cross the floorbands
all thru the night.
 Loveless

V2. I hear her crying, tears come falling on
down, leaking thru the cracks, splashin
on my face, I catch them in mouth

V3. Walk 'n' CRY x 4 From Her to Eternity

V4. I read her diary on her sheets,
Tore out a page + fled, out the window +
shinning it down the vine, Out a her
 back
nightmare thinto mine

V5. I don't believe in miracles no, no, no, no,
From her to Eternity.

V6. Here is the Church, here is the steeple
 Key hole
I make my confession up at the key hole
why open the door if you can be sick to steal
Here is the if ya can see thru the peephole
WRESTLING Sea-sick soul
BRISTLING walkin up the stairs

Song lyrics for 'From Her to Eternity'
by Nick Cave and Anita Lane, 1983
Released on From Her to Eternity
by Nick Cave & The Bad Seeds, 1984
For further reading see page 261

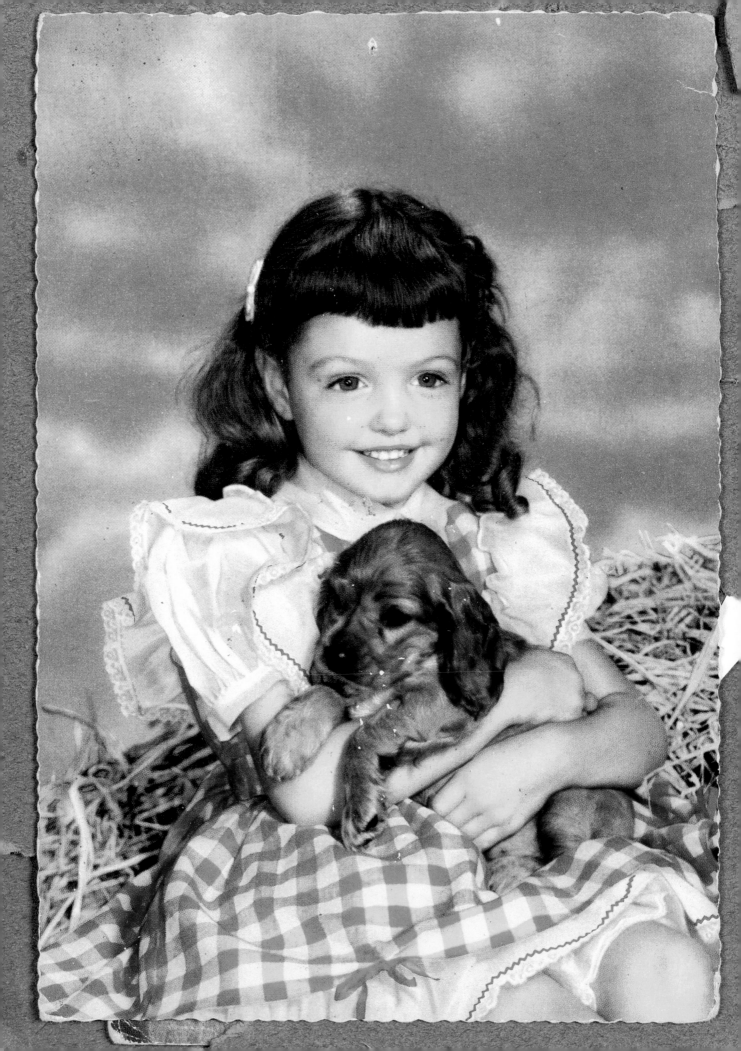

Statue of Christ, c. 1860
Present from Victoria Clarke to Nick Cave
on his fortieth birthday
For further reading see page 261

Previous page:
Postcard from handmade book
by Nick Cave, 1985

82

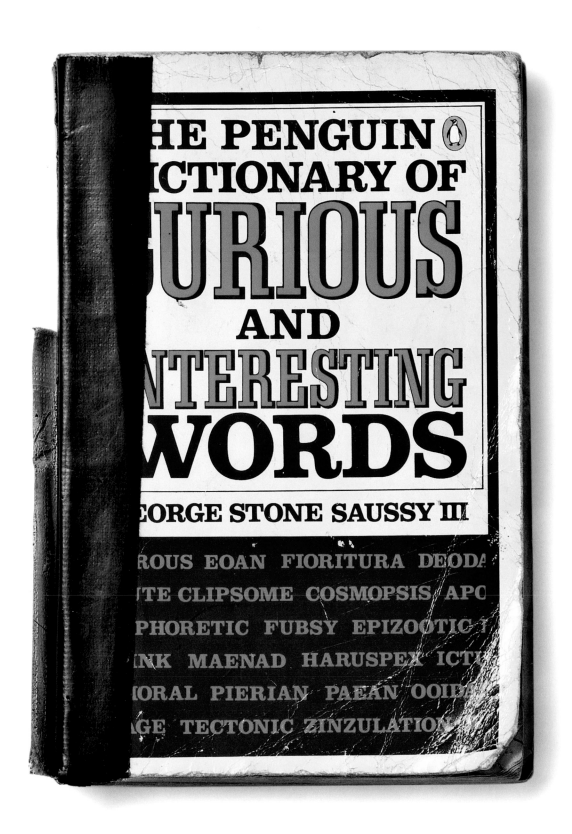

The Penguin Dictionary of Curious and Interesting Words
by George Stone Saussy III, 1986

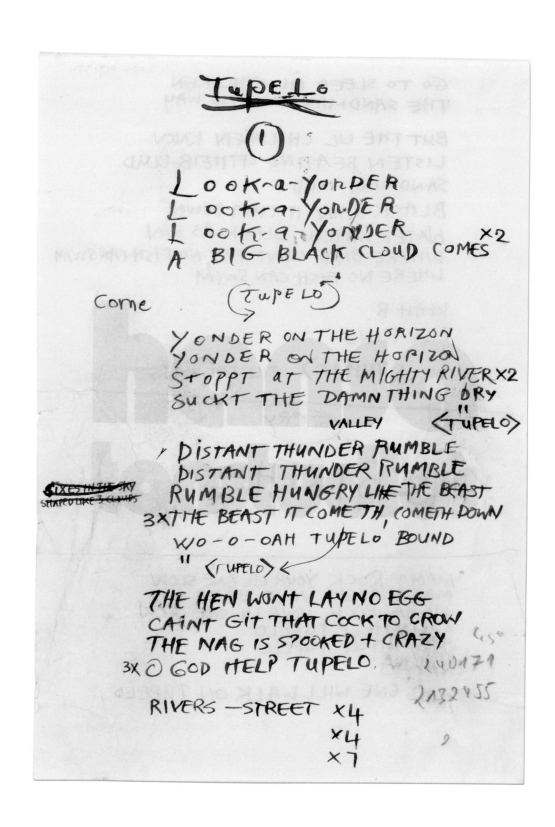

Song lyrics for 'Tupelo' by Nick Cave, c. 1984
Released on *The Firstborn Is Dead* by
Nick Cave & The Bad Seeds, 1985
For further reading see page 261

Opposite page:
Postcard from handmade book by Nick Cave, 1985

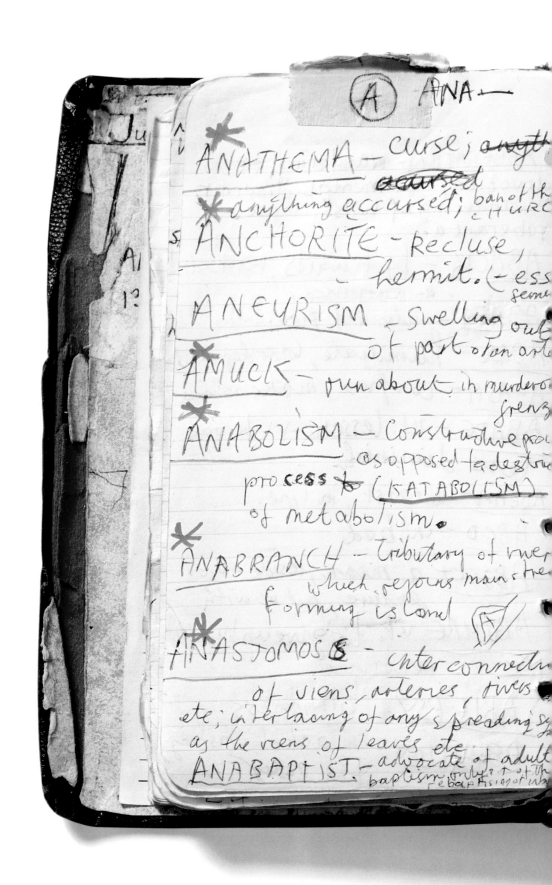

Handwritten dictionary of words
by Nick Cave, 1984-85
For further reading see page 261

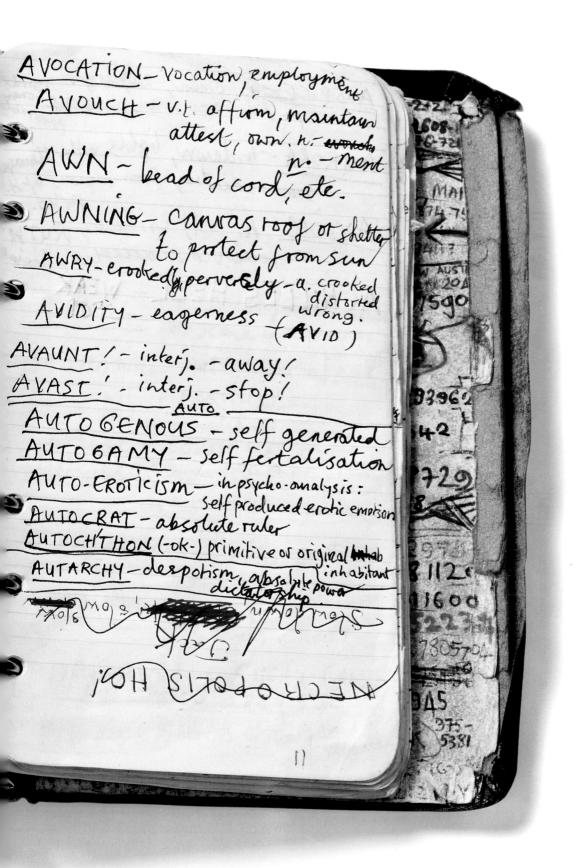

AVOCATION — vocation, employment

AVOUCH — v.t. affirm, maintain attest, own. n. ~~vouch~~
n. — ment

AWN — beard of cord, etc.

AWNING — canvas roof or shelter to protect from sun

AWRY — crookedly, perversely — a. crooked
distorted
wrong.

AVIDITY — eagerness (AVID)

AVAUNT! — interj. — away!

AVAST! — interj. — stop!

AUTO
AUTOGENOUS — self generated

AUTOGAMY — self fertalisation

AUTO-EROTICISM — in psycho-analysis:
self produced erotic emotion

AUTOCRAT — absolute ruler

AUTOCHTHON (-ok-) primitive or original ~~inhab~~
inhabitant

AUTARCHY — despotism, absolute power
dictatorship.

NECROPOLIS HO!

11

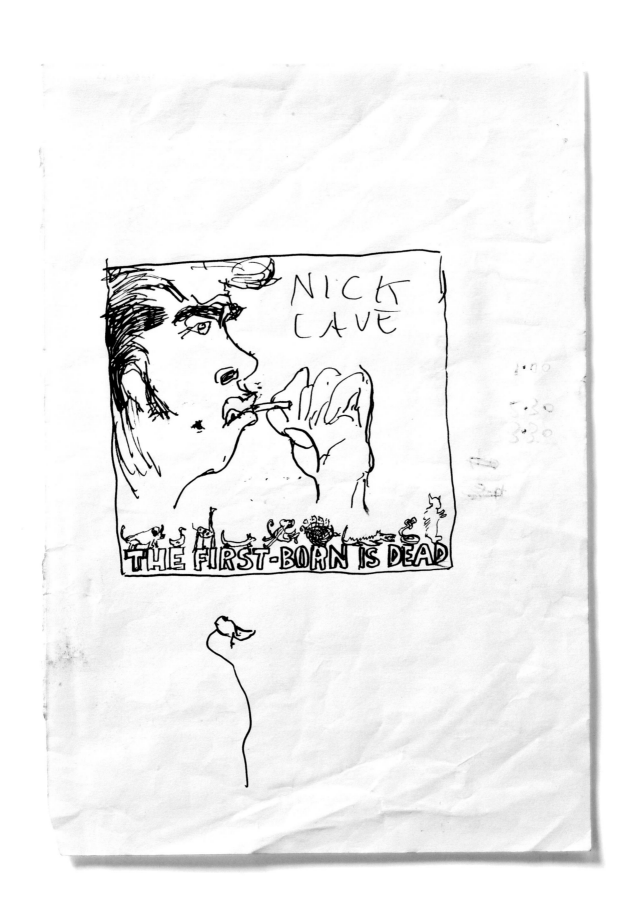

The Firstborn Is Dead
Drawing by Nick Cave, 1985

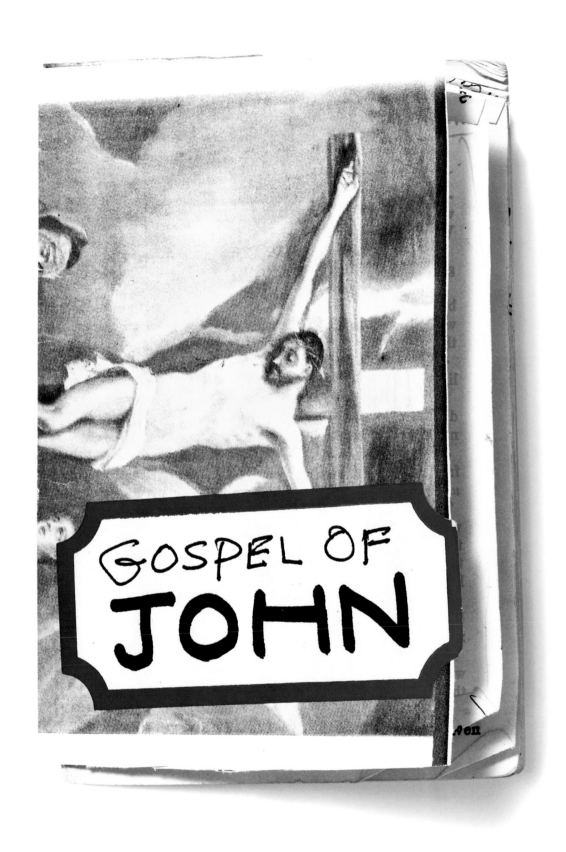

The Gospel According to St John, 1980s
Annotated by Nick Cave

thou gavest me; and they have received *them*, and have known surely that I came out from thee, and they have believed that thou didst send me.

9 I pray for them: I pray not for the world, but for them which thou hast given me; for they are thine.

10 And all mine are thine, and thine are mine; and I am glorified in them.

11 And now I am no more in the world, but these are in the world, and I come to thee. Holy Father, keep through thine own name those whom thou hast given me, that they may be one, as we *are*.

12 While I was with them in the world, I kept them in thy name: those that thou gavest me I have kept, and none of them is lost, but the son of perdition; that the Scripture might be fulfilled.

13 And now come I to thee; and these things I speak in the world, that they might have my joy fulfilled in themselves.

14 I have given them thy word; and the world hath hated them, because they are not of the world, even as I am not of the world.

15 I pray not that thou shouldest take them out of the world, but that thou shouldest keep them from the evil.

16 They are not of the world, even as I am not of the world.

17 Sanctify them through thy truth: thy word is truth.

18 As thou hast sent me into the world, even so have I also sent them into the world.

19 And for their sakes I sanctify myself, that they also might be sanctified through the truth.

20 Neither pray I for these alone, but for them also which shall believe on me through their word;

21 That they all may be one; as thou, Father, art in me, and I in thee, that they also may be one in us: that the world may believe that thou hast sent me.

22 And the glory which thou gavest me I have

... why is FAITH essential to eternal life, ... why the need to believe? THE GARDEN

ST. JOHN 18

55

ven them; that they may
e one, even as we are
ne:

23 I in them, and thou
a me, that they may be
aade perfect in one; and
aat the world may know
aat thou hast sent me, and
ast loved them, as thou
ast loved me.

24 Father, I will that they
lso, whom thou hast
iven me, be with me
here I am; that they may
ehold my glory, which
hou hast given me: for
aou lovedst me before the
oundation of the world.

25 O righteous Father,
he world hath not known
hee: but I have known
aee, and these have known
aat thou hast sent me.

26 And I have declared
nto them thy name, and
ill declare it; that the
ove wherewith thou hast
ved me may be in them,
nd I in them.

CHAPTER 18

WHEN Jesus had
spoken these words,
e went forth with his
isciples over the brook

Cedron, where was a gar-
den, into the which he en-
tered, and his disciples.

2 And Judas also, which
betrayed him, knew the
place: for Jesus ofttimes
resorted thither with his
disciples.

3 Judas then, having re-
ceived a band of men and
officers from the chief
priests and Pharisees, com-
eth thither with lanterns
and torches and weapons.

4 Jesus therefore, know-
ing all things that should
come upon him, went forth,
and said unto them, Whom
seek ye?

5 They answered him,
Jesus of Nazareth. Jesus
saith unto them, I am he.
And Judas also, which be-
trayed him, stood with
them.

6 As soon then as he had
said unto them, I am he,
they went backward, and
fell to the ground.

7 Then asked he them
again, Whom seek ye?
And they said, Jesus of
Nazareth.

8 Jesus answered, I have
told you that I am he: if

Following page:
Euchrid's Crib 1
Nick Cave in Yorkstraße, West Berlin, 1985
Photograph by Bleddyn Butcher
For further reading see page 261

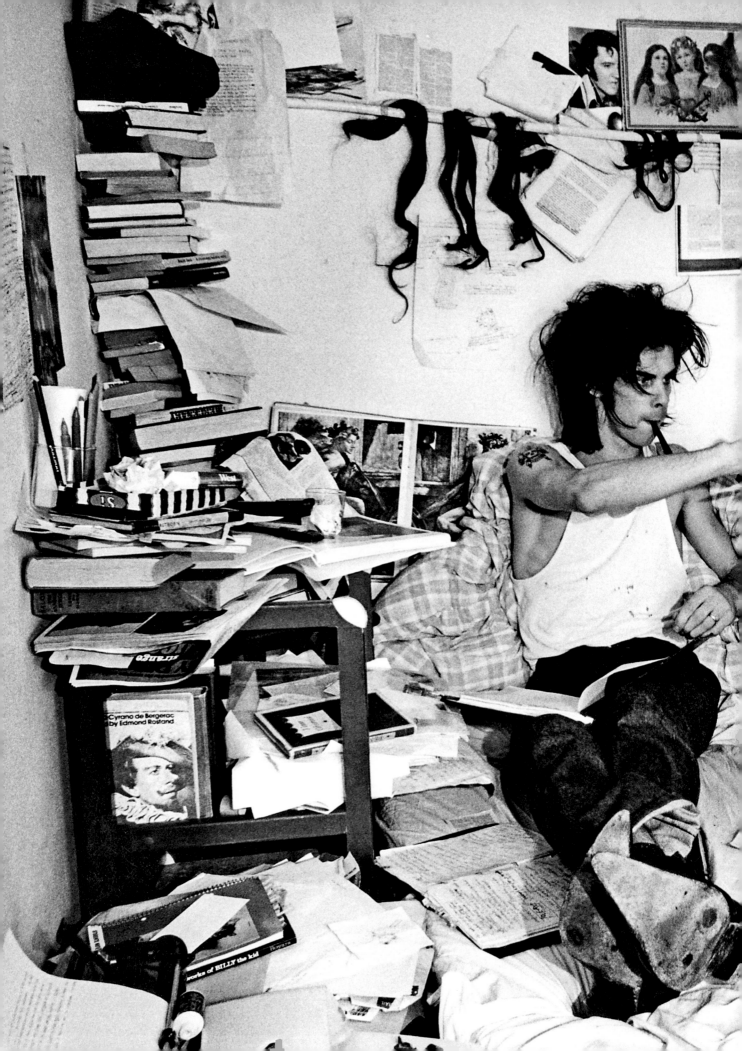

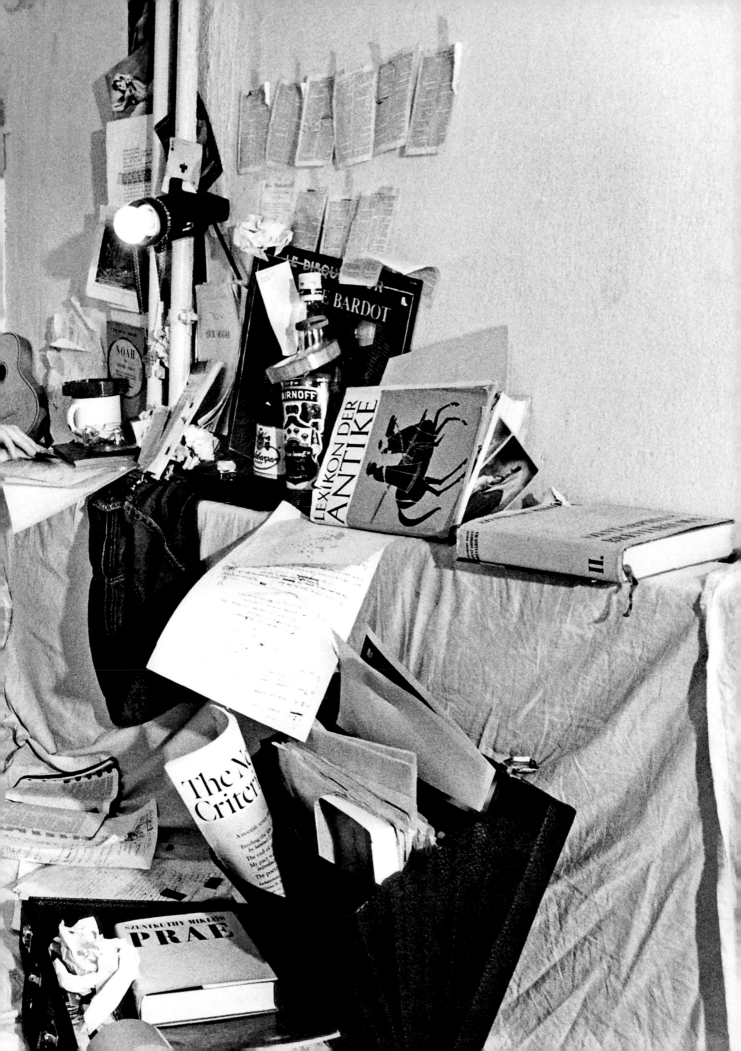

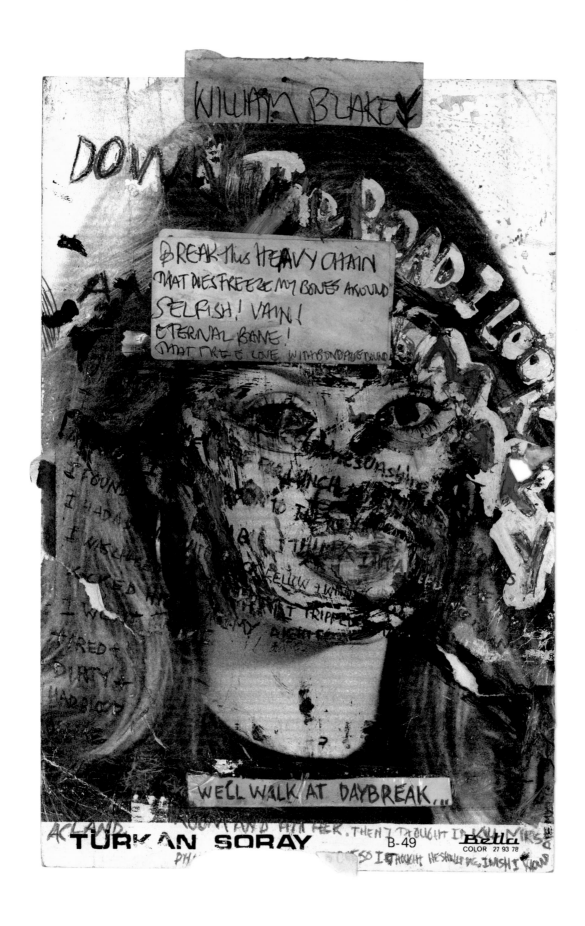

Collage entitled *Sad Waters*
by Nick Cave, 1986

Barbary Ape, Souvenir of Gibraltar, date unknown
Given to Nick Cave by Martyn Casey

Handmade book by Nick Cave, 1987
For further reading see page 262

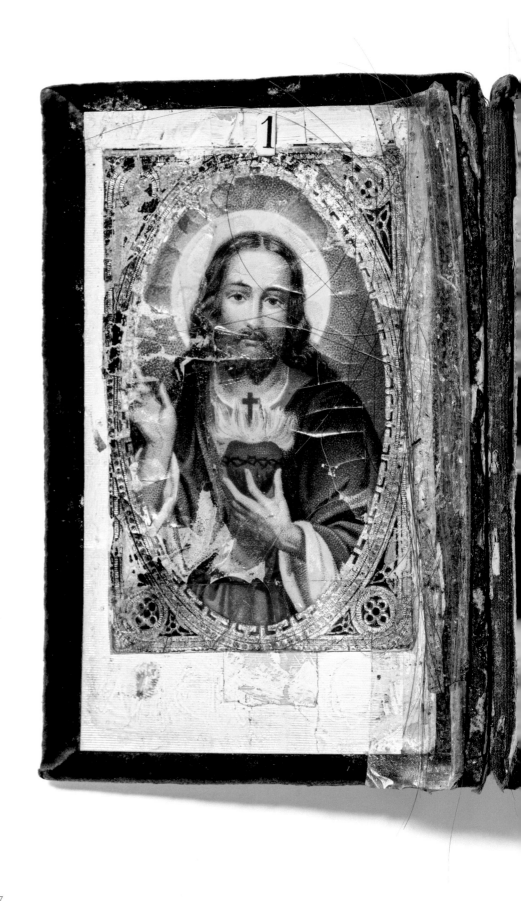

Handmade book by Nick Cave, 1987
For further reading see page 262

Handmade book by Nick Cave, 1987
For further reading see page 262

Get on board, little children,
Get on board, little children,
Get on board, little children,
There's room for many a more.

4

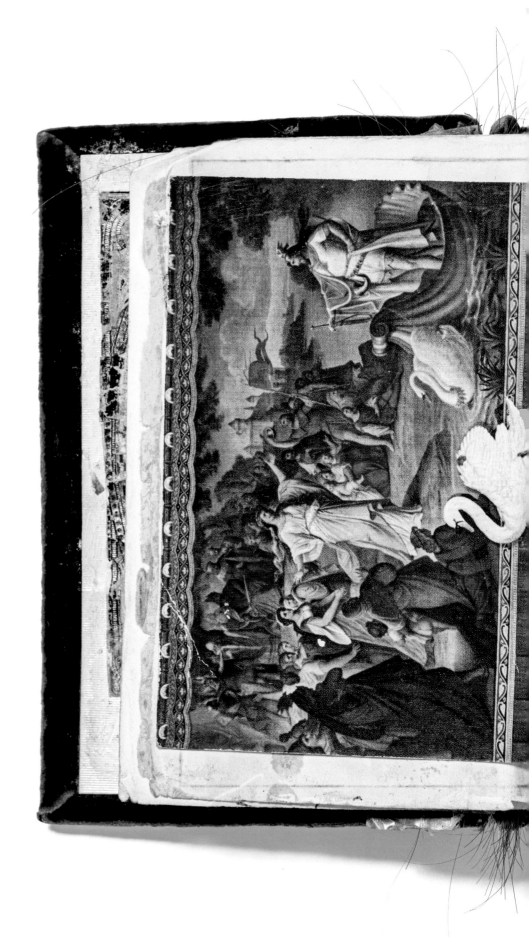

Handmade book by Nick Cave, 1987
For further reading see page 262

102

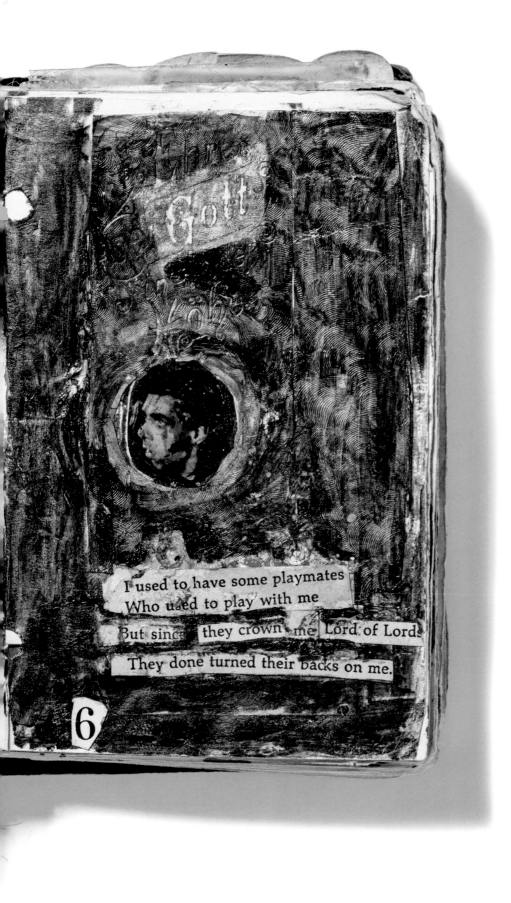

I used to have some playmates
Who used to play with me
But since they crown me Lord of Lords
They done turned their backs on me.

6

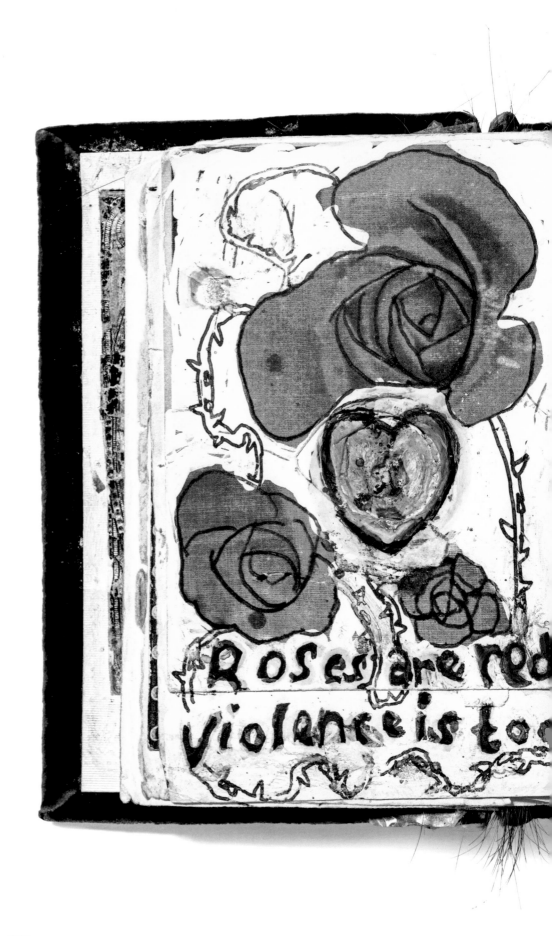

Handmade book by Nick Cave, 1987
For further reading see page 262

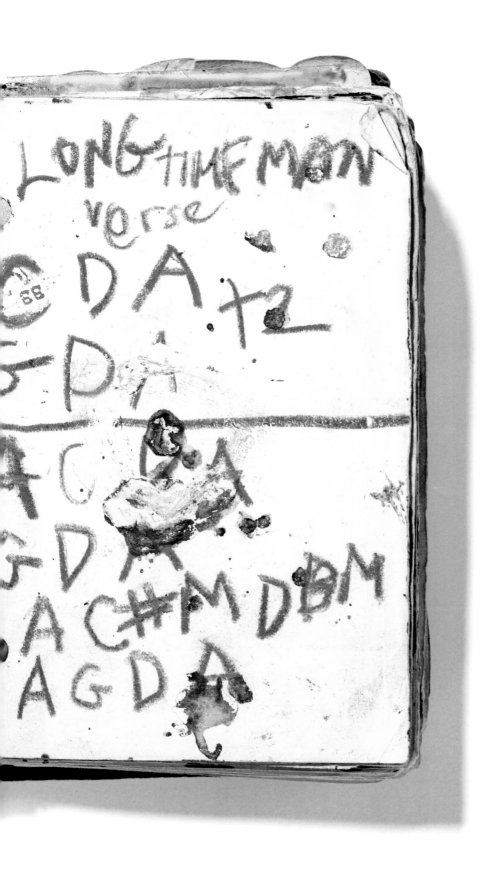

Handmade book by Nick Cave, 1987
For further reading see page 262

Hey four-eyes! It's me!

IT'S-ME-E-E-E!!!

"Basins bubble blood in Grubb St

Snow-man with six holes"

Clean through his fat guts

Giggling wounds as

I unload into his eyes

Scum Scum

SCUM! SCUM! SCUM! SCUM!

Handmade book by Nick Cave, 1987
For further reading see page 262

Handmade book by Nick Cave, 1987
For further reading see page 262

Raffael Verlag Ettal / 736

Handmade book by Nick Cave, 1987
For further reading see page 262

G. Bellini, 1505 Verlag Ettal / 682

Handmade book by Nick Cave, 1987
For further reading see page 262

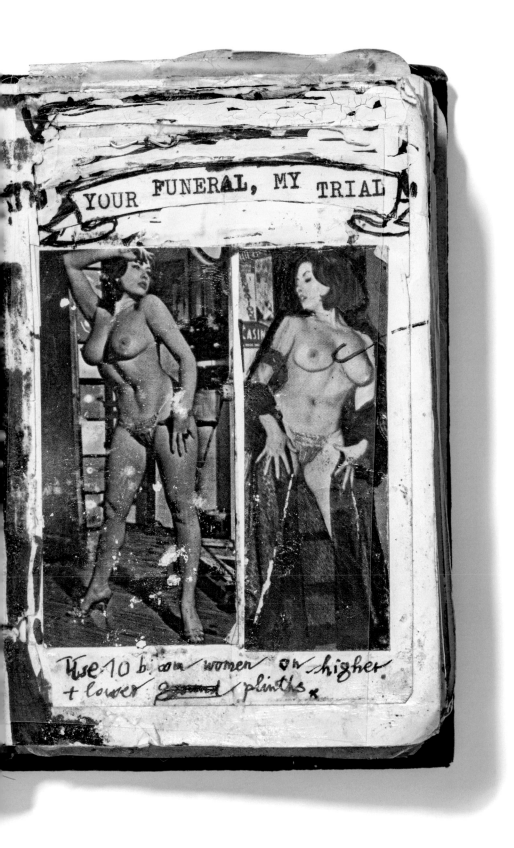

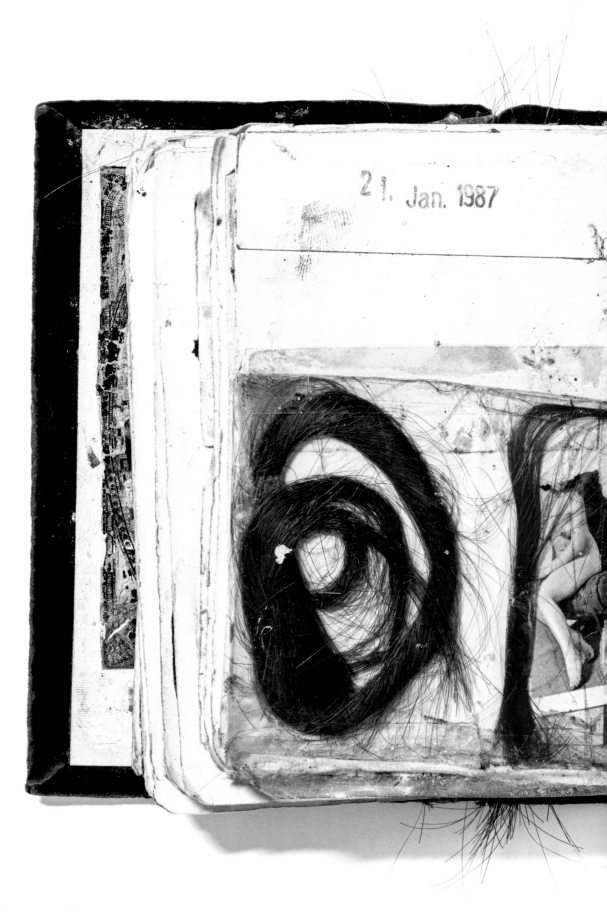

Handmade book by Nick Cave, 1987
For further reading see page 262

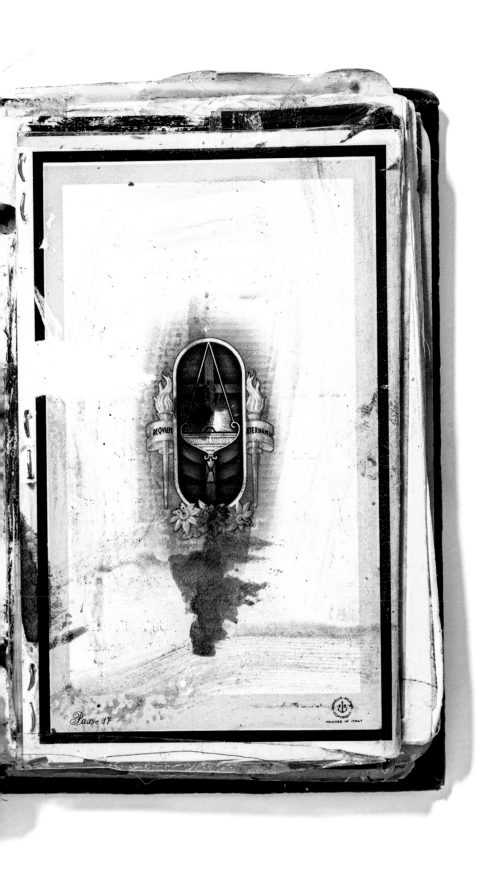

Pax - 17

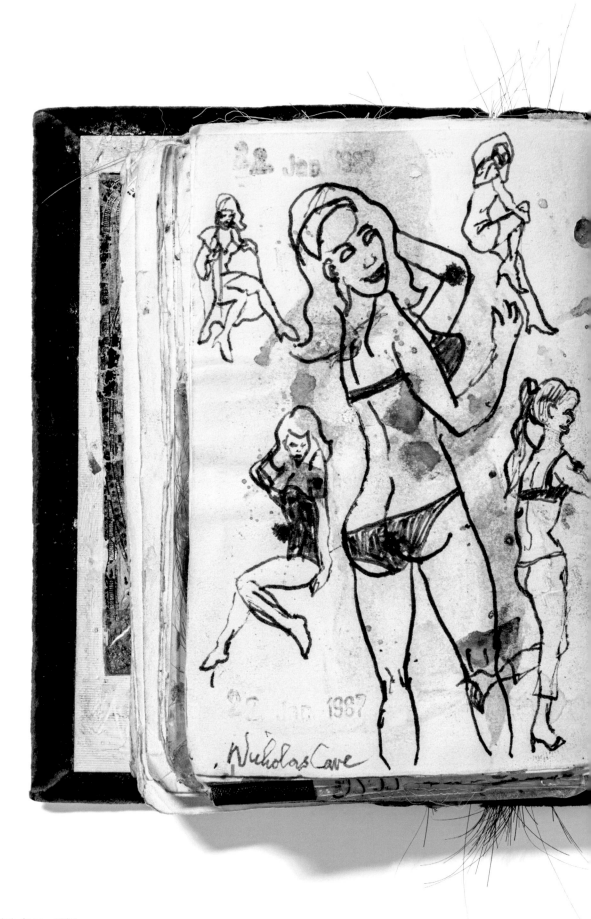

Handmade book by Nick Cave, 1987
For further reading see page 262

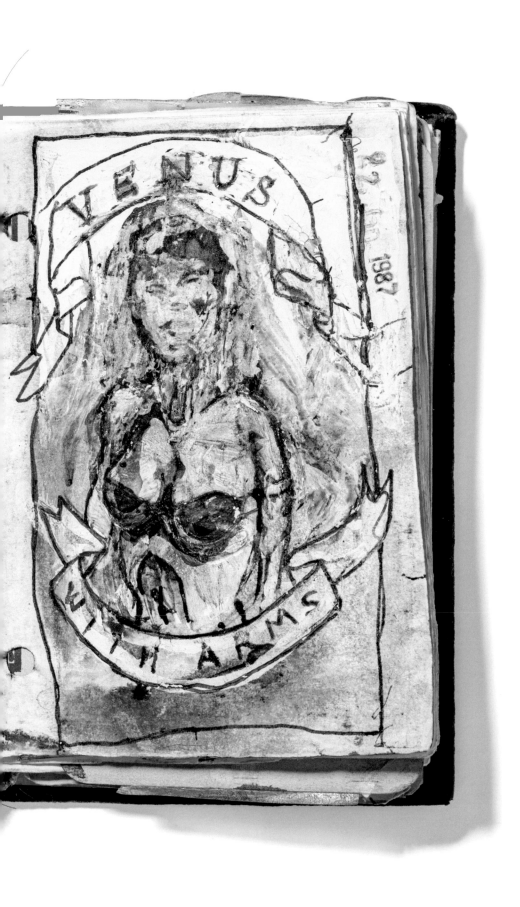

Handmade book by Nick Cave, 1987
For further reading see page 262

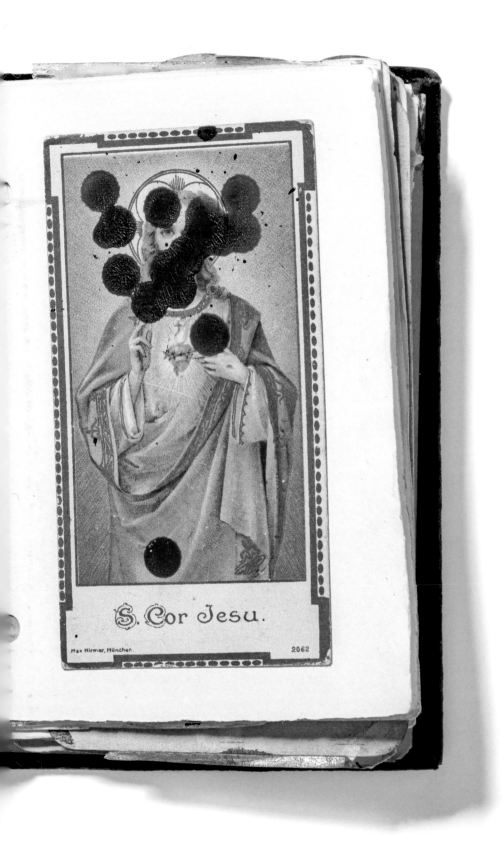

S. Cor Jesu.

Max Hirmer, München. 2062

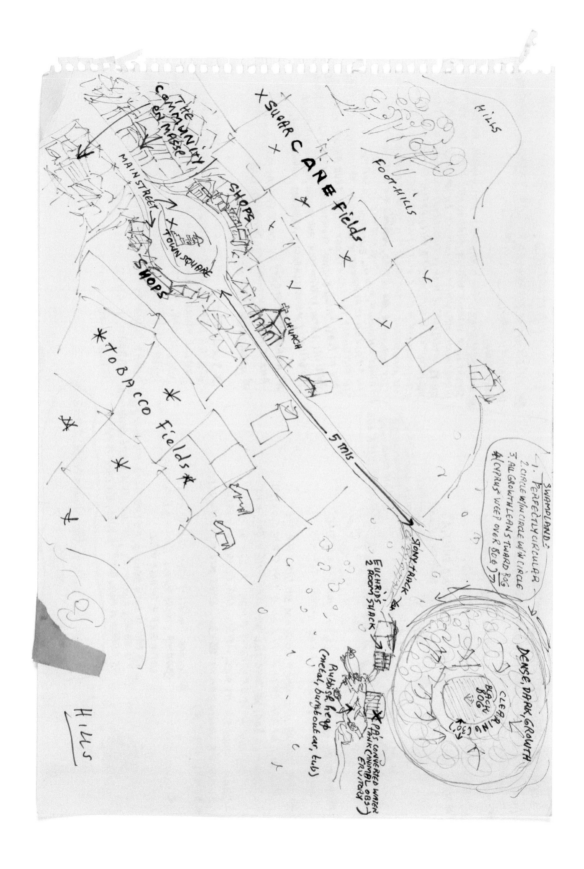

Map of Ukulore for *And the Ass Saw the Angel*
by Nick Cave, 1985

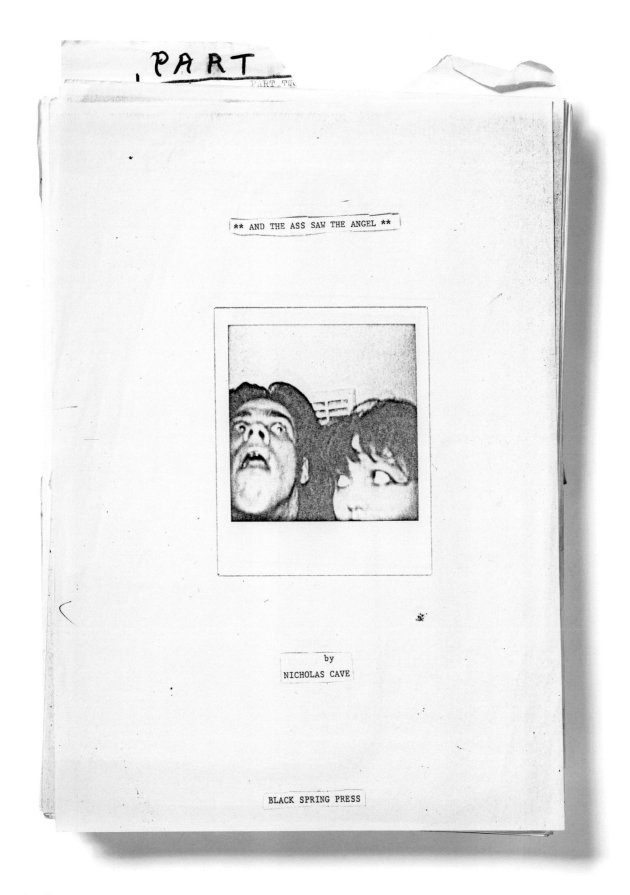

**** AND THE ASS SAW THE ANGEL ****

by
NICHOLAS CAVE

BLACK SPRING PRESS

Manuscript for
And the Ass Saw the Angel
by Nick Cave, 1985-87
Published 1989
For further reading see page 262

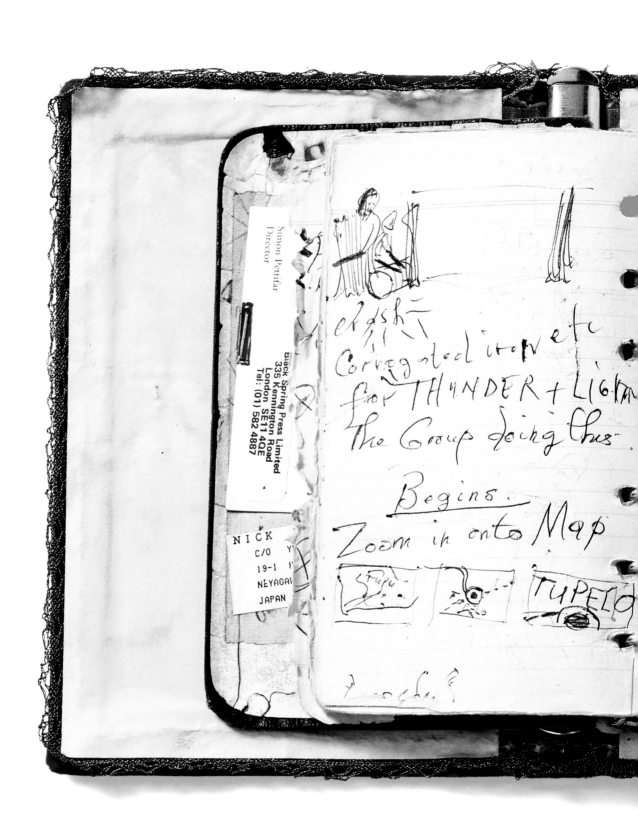

Notebook with ideas
for the 'Tupelo' music video, 1985

124

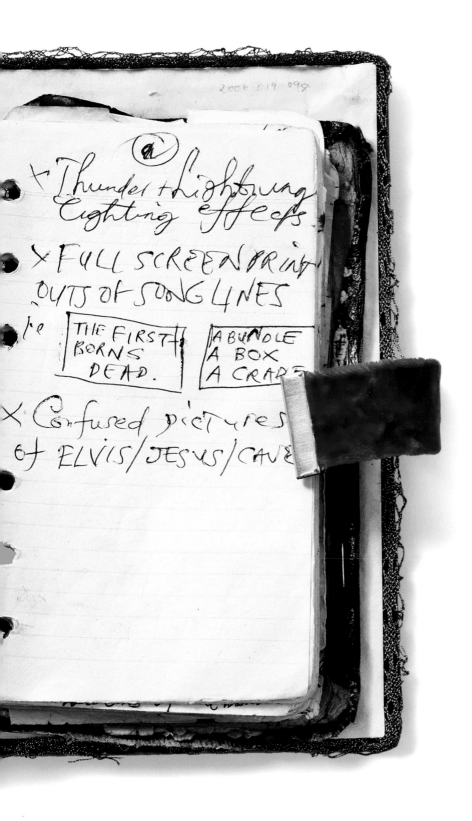

(a)

× Thunder + Lightning
Lighting effects

× FULL SCREEN Print
OUTS OF SONG LINES

ie | THE FIRST | | A BUNDLE |
| BORNS | | A BOX |
| DEAD. | | A CRATE |

× Confused pictures
of ELVIS/JESUS/CAVE

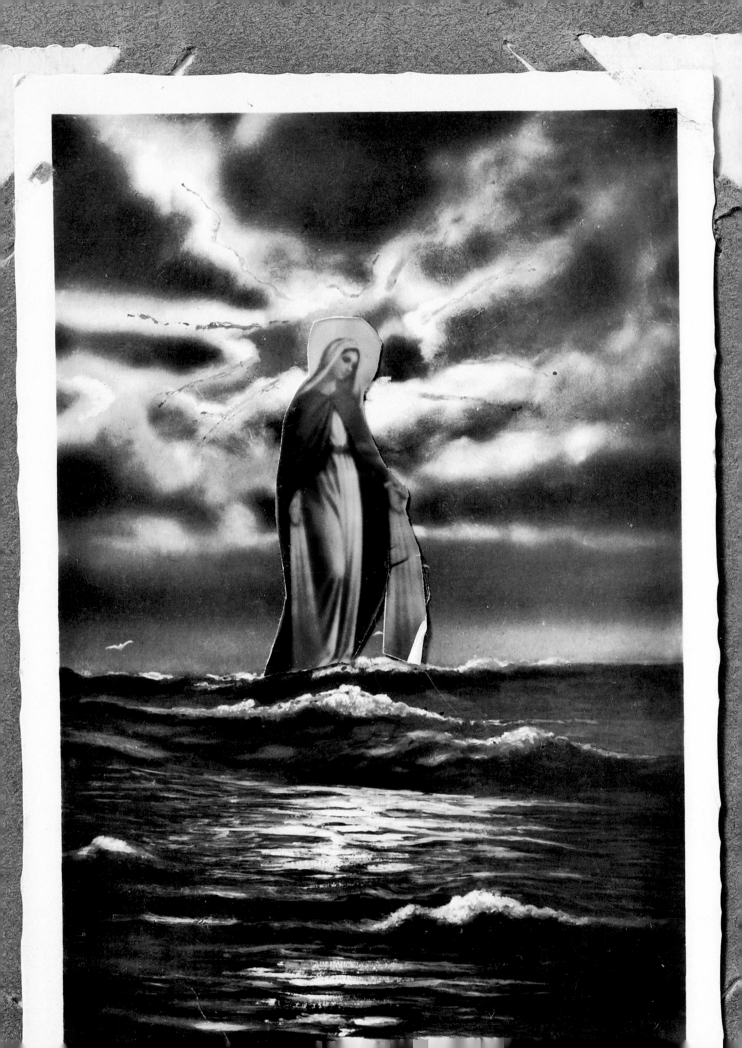

Handmade book
by Nick Cave, 1985
For further reading see page 252

Opposite page:
Postcard from handmade book
by Nick Cave, 1985

Victorian scrap picture and postcard
from handmade book by Nick Cave, 1985
For further reading see page 262

Drawing and postcard
from handmade book by Nick Cave, 1985
For further reading see page 262

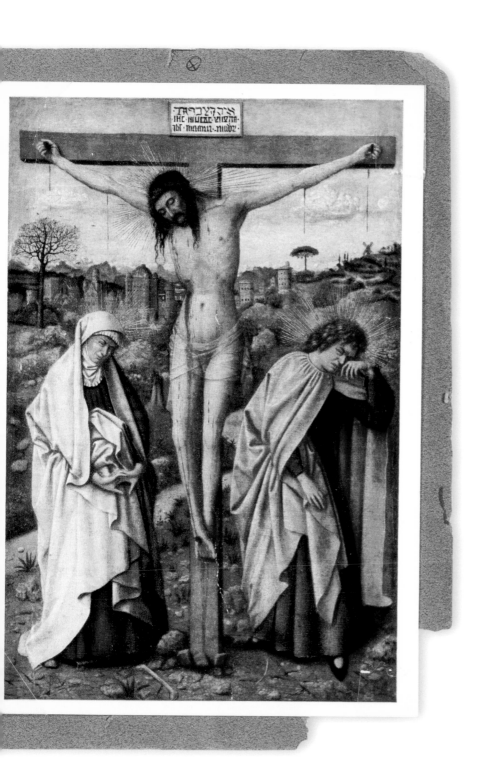

(a)

SAINT MATILDA

Image and postcard
from handmade book by Nick Cave, 1985
For further reading see page 262

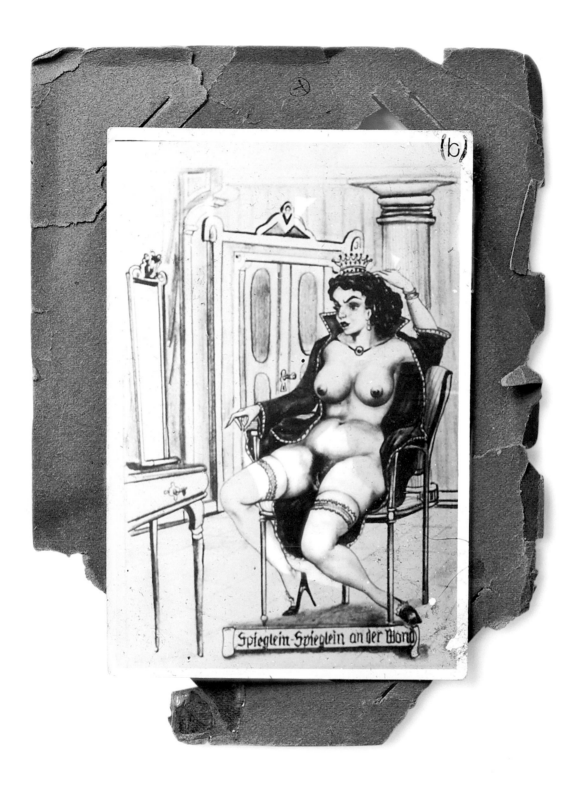

Spieglein-Spieglein an der Wand

SAINT JUDE

PATRON SAINT OF

SAINT JUDE

1985

JUDE

DESPAIR

2006·019·046

Saint Jude Patron Saint of Despair
by Nick Cave, 1985
For further reading see page 263

Three pieces of women's hair
stored in a Sarotti A-G Berlin box, 1985
For further reading see page 263

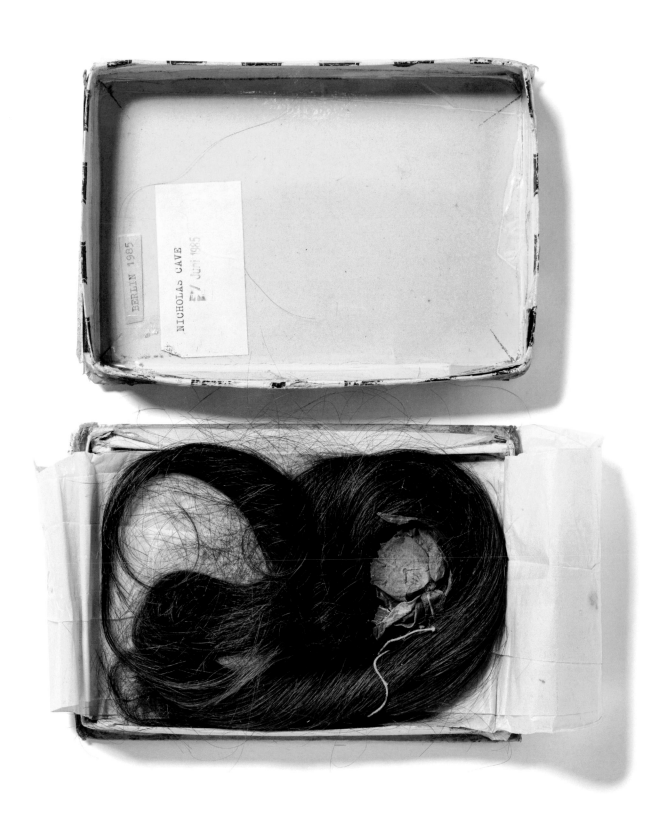

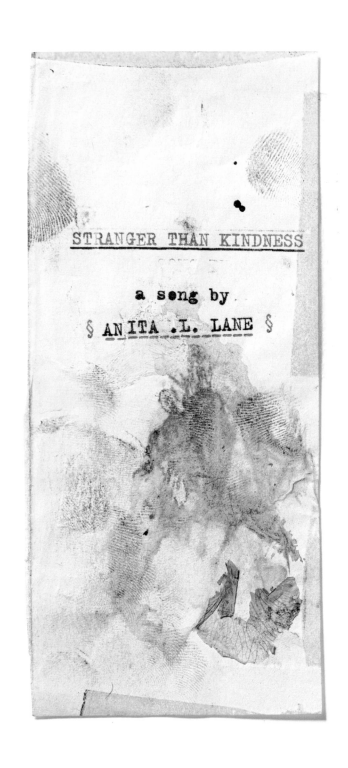

Song lyrics for 'Stranger Than Kindness'
by Anita Lane, 1986
Released on *Your Funeral... My Trial*
by Nick Cave & The Bad Seeds, 1986
For further reading see page 263

STRANGER THAN KINDNESS by Anita Lane

Stranger than kindness.
Bottled light from hotels
 Spilling everything.
Wet hand from the volcano
Sobers your skin. *Stranger than kindne*
You caress yourself and grind my soft
cold bones below.
Your map of desire burned in your slave.
Even a fool can come.
.A strange lit stair
 and find(~~the shadow of~~)a rope hanging there
Stranger than kindness

§

Keys rain like heavens hair.
There is no home, There is no bread.
We sit at the gate and scratch.
The gaunt fruit of passion
Dies in the light. *Stranger than Kindness*
Your sleeping hands, journey
Stranger than kindness.
Your hold me so carelessly close.
Tell me I'm dirty.
I'm a stranger to kindness

§

Handmade book by Nick Cave with El Greco's
The Crucifixion pasted onto the cover, 1986
For further reading see page 263

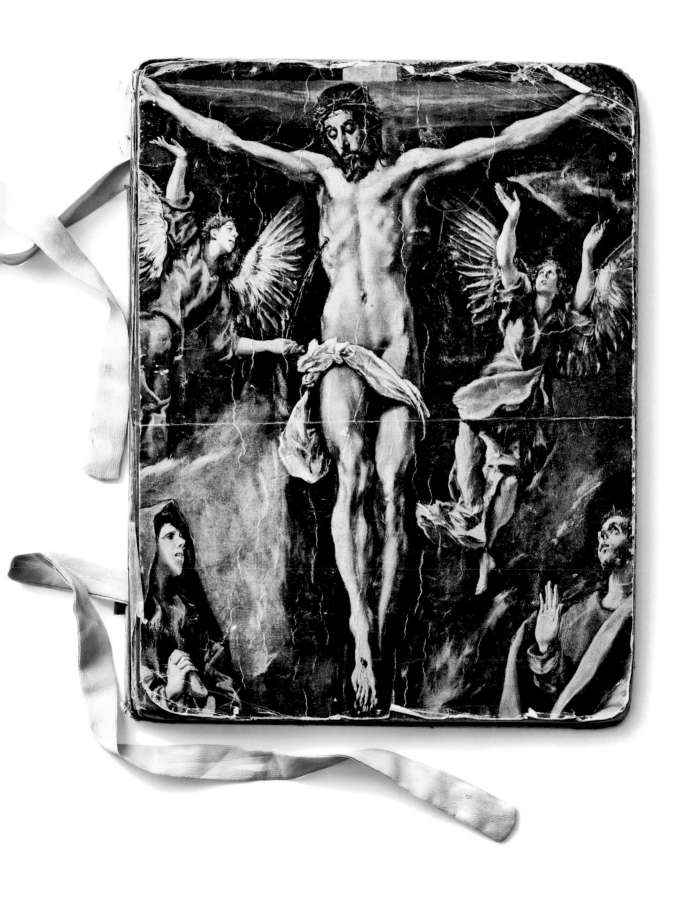

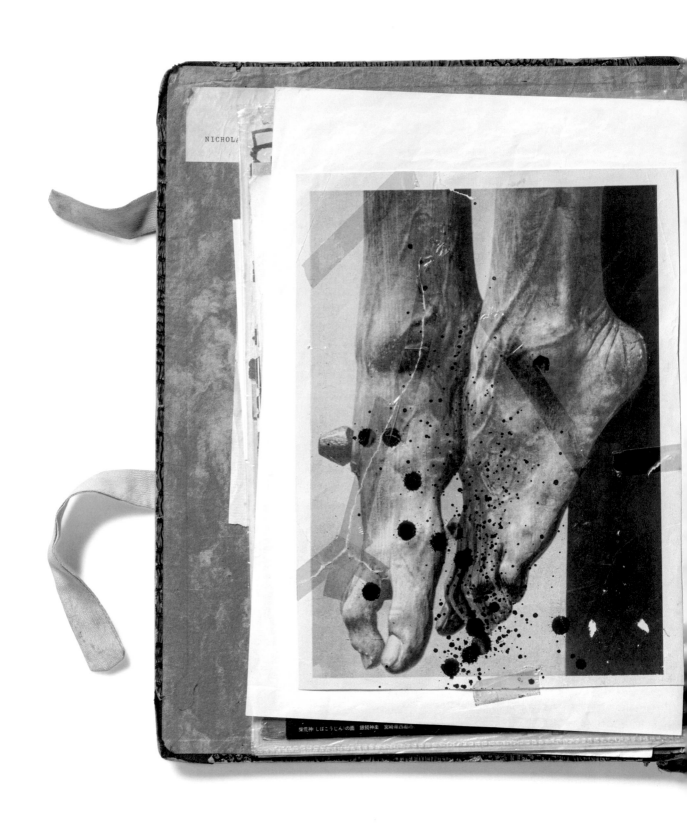

Collage in handmade book
by Nick Cave, 1986
For further reading see page 263

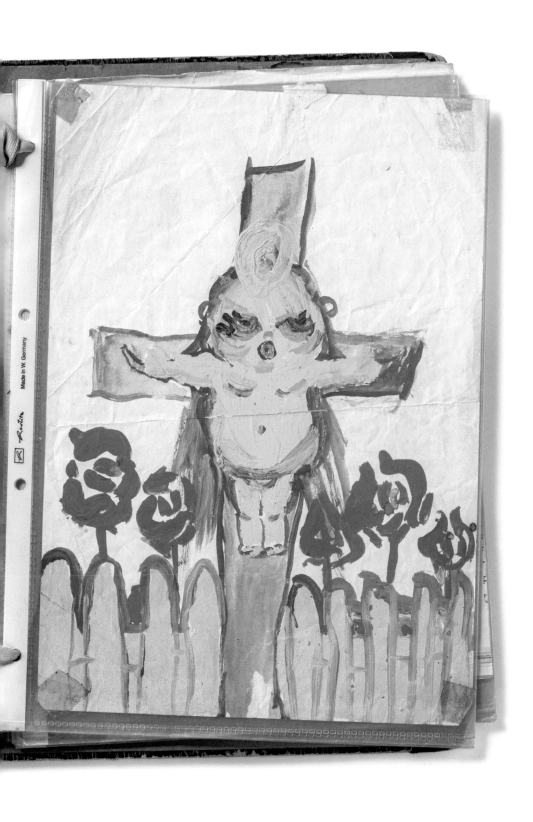

Artwork by Anita Lane
in handmade book by Nick Cave, 1986
For further reading see page 263

Handmade book entitled *Book Number 2*
by Nick Cave, 1987

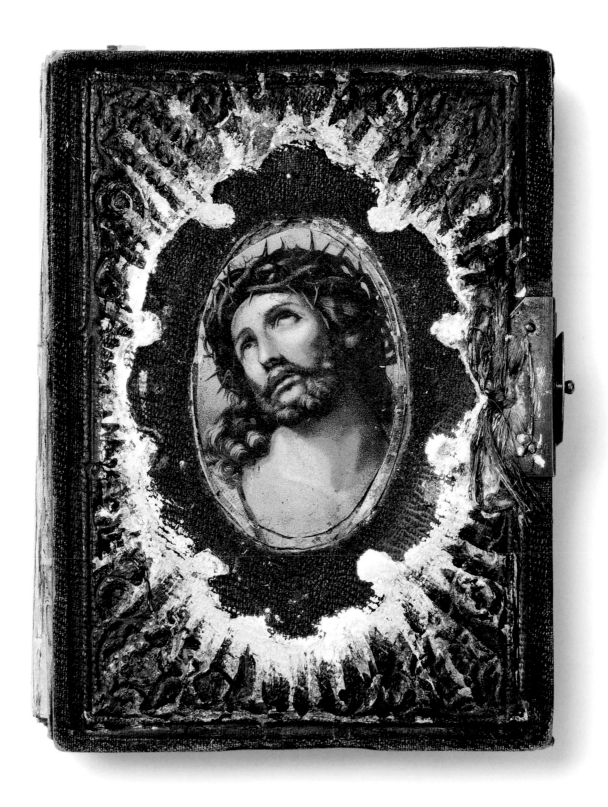

Handmade book entitled *Book Number 2*
by Nick Cave, 1987

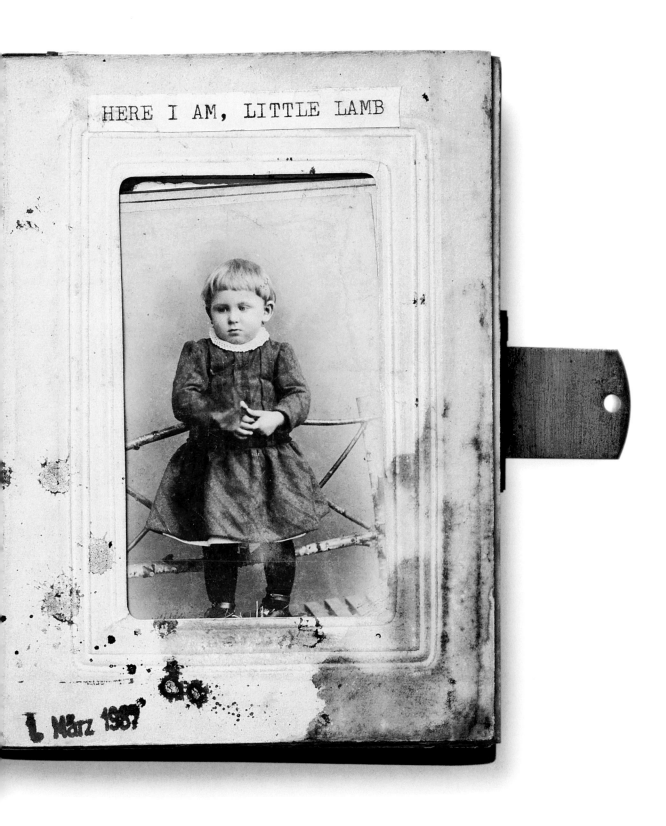

Lettera 25
manual typewriter, c. 1975
For further reading see page 264

Previous page:
Painting by Frederic Wall
Owned by Nick Cave while he
lived in West Berlin in the 1980s
For further reading see page 263

DEANNA by Nick Cave Dec. 1987 Berlin

4 1 O DEANNA
 YEAH DEANNA
 YOU KNOW YOU ARE MY FRIEND, YEAH
 § AND I AINT DOWN HERE FOR YOUR MONEY
 AND I AINT DOWN HERE FOR YOUR LOVE
 I AINT DOWN HERE FOR YOUR MONEY OR LOVE
 I'M DOWN HERE FOR SOUL

GAP
SOFT 4 2 THERE'S NO CARPET ON YOUR FLOOR
 AND THE WINDING-CLOTH HOLDS MANY MOTHS
 AROUND YOUR KU KLUX FURNITURE
 I CUM A DEATH'S-HEAD IN YOUR SAINT FROCK
 § WE MAKE A DEATH PLAN PLAN AND A PACT
 WE DISCUSS MURDER AND THE MURDER ACT
 MURDER TAKES THE WHEEL OF THE CADILACT
 AND DEATH CLIMBS IN THE BACK

8 3 OH DEANNA
 SWEET DEANNA
 OH DEANNA
 THIS IS A CAR
 THIS IS A GUN
 AND THIS IS DAY NUMBER ONE
 § OUR LITTLE CRIME OF HISTORIES
 BLACK AND SMOKING XMAS TREES
 AND HONEY IT AINT A MYSTERY
 WHY YOUR A MYSTERY TO ME

SOFT 4 4 WE WILL EAT OUT OF THEIR PANTRIES
 AND THEIR PARLOURS
 ASHY LEAVINGS IN THEIR BEDS
 AND WE'LL UNLOAD INTO THEIR HEADS
 § ON THIS MEAN SEASON MEAN SEASON
 ON THIS MEAN MEAN SEASON
 BUT THIS ANGEL THAT I'M SQUEEZING
 SHE AIN'T BEEN MEAN TO ME

4 GAP
 SOFT 4
5 OH DEANNA 6 O DEANNA
 YOUR MY FRIEND I AM A-KNOCKING
 YOUR MY PARTNER WITH MY TOOL-BOX AND MEK STOCKING
 IN THIS HOUSE UPON THE HILL I WILL MEET YOU ON THE CORNER
 § AINT DOWN HERE 4 YA money YES, YOU SQUEEZE POINT IT LIKE A FINGER
 " " " " love AND SQUEEZE IT'S LITTLE THING
 " " " " or HEAR THE KICK, FEEL THE BANG
 I'm down here 4 ya soul § AND LET'S NOT WORRY ABOUT IT'S ISSUE
LOVE + DON'T WORRY BOUT WHERE IT'S BEEN
 DON'T WORRY BOUT WHERE IT HITS
 CAUSE THAT JUST AINT YOURS TO SIN

8 7 NO THAT JUST AINT YOURS TO SIN
 O THAT JUST IDNT YOURS TO SINX
 SWEET DEANNA
 I AINT GETTING ANY YOUNGER
 I REAKSK YOUR MY FRIEND
 THE SUN, A HUMP AT MY SHOULDER
 I DON'T INTEND GETTING ANY OLDER
 O DEANNA
 § WELLR I AIN'T DOWN HERE FOR YOUR MONEY
 AND I AIN'T DOWN HERE FOR YOUR LOVE
 I AIN'T DOWN HERE FOR LOVE OF MONEY
 I'M DOWN HERE FOR YOUR SOUL

Song lyrics for 'Deanna' by Nick Cave, 1987
Released on *Tender Prey*
by Nick Cave & The Bad Seeds, 1988
For further reading see page 264

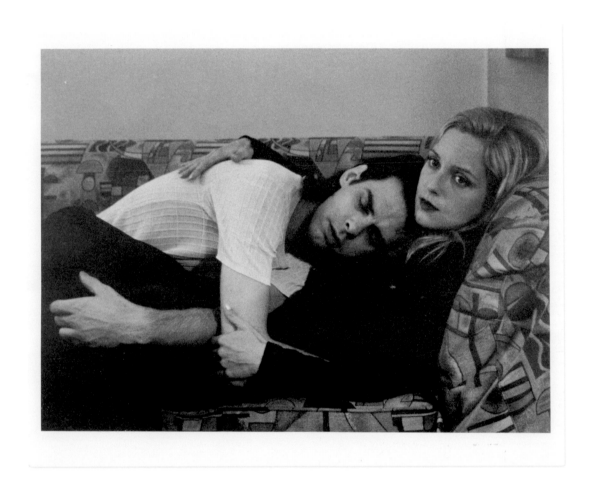

Nick Cave and Deanna Bond, c. 1988
Photograph by Wendy Joy Morrissey
For further reading see page 264

The Mercy Seat

19

UM, IT BEGAN WHEN THEY TOOK ME FROM MY HOME

AND PUT ME IN DEAD ROW

OF WHICH I AM NEARLY WHOLLY INNOCENT OFX, though

AND I SAY AGAIN, I AM NOT AFRAID TO DIE

Those sinister dinner dates meal trolleys, wrecked o...

I BEGAN TO WARM AND CHILL

TO OBJECTS AND THEIR FIELDS

A RAGGED CUP. A XXXXXX XXXXXX TWISTED MOP

THE FACE OF JESUS IN MY Soup

No. 2

LOOK OUT! WATCH
THAT SHADOW FALL
THE PULSING GLOBE
THE humming DOOR
A HOOKED DONE RISING FROM
MY FOOD
LOOK OUT! ALL THINGS EITHER G + UNG.

WATCH THE ... FLOOR.
LOOK OUT! WATCH
THAT SHADOW FALL
THE ... GLOBE MAN
THE humming DOOR
+ THE

BEWARE THE PEACH-GAS WALLS. LOOK OUT! A SHADOW FALLS.
LOOK OUT! The pulsing globe, the humming door,
A HOOKED DONE RISING FROM MY FOOD
LOOK-OUT! ALL THINGS EITHER GOOD OR UNGOOD.

No. 1
No. 3

FOG

INTERPRET SIGNS AND CATALOGUE

AD BLACKENED

A BROKEN TOOTH. A SCARLET ~~BUG-CLOTH~~

the

LOOK OUT! THE WALLS ARE BAD. BLACK. BOTTOM KIND

LOOK OUT! THEY ARE THE SICK BREATH ~~GATHERING~~ AT MY HIND *DON'T EVEN TRY!*

LOOK OUT! THEY ARE THE SICK BREATH. LOOK OUT! DON'T LOOK BACK.
NO.
THEY ARE THE SICK BREATH GATHERING AT MY ...

LOOK OUT!
KEEP STILL!
STAND BACK!

ALL

LIKE, MY GOOD HAND TATTOOED EVIL ACROSS IT'S BROTHERS FIST

THAT FILTHY 5, THEY DID NOTHING TO CHALLENGE OR RESIST

W

1

MY KILL-HAND IS CALLED "EVIL"

WEARS A WEDDING-BAND THAT'S GOOD

'TIS A LONG-SUFFERING SHACKLE

THAT ~~...~~ BLOOD

COLLARING ALL ~~......~~ ~~...~~ ~~...~~

THAT REBEL BLOOD

Song lyrics for 'The Mercy Seat' by Nick Cave, c. 1987
Released on *Tender Prey*
by Nick Cave & The Bad Seeds, 1988
For further reading see page 264

MUTE 9684977
0011441-

MERCY SEAT by N. CAVE BERLIN/LONDON/MELBOURNE 88

(Spoken) Um, it began when they come took me from my home
And put me here in Dead Row
Of which I am ~~wholly~~ nearly wholly innocent, you know
And I'll say it again
I .. am .. not .. afraid .. to .. die ..

I began to warm and chill
to objects + their fields
a ragged cup, a twisted mop
the face of Jesus in my soup
those sinister dinner deals
the meal trolleys wicked wheels
a hooked bone rising from my food
all things either good or ungood

(sung)
And the mercy seat is waiting
And I think my head is burning
And in a way I'm yearning
to be done with all this measuring of truth
An eye for an eye
And a tooth for a ~~tooth~~
And anyway I told the truth
And I'm not afraid to die

(Spoken)
Interpret signs and catalogue
A blackened tooth, a scarlet fog
the walls are bad, black, bottom kind
they are the sick breath at my hind
they are the sick breath at my hind
they are the sick breath at my hind
they are the sick breath gathering at my hind

(Sung)
In Heaven His throne is made of gold
The ark of His testament is stowed
A throne from which I'm told
All history does unfold
Down here its made of wood and wire
And my body is on fire
And God is never far away

This verse is at the ✱ sign

Song lyrics for 'The Mercy Seat' by Nick Cave, c. 1988
Released on *Tender Prey*
by Nick Cave & The Bad Seeds, 1988
For further reading see page 264

155

'Kylie' bag owned by Nick Cave, c. 1992
For further reading see page 264

Well I leaned across the counter
+ squeezed the trigger tight ~~tangle~~
+ when I shot I was so handsome
it was the angle, was the light

"I am the man for which no God waits
Of which all ~~million~~ women yearns
I am marked by darkness + by blood
+ ~~one thousand~~ powder burns

~~O'malleys wife she started wailing~~
~~her hands were in the sink~~
~~I am the~~ The screams of O'malleys wife stopped me from my
I rested the gun upon her neck
and ~~the~~ spray was fine. + pink
her
And little Sister Slobhān ~~Mary~~
plied her trade ~~from~~ dusk till dawn
who ~~boasted~~ swore upon her swollen breast
twas this town which she was ~~bred~~ + born
sat shivering in the corner Well, I swooped
as I approached her like a thief
like the ~~Madonna~~ painting of ~~OUR LADY~~ the Madonna
painted on whales blood + banana leaf
~~I shot her through the heart~~ I snapped
her crumble
Then heroically spun around throat
to see Caffrey rising from his seat
I shot that ~~motherfucker~~ down
Mr. Randolph Caffrey

Notebook containing song lyrics
for 'O'Malley's Bar' by Nick Cave, 1991-96
Released on *Murder Ballads*
by Nick Cave & The Bad Seeds, 1996
For further reading see page 264

I have no free will " I sang
 as I sley about the murder
 Richard ~~screaming~~ ~~screamed~~
& Mrs [Holmes ~~~~ ~~~~ him the door ~~screamed~~
 screamed
you really should have heard her

And I sung + laughed + howled + wept
 + panted like a pup
I blew a hole in missers Holmes
+ her husband he stood up and screamed
" ~~See you in Hell~~ " ~~he~~ ~~screamed~~ at me
your an Evil man
 + I paused a while to ~~wonder~~ ponder
If I have no free will how can I
be morally culpable, I wonder
I shot Richard Holmes in the stomach
+ gingerly he ~~~~ sat down
" ~~I take it back~~ " he * whispered weirdly " No offense "
 No offense ~~long~~ upon
Then ~~weirdly~~ he lay ~~down~~ the ground
" No ~~offence~~ taken " I replied to him
 to which he little
+ ~~~~ ~~~~ + ~~he~~ gave a weary cough
+ with blazing wings I neatly aimed
blew his head completely off
" I've lived in this town near 30 years "
 And to none of you am
✱ ~~You're all acquaintances of mine~~ I stranger
ext + I ~~~~ ~~put brand new bullets~~ ~~my gun~~ + I put new bullets
age ~~cham~~ ~~~~ my gun to ~~~~ chamber who knows my
And as I turned ~~upon~~ the bird - like ~~~~ ~~~~ no
 Mr ~~.~~ Brookes
I thought of St. Francis + his sparrows
+ when I shot down the youthful Richanson
it was Sebastion and his arrows
 (I remembered)

Well one man said, stop all this mess
This is not a violent town
I before the man could draw his knife
Well I took my gun + can't you guess
+ blew that mother fucker down
Aa ha A-a hah — ha
A a ha - A ah ah ha

I'm
with a deadly mother fucker in my hand
"Ah-ha . Ah-hahe

A man came
Well I've read the writing on the wall
What cannot rise in time must fall

A man came stalking down the hall
I spun around, I did not stall
What cannot rise, in the death, must fall
You can see it written on His wall
I wrote it in blood upon

There goes a man "cried
Well there goes Pete the Dragon And w
He's on the water wagon
he's got that terrible look of concentration + mourning in his face
He's really something special he's the saddest down man
but when he hits the bottle And
IFI moved to come up
IF I FOR A MOMENT DROPPED MY GUARD

Notebook containing song lyrics
for 'O'Malley's Bar' by Nick Cave, 1991-96
Released on *Murder Ballads*
by Nick Cave & The Bad Seeds, 1996
For further reading see page 264

160

I'M GONNA HURT SOMEBODY

WITH REALLY HARD THIN, CHEAP ELECTRIC guitar

I am tall + I am thin
walk between a swagger + a sway
I have been known to look quite handsome
in a dark + brooding sort of way
→ I am *the sort of* man who digests entire countries
of which he rarely returns
And I walk all covered in darkness
+ in blood + in powder burns

O'Malley

I am tall + I am thin *and of an enviable height*
~~I like to fuck + I like to fight~~
+ I've been known to be quite handsome
From a certain angle + in a certain light
And sometimes my eyes are blue *as ice* ~~blue~~
sometimes they're steely grey
+ When I go to town each Friday night
~~In dark and brooding sort of way~~
Well I entered into O'malleys *I hear the people say* *little*
Said O'malley I have a thirst
O'malley simply smiled at me
~~But o'malley would be the first~~
Said "you wouldn't be the first"

but the family of man is so completely ~~fucked up~~ animosity

More O'MALLEY'S BAR

Well, it's not in my nature to hate
To no-one do I bear animosity
 great
I'm a lover of the family of man
 patron
But the family's of ~~man~~ become such an ~~already~~

I said it's not in my nature to hate
 did
But I loathed the foppish Rodney Thackeray
I ordered him to take one last sip of his drink
Then ~~shot him~~ through his Strawberry Daiquiri

am not ~~as~~ such human things as hate

I'm not made of such human stuff as hate
To no-one do I bear animosity
I'm a true lover of the family of man

Notebook containing song lyrics
for 'O'Malley's Bar' by Nick Cave, 1991-96
Released on *Murder Ballads*
by Nick Cave & The Bad Seeds, 1996
For further reading see page 264

You made me.

all
I was fallen from grace
you took me by the hand
you made me, baby
made me what I am

The air is heavy
& the fog has not yet lifted

she was so hardboiled
a pint of piss + vinegar
she ~~had~~ was Hades, high-piled
~~vinegar~~ she had death + it's devils in her
~~linear~~
kin of her

② I said its not in my nature to hate
But I ~~fucken~~ despised the fop Rodney Thackeray
"Take a ~~slip~~ of your drink, darling" I said to him
Then shot him through his strawberry daiquiri
I'm not made of such human stuff as hate
that's
I want a life cosey + warm + tucked up
I'm a true lover of the family of ~~man~~ man
 But the family of man has got so fucked up

DAQUIRI
DA~~K~~O DAIQUIRI ②

Song lyrics for 'Papa Won't Leave You, Henry'
by Nick Cave, c. 1991
Released on *Henry's Dream*
by Nick Cave & The Bad Seeds, 1992
For further reading see page 265

PAPA WONT LEAVE YOU, HENRY.

*Italics

Verse I

I WENT OUT WALKING THE OTHER DAY
THE ~~WIND~~ HUNG WET AROUND MY NECK
MY HEAD IT RUNG WITH SCREAMS AND GROANS
FROM THE NIGHT I SPENT AMONGST HER BONES
AND I PASSED BESIDE THE MISSION HOUSE
WHERE THAT MAD OLD BUZZARD, THE REVERAND
SHRIEKED AND FLAPPED ABOUT LIFE AFTER YOU'RE DEAD
WELL, I THOUGHT ABOUT MY FRIEND, MICHELLE
HOW THE ROLLED HIM IN LINOLEUM
AND ~~THEY~~ SHOT HIM IN THE NECK
A BLOODY HALO, LIKE A THINK-BUBBLE
CIRCLING HIS HEAD
AND I BELLOWED AT THE FIRMAMENT
LOOKS LIKE THE RAINS ARE HERE TO STAY
AND THE RAIN PISSED DOWN UPON ME
AND WASHED ME ALL AWAY
SAYING
PAPA WONT LEAVE YOU, HENRY
PAPA WON'T LEAVE YOU BOY
PAPA WONT LEAVE YOU, HENRY
PAPA WONT LEAVE YOU, BOY
WELL THE ROAD IS LONG
AND THE ROAD IS HARD
AND MANY FALL BY THE SIDE
BUT PAPA WONT LEAVE YOU, HENRY
SO THERE AINT NO NEED TO CRY

AND I WENT ON DOWN THE ROAD
*he went on down the road
I WENT ON DOWN THE ROAD
*he went on down the road

Verse 2

WELL THE MOON IT LOOKED EXHAUSTED
LIKE SOMETHING YOU SHOULD PITY
SPENT AND AGE-SPOTTED
ABOVE THE SIZZLING WIRES OF THE CITY
IT REMINDED ME OF HER FACE
HER BLEACHED + HUNGRY EYES
HER HAIR LIKE A CURTAIN
FALLING OPEN WITH THE LAUGHTER
AND CLOSING WITH THE LIES
AND THE GHOST OF HER STILL LINGERS ON
THOUGH SHE'S PASSED THROUGH ME
AND IS GONE

CONTINUED

165

THROUGH THE TOWNS HEART
PAST THE MARKET STALLS
WHERE THE MERCHANTS + MONGERS
CLAMOUR + CALL

TO THE VERY EDGE OF TOWN
THE FIRES BURN ALONG THE BORDER
~~THROUGH THE BORDER FIRES~~
 BUILD KINGDOMS
WHERE THE HOBOS ~~GROW~~ THEIR ~~JUNGLES~~
OR ~~————~~ MURDER
 DISAPPEARING
~~FOR~~ ALL THROUGH THIS ~~UNFOLDING~~ LAND HE COMES
HE COMES WITH HIS RED RIGHT HAND HE COMES
WITH HIS RED RIGHT HAND

THROUGH THE BRAKES, THE BRACKEN
 BOGGY MIRE
THROUGH THE ~~MAY SLOUGH~~
~~~~ THROUGH THE ORCHARDS + VINEYARDS
THE FRUIT RANK ON THE VINES

THUNDER HEADS UPON HIS BACK

SCRAPS OF GREEN PAPER, HE HOLDS
IN HIS RED RIGHT HAND, HE HAS
IN HIS RED RIGHT HAND

cra
INTO THE TOV
THROUGH THE B
PAST THE CH_
IS IMPALED UP

THE FRUIT RANK U

THE PEOPLE J
ACROSS TH_
HIDDEN
HIS RED R_

A GREA_
WHERE

SCRAPS O_
IN HIS RE_

Notebook containing song lyrics
for 'Red Right Hand' by Nick Cave, c. 1993
Released on *Let Love In*
by Nick Cave & The Bad Seeds, 1994
For further reading see page 265

HT HAND

ON THE SHANTY TOWNS

Take a little walk to the edge of town go across the tracks
~~through the whispering grass~~
~~and across the tracks~~ from the twilight gloom
where the viaduct looms, like a bird of doom as it grows
~~there empty lies~~ the harder fires ~~where~~ + cracks
the humming wires, hey man, +
Your never ever coming back        past the

past the square, past the bridge, past the mills,
past the stacks
On a gathering storm comes a tall dark man
in a ~~dusty~~ black coat
with a red right hand

RT
ING PEOPLE
a cloud
eple

INE

ON A
~~THROUGH THE~~ GATHERING STORM
S PRAISES          COMES A ~~TALL~~ TALL HANDSOM MAN
EARING CAND       ~~MAN A WITH A~~ ~~DARK~~ DUSTY ~~BLACK~~ COAT
OAT               ~~THE~~ RED RIGHT HAND
ND                WITH ~~THE~~ A

Y IS CAST    WITH HIS              BAN, CAN, DAMN, FAN
STAND) + his ROPE OF SAND          LAND, LAND, MAN, RAN
PAPER        THROWN TO THE DYING   SAND, BRAND, BLAND
HAND         BY HIS RED RIGHT HAND GRAND, FANNED, SPANNED
                                   STAND, RAM

Layout for *Let Love In* cover by Nick Cave, 1994
Photograph by Polly Borland

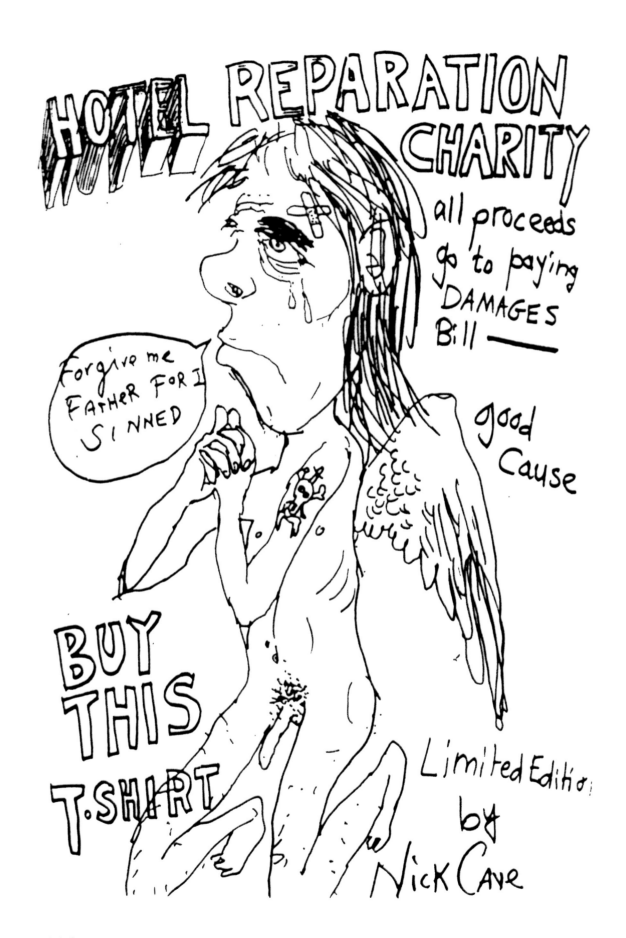

Drawing by Nick Cave
for hotel reparation charity t-shirt, 1993

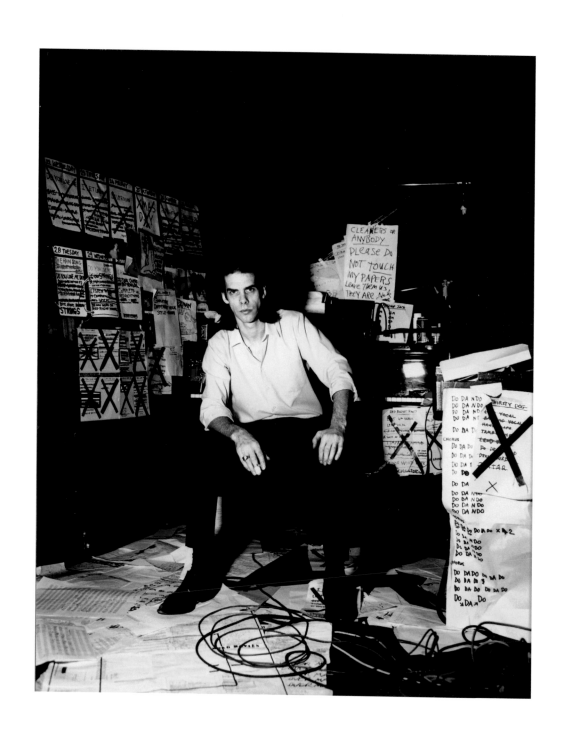

Nick Cave, Metropolis Audio, Melbourne, 1994
Photograph by Polly Borland
For further reading see page 265

## EAR FROM ME

### FINAL VERSE

YOU SAID THAT YOU'D STICK BY ME
THROUGH "THE THICK AND THROUGH THE THIN"
THOSE WERE YOUR VERY WORDS
MY **FAIR WEATHER** FRIEND

YOU WERE MY BRAVE LITTLE LOVER
AT THE FIRST TASTE OF TROUBLE WENT RUNNING BACK TO MOTHER
FAR FROM ME
FAR FROM ME
WELL MAY YOU STAY AND FOREVER ALWAYS BE

FAIR FROM ME
FAR FROM ME

AT THE FIRST TASTE OF TROUBLE WENT RUNNING BACK TO MOTHER

YOU WERE MY BRAVE-HEARTED LOVER
WHO FLED LIKE A          AT THE FIRST SIGN OF TROUBLE          BRAVE-HEARTED LOVER
    RAN                                                       TRUE-HEARTED LOVER

YOU WERE MY TRUE        (LOVER)
RUNNING LIKE A DOG   AT THE FIRST TASTE OF TROUBLE
SO FAR FROM ME
FAR FROM ME
WELL MAY YOU STAY AND FOREVER ALWAYS BE
FAR FROM ME
FAR FROM ME
RID OF ME

Song lyrics for 'Far From Me' by Nick Cave, c. 1996
Released on *The Boatman's Call*
by Nick Cave & The Bad Seeds, 1997
For further reading see page 265

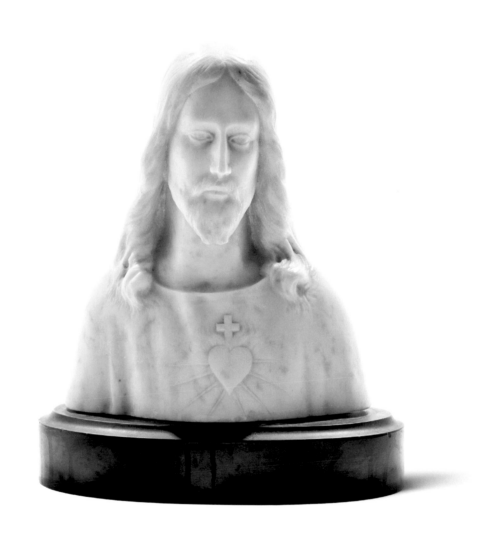

*The Sacred Heart of Jesus*, date unknown
For further reading see page 266

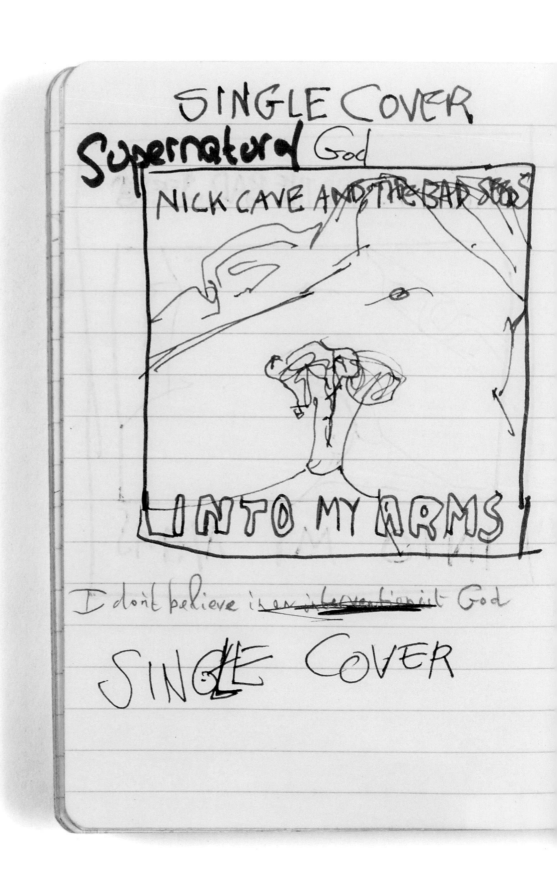

Notebook with Nick Cave's initial proposal
for the 'Into My Arms' cover.
Rejected by Mute Records, 1996

176

# MOJO for FILM

)

His NAME is PETE the DRAGON
He's on the WATER - WAGON
He's got that look of concentration + mourning
In his Face
He carries a .38 special
with a six inch barrel
He's the sickest ~~mf~~ man
    In the entire human race
       damn

Mojo
Mojo
We're all gunna go / (just that little bit more)
               about desire, need
Mojo.

D

↓

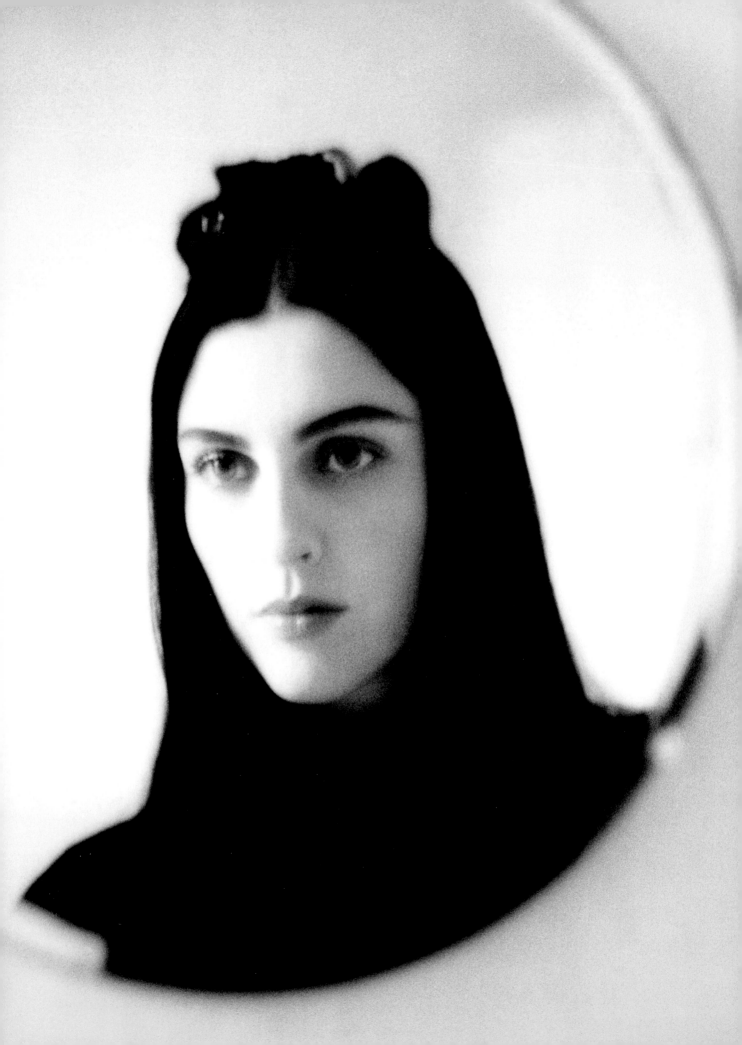

The first time I saw Susie was at the Victoria & Albert Museum in London and when she came walking in, all the things I had obsessed over for all the years – pictures of movie stars, Jenny Agutter in the billabong, Anita Ekberg in the fountain, Ali MacGraw in her black tights, images from the TV when I was a kid, Barbara Eden and Elizabeth Montgomery and Abigail, Miss World competitions, Marilyn Monroe and Jennifer Jones and Bo Derek and Angie Dickinson as *Police Woman*, Maria Falconetti and Suzi Quatro, Bolshoi ballerinas and Russian gymnasts, Wonder Woman and Barbarella and supermodels and Page 3 girls, all the endless, impossible fantasies, the young girls at the Wangaratta pool lying on the hot concrete, Courbet's *Origin of the World*, Bataille's bowl of milk, Jean Simmons' nose ring, all the stuff I had heard and seen and read, advertising and TV commercials, billboards and fashion spreads and Playmate of the Month, Caroline Jones dying in Elvis's arms, Jackie O in mourning, Tinker Bell trapped in the drawer – all the continuing, never-ending drip feed of erotic data came together at that moment in one great big crash bang and I was lost to her and that was that.

Susie Bick, 1990
Photograph by Dominique Issermann

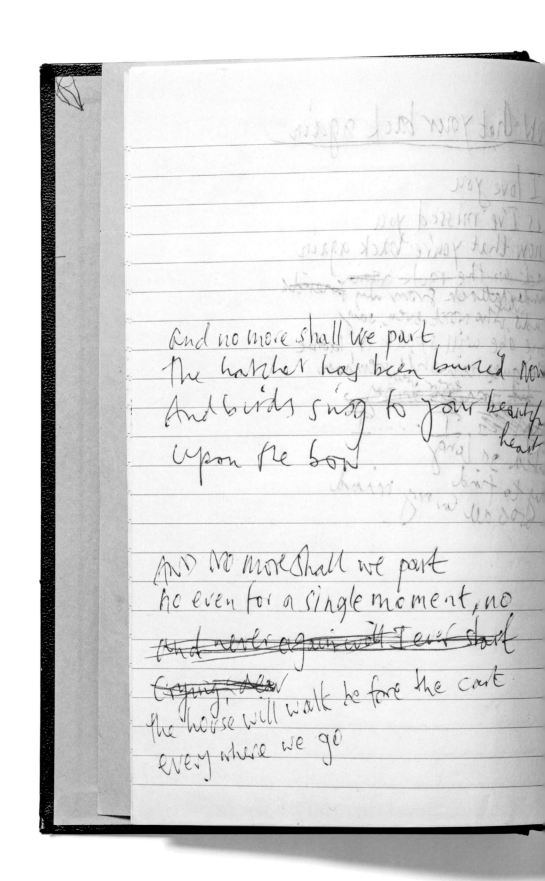

And no more shall we part
the hatchet has been buried now
And birds sing to your beauty
upon the bow

AND No more shall we part
no even for a single moment, no
~~And never again will I ever start~~
~~crying over~~
the horse will walk before the cart
every where we go

Notebook containing song lyrics
for 'And No More Shall We Part' by Nick Cave, 2000
Released on *No More Shall We Part*
by Nick Cave & The Bad Seeds, 2001

No more shall we part
Contracts are drawn up the ring is locked upon the finger
Never will my letters start
sadly, or in the depths of winter

As I sat sadly by her side
No more shall we part
birds will live again on the trees long arm
at last we can take heart
in a world that's strange + wrong

No More shall we part
it shall no longer be necessary
no more shall will I say, my dear heart
I am alone, she has left me

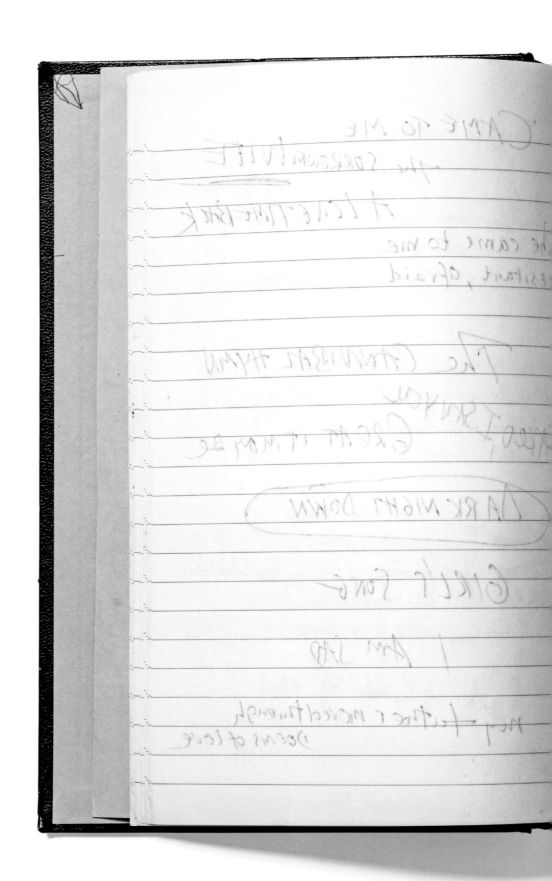

Notebook containing song lyrics
for 'The Sorrowful Wife' by Nick Cave, 2000
Released on *No More Shall We Part*
by Nick Cave & The Bad Seeds, 2001
For further reading see page 266

# THE SORROWFUL WIFE

Married my wife on the ~~her~~ day of the eclipse

~~our~~ friends awarded her courage with gifts

Now as the ~~seasons~~ nights grow longer + the seasons shifts

I look ~~at my~~ to the sorrowful wife

~~the electric cloud~~ who is tending to her flowers

The water is high on the beckoning river

I made her a promise I could not deliver

The screech of the birds sends ~~an eerie~~ sends a shiver

through my sorrowful wife ~~me +~~

Ring Little

and throw caution to the wind

Now she sits beneath the knotted Yew
The blue-bells bob around her shoes

The knotted Yew

The blue-bells bob around her feet

DARWIN ~ ADRIAN DESMOND
+ JAMES MOORE

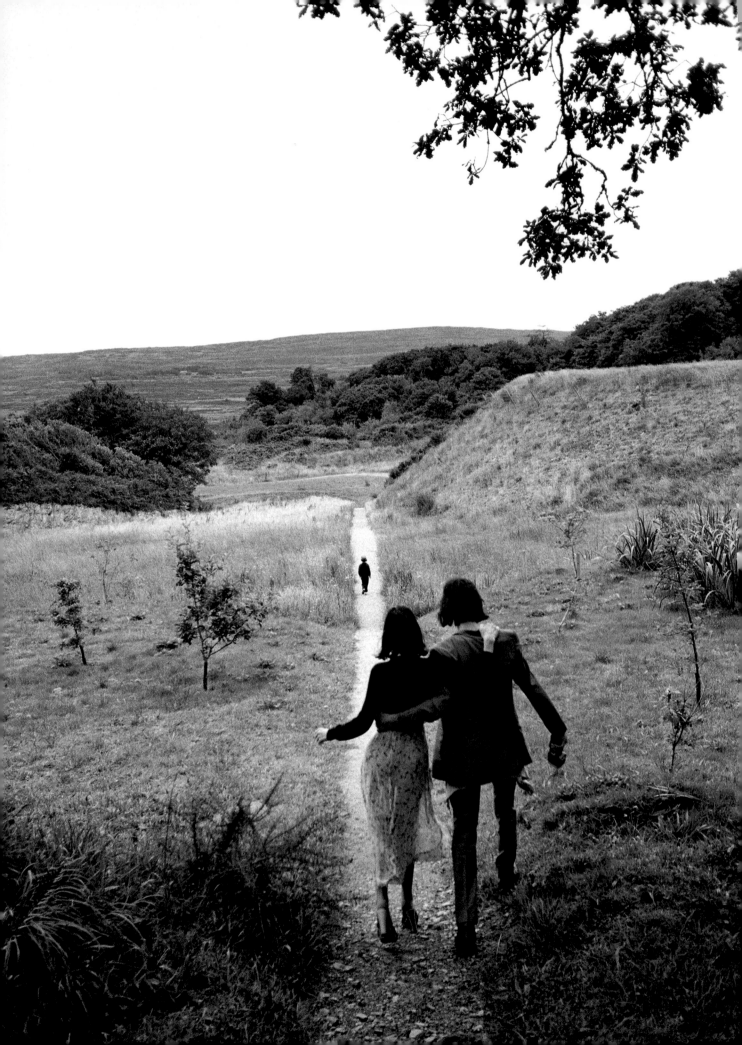

Nick Cave, Susie Bick and Luke Cave, 1998
Liss Ard Estate, Skibbereen, West Cork Islands, Ireland
Photograph by Dominique Issermann

White beard. The sky is a lovely pale blue and clouded and a warm sun is streaming through the window onto my desk as I write. That it, I'm off.

10 SEP 2001

2.00 pm. This morning, blue skies with some clouds and a chill in the air as I drive Luke to school, radio babbling and mega tons of stalled traffic. Went back to bed. In office late, hammered down by things but feeling better now. Huge cloud, like a giant baby on its back with a smashed in face sails past my window, warm sun on my desk.

11 SEP 2001

12 SEP 2001

13 SEP 2001

14 SEP 2001

15 SEP 2001

16 SEP 2001

17 SEP 2001

6.10 Clear, pale blue sky with small clouds, the air chilled, in the yard, with my fag and cup of tea. Planes move overhead. The kids still throw there food around. Usual knot in the stomach, the leaking, poisonous anxiety. Driving to the office, the air cold, the sky clouded over now and here,

Notebook known as The Weather Diaries
by Nick Cave, 2000-01
For further reading see page 266

at my desk, the sky is a steely grey and ghost-planes cross the top right hand side of my window, shrouded in cloud. The tree that frames the left side of my window, ~~which~~ is whipped by the wind. The weather is getting interesting, cloud is interesting, wind is interesting, rain and thunder and lightening are interesting as I sit here, at my desk, feeling nothing will ever be the same, feeling it's all business-as-usual.

11:00 Wind savage now, blasting down ~~the~~ Lots Road and cold.
11:15 Back out on the street, down to shop to buy lighter, I forgot the first time (my brain, by the way, actually feels numb) I move beyond the penumbra of the power-station, the clouds part and warm sunlight pours down on me. The clouds them-selves, now backlit, show their leaden bellies.

13 SEP 2001

7:30 am. Drizzling grey rain from a grey sky and cold. Later at 11:00 am rain persists but as I drove to office becomes a light spit. Wind moves tree gently outside my window, the leaves wet from interesting rain. The sky above seems uniform silver/grey but on closer inspection cloud cover moves rapidly, violently. I want for a plane to cross right hand corner of window but see none, the planes lost within the angry cloud.

Painting entitled *On the Sofa*
by Louis Wain, 1927
For further reading see page 266

188

Notebook entitled *Bad Seeds Lyrics*, 2007

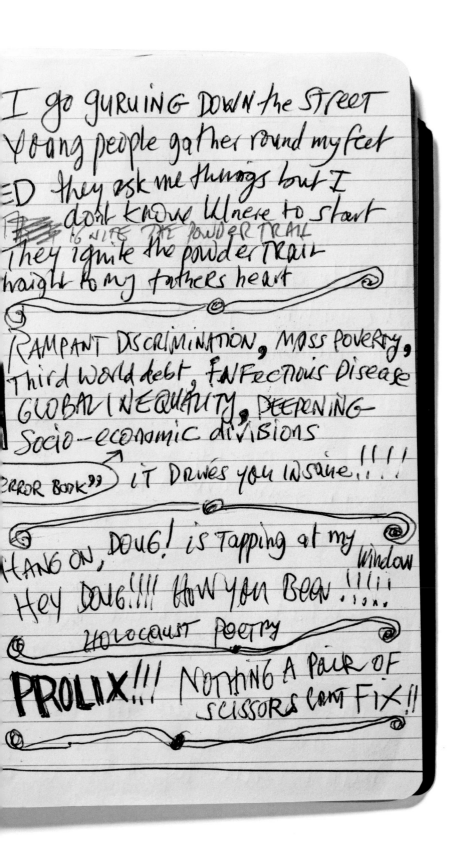

I go GURUING DOWN the STREET
Young people gather round my feet
ED they ask me things but I
       don't know where to start
IGNITE THE POWDER TRAIL
They ignite the powder TRAIL
straight to my fathers heart

RAMPANT DISCRIMINATION, MASS POVERTY,
Third World debt, INFectious Disease
GLOBAL INEQUALITY, DEEPENING
Socio—economic divisions

ERROR BOOK'' → iT DRIVES you INSANE!!!!

HANG ON, DOUG! is Tapping at my
                                        Window
Hey DOUG!!!! HOW YOU Been!!!!!
       HOLOCAUST POETRY

PROLIX!!! NOTHING A PAIR OF
              SCISSORS CANT FIX!!

Following page:
Nick Cave writing the final chapter
of *The Death of Bunny Munro*
on holiday at Villa Lina, Italy, 2008
Photograph by Dominique Issermann

Anti Social Behaviour Order

~~Bunny slows and looks at a~~ ~~line of BoBó~~ and of course there is the other things!

Bunny also has three [ASBO's] in the Sussex area. A fourth could get him put away. "What?" he says

"The soaps." says Bunny Jnr.

"Smaller"

Bunny holds his thumb and forefinger about half an inch apart and whispers spookily, "They are tiny."

~~Bunny Jnr.~~ He waggles his plastic ~~toy~~ figurine. He can smell the fish (black) Bunny Jnr. the salt drifting up from the waiting

"Soap for Darth Vader." Portslade, beach sea. the headlig illuminate a wet sea mist

Bunny flips up ~~last~~ high beams on Audi and says "You got it, Bunny Boy." the

face hold

Libby still ~~had~~ the high ~~rate~~ flush of the new mothers but it was nothing compared

to the baby
who was

For some reason

> Bunny remembers ~~taking the baby back from the hospital~~ his wife Libby back from the hospital the infant Bu

wrapped up ~~in her arms~~ the day ~~he~~'s he & Libby arrived home with the baby from the hospital. Bunny Jnr. ~~lying~~ in his cot, his little ~~pink fists~~ ~~pushing the air~~ squashy + his eyes yet to find their colour peered out of his ~~red face~~ flushed face

Bunny said to Libby as they leaned over the crib, "I don't know what to say to him."

"It doesn't really matter, Bun, he's two days old."

"Yeah, I guess"

"Tell him he's beautiful" said Libby ~~you say time at those~~

"But he's not. He looks like somebody stepped on him"

"Well tell him that then" she said "...you know.. in a nice voice."

> "You look like somebody put you through the mincer, said Bunny little guy.

~~Bunny leans into the crib~~

Bunny Jnr. ~~shoots~~ stirs his little bundled fingers in the air + changes the shape his mou

"See? He likes it" says Libby

You look a bit like

"You look like a bowl of ~~bolognese sauce~~" says Bunny "A baboons arse" touches the

Libby ~~grabs~~ puts her hand down, her fingers raw and swollen, and ~~strokes~~ the ba

brow — and says "You sweet little boy"

~~crosses~~ Don't listen to him

how on earth he ever ended up th

• While Rita made Libby a cup of tea
                                    Rita
That was also the day that ~~Lyn~~ Cochivera, ~~Libby's~~ workmate from ............. dropped around ~~visited~~
and Bunny was ~~hit~~ with a compulsion wholly new + unexplored that involved his hand
(visited)  (venereal)          + unexpected
and Rita's ~~cunt~~. And though nothing came of it and it was the last time he ever saw
        posterior                                    Bunny felt
Rita Cocivera, a ~~course~~         was set in motion that was beyond ~~Bunny's~~ control. —
            chain of events              command        beyond his
There was a voice, there was an ~~order~~ ~~†~~, there was an action and indeed there
                                                                      ┌ the shock waves reverberated through the Munro household for
was a consequence. ─         weeks. Even the baby, Bunny thought, seemed to look up at him accusingly.
And as the infant that lay gurgling in his crib ~~gotta~~ grew into a toddler, so ~~†~~
Bunny's ......... grew exponentially        inexorably  darling  resting place
                                          ∨ toward its ~~marble~~
Bunny rarely thought about that first miscalculation what it was that ~~fixed~~ his hand
                        to speak, but he did often think about Rita Cocivera's ~~buttocks~~ under
again. ~~the~~ thin crepe skirt she was ~~wearing~~ (the feel), that wonderful contracting of the
        her                              posterior or ~~cheeks~~ felt
buttock, before the shit ~~hit the fan~~.       ↑
(the jump of the muscle)   ┌ intersected ~~yet~~ so completely with the fan. ↗
              outraged
And as he ~~lies~~ on his back on a bed in a cheap hotel in ............, working
                single
his way through a bottle of scotch and watching with glazed eyes the tiny TV
                                    Bunny          dwells
that blithers in the corner of the room ~~and~~ thinks about all that ~~lives~~ beneath
Rita Cocivera's thin crepe skirt, her lissom buttocks and her sleek haired Italian
~~vagina~~ ~~cunt~~ pussy.                    ┌ in a near-tearful reminiscence
Bunny lifts a finger and gently places it on the bridge of    and ran down his chin
his swollen nose and two thin red rivulets of ~~blood~~ new blood emerge and he
swears to himself, rolls ~~to plug~~ a tissue into plugs ~~and~~ inserts them ~~up his~~ each
nostril.                    in his shorty pjs,
Bunny Jnr. lies on the other bed beside him, engaged in an epic battle with his
                                              then
eye-lids, nodding off, then jerking back awake ~~only~~ to nod off again — a little
yawn, a little scratch, a little folding of the hands to sleep etc. — ~~worked out~~
                                            scarlet, paisley  embryonic twisty
The room itself is a riot of psychedelic Zoffany ~~&~~ ~~gyrostat~~ Axminster as
                                            eyeball          that had designed around my ghastedwashy moves &
stars through the kaleidoscopic ~~optics~~ of a manic-depressive. The room a  backing
                            (an ~~oft~~ Australian)      bleachy            abortion
stinks of a faintly ~~fecal~~ ......... ~~smell~~ of bad plumbing and damp carpets and there ~~†~~
~~was~~ no room service and there ~~was~~ no minibar.        and the paper tastes lamp shade
                          strips of                        writhes with ~~furry~~
The blood-coloured curtains hang like ~~pieces~~ of draped meat ~~†~~ chinese dragons fierce
  drapes                              ~~unrooted~~  ~~draped~~        ~~fierce~~ winking
                                                                    ~~teepee?~~
Bunny ~~lies back in~~ the bed, drunk in his underwear, the Daily Mail ~~spread~~ over his
semi-tumescent member, stops thinking about Rita Cochivera + starts thinking
about Avril Lavigne ~~who~~ Bunny thinks ~~has~~ the Valhalla of ~~vaginas~~. ~~and~~
                              Avril Lavigne probably all
~~to realise that~~      Avril ~~Lavigne~~ (possesses)   fucking
Eventually he is distracted by a confessional talk show of some kind ~~that~~
                    a woman on

and with a crooked finger realigns her bikini bottoms then
The ~~little~~ young girl ~~smiles at~~ Bunny Jnr. and says "cool."
(~~pushes wipes~~ her fringe out of her eyes ~~at~~) "My dad says I don't ha

They say nothing for a minute and ~~the girl~~ Bunny Jnr. adjusts to his shade
the girl cocks her eye at ~~Bunny~~ the little boy sitting in ~~the car~~ ~~and~~ ~~in~~
and the sun beat down
front of the beat up vehicle gently she
her bell twice. Bunny Jnr reaches over to the driver's side and taps the
horn of the car ~~gently twice~~ two times in response. + B's stomach ~~wan~~
They smile at each other ~~shyly~~
and then together look up and down the road somemore. sunscorched

They both see Bunny exit the house and march across the lawn
his shirt into his trousers. "Here he comes" says Bunny Jnr quietly.

Bunny Jnr wishes his Dad ~~would~~ turn around and go back into the house
because he ~~didn't~~ want to see his dad, who ~~looks~~ a lot better coming out
the house than ~~going~~ he did going in — on the way to ____, O
his dad kept ~~turning~~ the radio on and then turning it off and move around
+ swigging from his bottle
in his seat and sounding the horn and driving like a mental case and w
he arrived at the cremetonick house, he actually hopped across the law
he thought he was a
like a ~~bunny~~ rabbit — ~~no no~~, he wanted his dad to go back into the
house because all of a sudden he could think of a million things he w
to tell the girl on the bicycle — about outer space and the veldts of
and the microcosmic world of insects and the substratum layers of
blah blah, and he didn't even know the girls name. marches up to
moves toward the
Bunny "Excuse me, young lady" says Bunny as he ~~opens~~ ~~the~~ door to the Au
not about the young girl but
is thinking ~~though~~ that there is nothing like getting your pipes cleaned in the
part of
to put the day on track. He'd woken gloomy and hungover and full of ~~bulging~~ dirty water
He hopes he may have
probably hit the bottle a little hard in compensation. He'd set something up wel
breakfast room of the another time he thinks
the waitress in the B & B for later on (maybe ... fingers crossed) but he'd needed som
there and then with kind of monomaniacal fervour that got the pyramids built.
the same
~~Desperate measures~~ for sure, but Betty whats-her-name in Ovingdean was a ~~f~~ pie
~~stop for only~~ well known in the ~~circle~~ and among the ladies men of Surrey and
beyond. "Excuse me, young lady" he says again.
"Finished giving my mum a fuck?" says the young girl on the bicycle
write Eh
about "What?" says Bunny opening the door of the Audi
the
NYMPHO "Finished sticking your dick in my mum?"
circuit
Bunny leans close ~~into~~ the girl ~~stiffs for~~ sucks his teeth K and says
"Actually, yes I have and it was very nice, thankyou very much
then folds himself up and drops into the drivers seat. ~~He starts the car~~
contemptuous
~~gives a grunt~~

Notebook containing the script
for *The Death of Bunny Munro* by Nick Cave, 2008
Published 2009
For further reading see page 266

turns the key

He ~~starts the engine~~ and the Audi makes its noises and ~~contemptuously~~ and ~~with great effort~~ starts first time. [insertion top right: and the engine, insolently & unwillingly]

"Jesus, who's your girlfriend?" says Bunny "What a little ball-breaker."

~~me,~~ Bunny moves off. ~~Than~~ Whisps of sea mist persist, ~~on~~ ~~floating~~ curling up over the ~~Hen~~ cliffs and flocks of birds feast on the newly turned earth in the fields that line the ~~coastal~~ road. [insertions: from the day before; sea]

"She just came and talked to me, Dad." said Bunny Jnr, but what he really wants to ~~say is~~ know ~~"He said~~ ~~whether they~~, will we be going back to that ~~place~~ again?" [insertion: Ovingdean]

"Fancy you, did she?" says Bunny, popping a fag between his teeth and patting his pockets for his Zippo. Bunny Jnr. ~~worries~~ his Darth Vader and says "Da-a-d." and ~~reddens and giggles.~~ + ~~feels a~~ kind of rising heat. [insertion: fingers]

"No, she did. I can tell." ~~Bunny Jnr~~. She had that special ~~light~~ in her eyes." [insertion right: special ~~love~~ light]

"Da-ad!", says Bunny looking up with love.

"I'm telling you, Bunny Boy. I can spot it a mile off."
Bunny turns to his son and punches him on the arm. Bunny Jnr is happy that his dad is happy and he is happy that his dad is not mental, and he is also just happy and he says in a loud voice.

"Maybe I should give her a fuck!"
Bunny looks at his son as if for the first ~~sugar~~ time and then his ~~face opens into a~~ ~~grin~~ great laugh. He knuckles Bunny Jnr's skull. [insertions: and green fields, the other; throws out a; on one side; with the blue sea beyond]

"One day, Bunny Boy, One day!!" he exclaims and Bunny Jnr waves the list in the air and holds up the A-Z and says "Where to now, Dad!" Soon Bunny Jnr. will sit back in his seat and think that even though his mother would come into his room and hold him and stroke his forehead and cry her eyes out, her hand was the ~~safest, warmest thing~~ in the world and he will look up and see a flock of starlings ~~cross the~~ ~~angles~~ of her face in the ~~pale~~ sky and he ~~thought~~ if he could just feel that hand on his forehead again then he would he didn't know what. [insertions: he'd ever felt; with their wings; features; her he remembered]

~~Betty~~ from Ovingdean was ~~becoming~~ a dependable pit-stop ~~among~~ well known among the ~~ladies~~ Men of Sussex and beyond. ~~But the~~ They used to be quite a few on the nympho-convict ~~on medication~~ but they get used up pretty quickly, grow old, get married, pack up + leave, go bat for the other side or as in the case of the ~~jump off~~ the cliffs at Rottingdean. [insertions: soft warm; good; 12 step program]

~~poodle who spends much of his time in chat rooms on the internet~~ chalk ~~is~~ ~~porn sites on the internet has a book~~ collection of names that he is constantly updating, but ~~mies~~ it has to be said, have been ~~slim~~ of late. ~~g story goes that, so Poodle says,~~ Little scrubber half his age went ~~batshit~~ ~~Betty~~ from Ovingdean's husband ~~walked~~ took off with some ...... and Betty ... has been involved in ~~some~~ a kind of epic revenge-fuck ever since, ~~meanwhile~~ word has spread around the local ~~phones~~. This kind of opportunity is usually short-lived and always ends in tears but there is no ~~denying~~ that in throes of this wild justice these bitches go off like fucking firecrackers.

seaside ~~apt~~ flat
Bunny walks up the pebbled path of a ~~ground floor flat~~ in ........ and ~~he~~ wonders
he is doing. He turns and ~~looks~~ sees his son's face watching him through the ~~re~~ window
of ~~the~~ the AUDI - he sees him flash his ~~top-sided~~ ~~wonky~~ smile - and he wonders what he is doing.
At the door, the boy he presses the buzzer, and as he sees ~~the~~ a dark shape ~~wobble~~ like a mirage ~~on the ot~~
side of the frosted glass, (bevelled) then rattle a series of locks and chains he wondered what b
fuck he was actually doing. Then he looked at ~~his list and it said~~ the name on the
list and it said Mrs. Candice Brookes, and he experienced in the base of his spine a ~~th~~
of sexual anticipation that brought a clarity of purpose to his ~~m~~ ————→ mind, ~~B~~
the door opened and a tiny, bent, ancient lady in dark glasses ~~and is with~~ stands before him and s
~~in a adult and ~~ ~~many orged claws~~. says a surprisingly youthful voice "Yes?
and once again Bunny wonders what he ~~was~~ is doing. And then he remembe
~~then~~ he ~~was~~ there to sell stuff and he says "I'm looking for a..." and cons
his list again, "... a Mrs. Brookes." The old lady adjusts her glasses with an ~~auth~~
and ~~really forged~~ bejewelled claw and says "Yes. I'm Mrs. Brookes. Can't be of any h
Bunny notices that Mrs. Brookes is blind and wonders weather this is, ~~for him~~ an advanta
or a disadvantage and says "Mrs. Brookes, My name is Bunny Munroe. I am a
rep ~~from~~ representative of Eternity ~~products~~ Cosmetics. You have contacted Central Office and asked for a de ~~free~~
stration of our ~~collection~~ range of beauty products." her hands quavering along
   "I did?" says ~~Mrs Brookes~~ the old lady, ~~touching~~ the edges of the door
   "Your name is on our list, Mr. Brookes."
   "O I don't doubt it, Mr. Munro. I ~~will~~ no doubt forget to turn up to my own funeral." ~~Mrs~~
~~Goes if.~~ Mrs Brookes invites Bunny in and leads him through a neat little kitchen
into the living room. Bunny is thinking, as he checks her ~~support~~ new stockings swollen an
and support stockings ~~that~~ changes his Mrs Brookes ~~would~~ will be a classic "time-waster" - a lonely
lady who just wants to talk. ~~When he went out with his father as a teenager Bunn~~
~~But~~ He remembers his father, who was into the antiques business, and it was precisely this kind
~~They were his bread + butter~~ When he used to go out with good natured old biddy that his dad could really sque
He was a master at it. ~~you wouldn't~~ ~~You wouldn't know it today but he would t~~
~~oke~~ - a true charmer. Taking their furniture was one thing but selling t
beauty products was another thing entirely. EXPAND ~~rying to~~
     "I hope the new girl ~~I have~~ cleans for me has left the place lookin
nice. I never really know. They ~~come and~~ who comes + l go, these young things, They cost the
earth and none of them really want to be looking after a dotty old ~~bat~~ like
me" "Hired hinderance, Mrs. Brookes" says Bunny and Mrs. Brookes chuckles
     "Exactly, Mr. Munro." tapping lightly with her white cleated stick.

Bunny enters the living room and it is ~~cold sunless~~ sunless and heavy as if time ~~lay~~ itself has ~~coalesced~~ into something covered in ossified

The shelves of the living room are crammed with ancient hard back books, ~~and~~ a patina of dust

~~spit~~ and there is a terrible haunted absence of a T.~~elevision~~ spectral Television set immobile and unyielding

the opened ~~topped~~ lidded upright Bosendorfer along one wall (the ~~old~~ wall) would like a with its rictus of yellow wonky keys

nice little corner for some enterprising Antiques dealer in a couple of years, t'me fault however

~~that~~ he does enquire of Mrs. Brookes

that is no concern to Bunny at this moment in time. I don't ~~let~~ the cleaners in here.

"Do you play?" says ~~Bunny~~ says Mrs. Brookes pointing uselessly at the piano

"Only on Halloween," ~~say~~ ~~chuckles~~ ~~the~~ ~~Bunny~~ ~~laughs and~~ ~~she has a~~ the tinkling

laugh ~~ter~~ of a young girl fills the room. + laughs ~~with~~ like a young girl. + she makes monster claws of her ~~two~~ arthritic hands

"You are a very trusting lady, ~~Mrs. Brookes~~. Do you always let strangers

into your home?" Magnolias ~~camelias~~ mauve— him finding a

With ~~her~~ antennae-like stick clicking ~~against~~ the furniture the old lady makes

her way to ~~an~~ ~~the~~ chintz covered armchair ~~and with a few flattery movements of~~

~~it hands this~~ and before Bunny can offer any help has lowered herself into ~~it~~ the

"Trusting? Nonsense! I have one foot firmly planted in the coffin alcoholic

Mr. Munro. What would anyone want with me?" + suddenly remembering a dream he had had the night before that involved a ~~met~~ ~~death~~ cult of celebrity suicides

"I'ould be surprised," says Bunny looking at his watch.

"I may be blind, Mr. Munro but my other senses have yet to desert me,

You seem like a nice man. You have a nice voice." ~~M~~ Mrs. Brookes offers

Bunny a seat and Bunny has the sudden urge to turn around and ~~walk out~~ make a

run for it but instead he sits and ~~says~~ places his sample case on the ~~queen-anne~~ table in front of

him, ~~there is a radio~~ ~~playing and Bunny sits~~ and a ~~telephone and the~~ Bunny

~~On the table~~ transistor has been Mrs. Brookes swoons dramatically

is surprised to hear that ~~there~~ music coming out of it.

all along (classical) big

~~and says with~~ ~~then~~ she rocks back and forth with a smile on her face like, thinks

metronomically

Bunny, Stevie Wonder or Ray Charles or something and says with great reverence:

"Beethoven... next to Bach no one does it better. Streets ahead of ~~Mozart~~ Kate Mosses' Naomi Campells Jordan's Pamela Andersons

Motzart. Beethoven understood suffering in the most profound of ~~cows~~ and Avril Lavignes

way. You can feel his deep belief in God and his raging ~~he spent the whole dream trying unsuccessfully to~~

love for the world" punch holes in the lid with a blunt knitting needles

"It's all a bit over my head," says Bunny "I'm just a working stiff while the little pink petit pois screamed for air.

"Auden said it all. We must love each other or die...

Mrs. Brookes ~~his happen~~ hands ~~twitch~~ on the armrests of her chair and ~~smiles at Bunny~~

~~many-ringed~~ like alien spiders + her rings ~~twitches~~

"Have you read Auden, Mr. Munro?" clicking sound Outside Bunny can hear

Bunny ~~sighs~~ + snaps open his case. make an unsettling the bitching squawk of seagulls and the

needle "Bunny, Call me Bunny" low drone of the seafront traffic

invitation (he says) he says "Please ~~Bunny~~" Mrs. Brookes says to Bunny

~~as~~ "Only on Halloween" + Mrs. Brookes laughs like a little girl ~~she says~~ again

~~stick clicking~~ against the furniture, Mrs. Brookes ~~makes once~~ ~~of the~~ back ~~and~~ with quick little movements

~~clicking~~ of her ~~fingers~~ hooks herself into her armchair

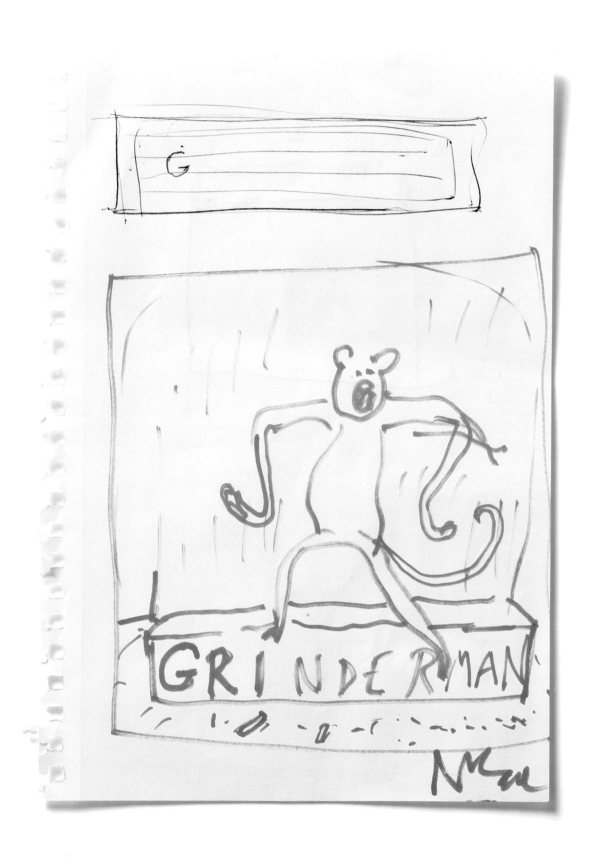

Sketch for *Grinderman* cover
by Nick Cave, 2006
For further reading see page 267

204

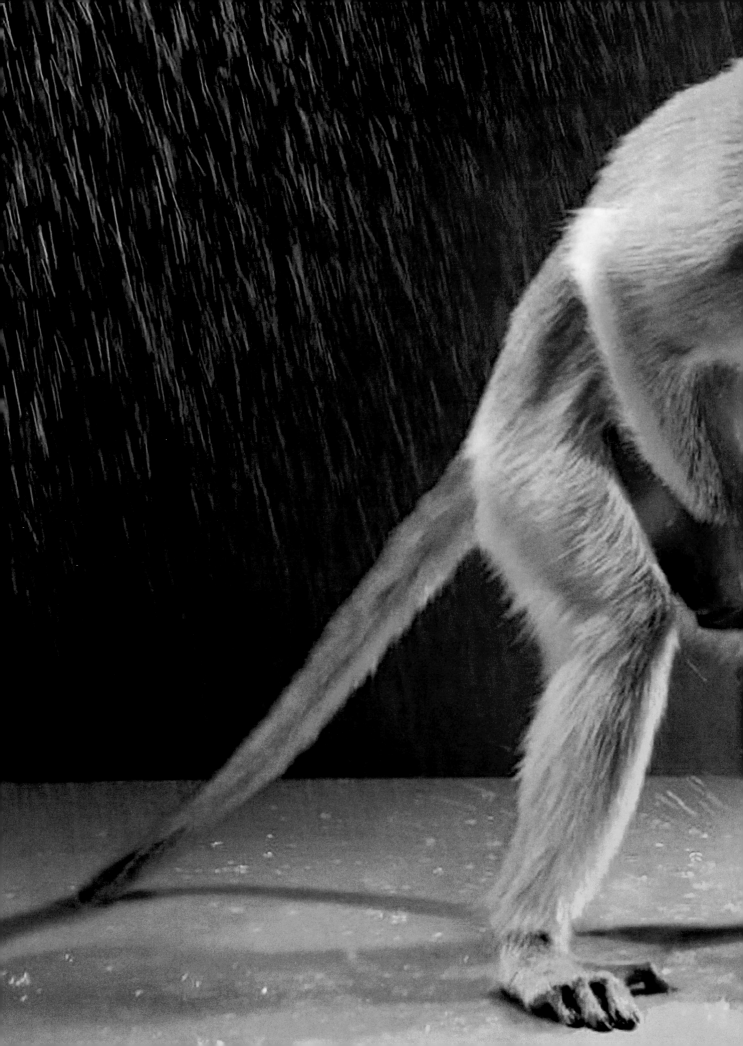

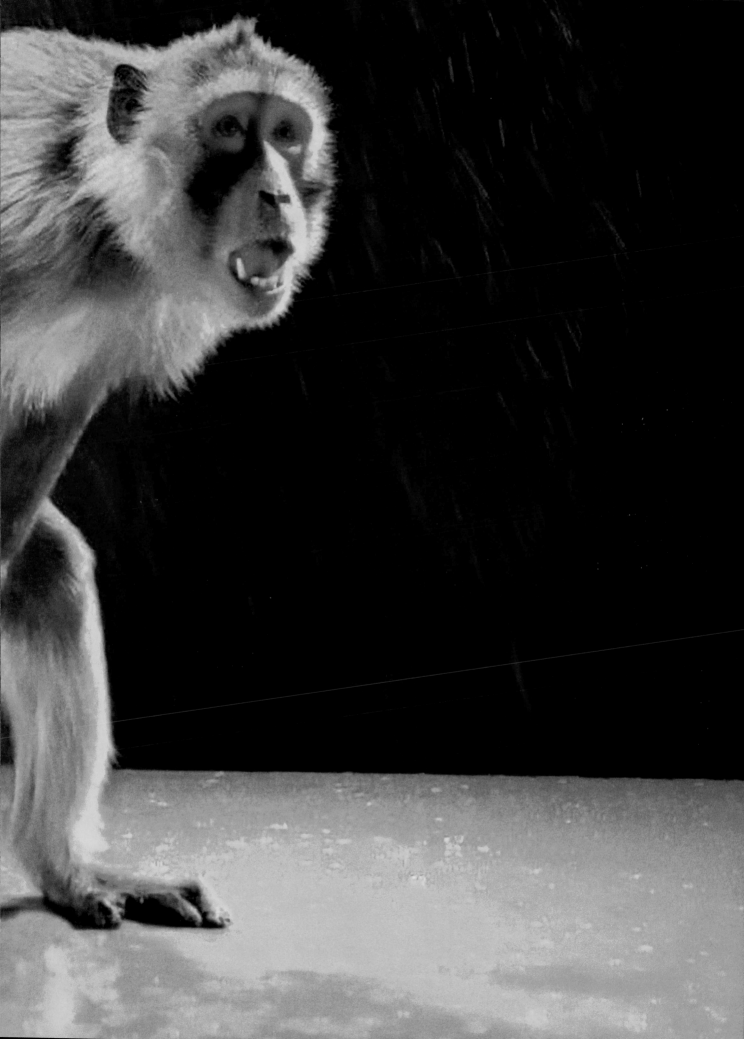

I saw you standing there on Dec. Day
You were a revelation
I could not find a single word to say
As I fell out of the train + onto the stat...

# NO PUSSY BLUES

I can't help but think, sitting standing up here
in all this applause, gazing down,
from a face that's finished

I saw a girl in a crowd
I charged over, I shouted out
I asked her could I take
her out
but I could see she
didn't want to

At all these young + beautiful
the
that with their questions
its enough to move you to murder

I changed the sheets on my bed
I combed the hairs across my head
Sucked in my gut but still you said
that But you never wanted to.

I read you Eliot, I read yo
years
I tried my best to stay up
late

But you just never wanted t...

I thought I try another tack
I drunk a bottle case of Conac
I threw her down upon her back
But she laughed and said she just didn't want to

I must agree
I can't sit stil...

I played her that song about a big brass bed
I played her Barry White instead
She licked her lips + groaned + said
she just did not want to

I wrote a song for her w/ 100 lin...
I picked a bunch of dandel...
I walked her thru the tremb...
pine
but still she didn't wan...

Notebook containing song lyrics
for 'No Pussy Blues' by Nick Cave, c. 2006
Released on *Grinderman* by Grinderman, 2007

IDEA as she made her bed
thought
~~she changed her sheets~~
gave up, went home,
~~I went home but~~ she came on round
with nothing on but her dressing gown
she said come in, ~~she licked her~~ lips + lay right down
daddy
But, I dunno, suddenly I just
didn't want to

I got the no pussy blues

DEPTH CHARGE ETHEL

I got know a woman that a river runs through
She is famous throughout the land
people bathe in her, you know I do
~~But lately it's getting completely out of hand~~
If might seem like I'm ~~laying~~ it on a bit thick
But I love her right down to her little shoes
And ~~But~~ if you want her, you better get in there ~~fast~~ quick
Around about now there's a ticket box + a queque

Depth Charge Ethel, is something special

She thinks it's truly beautiful the way we can all love one another
something
~~She thinks~~ it's special
the nights star-lit cover
I'm in a taxi-cab under a ~~yellow street light~~
I know there gunna send me Depth Charge Ethel
Depth Charge Ethel is something special

I think I got a solo coming on

209

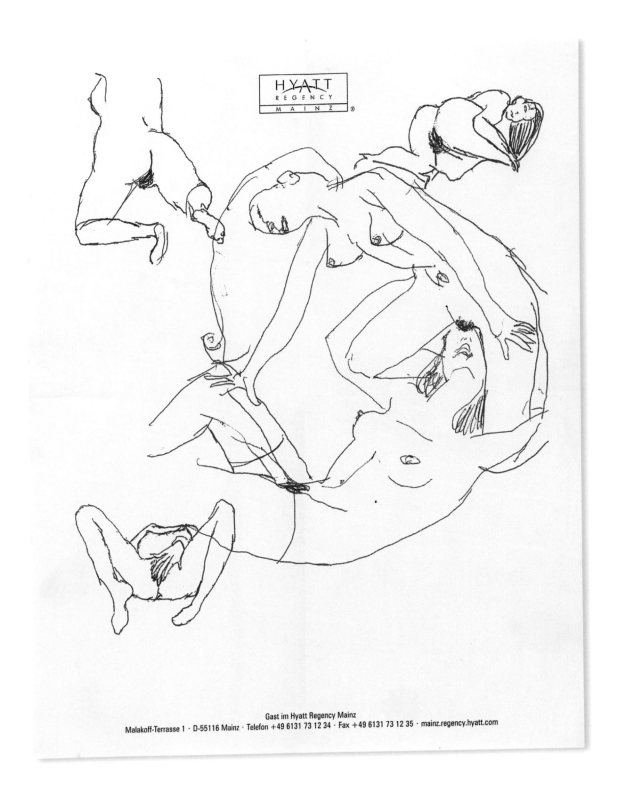

HYATT
REGENCY
MAINZ ®

Gast im Hyatt Regency Mainz
Malakoff-Terrasse 1 · D-55116 Mainz · Telefon +49 6131 73 12 34 · Fax +49 6131 73 12 35 · mainz.regency.hyatt.com

Doodles by Nick Cave
Hyatt Regency, Mainz, 11 November 2006
Later used for the Grinderman singles 'Get It On'
and '(I Don't Need You To) Set Me Free', 2007
For further reading see page 267

210

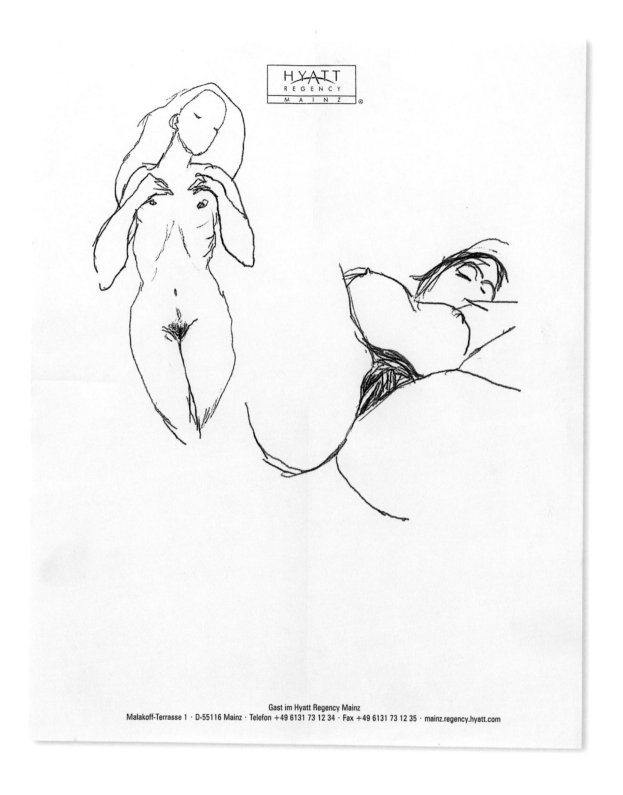

211

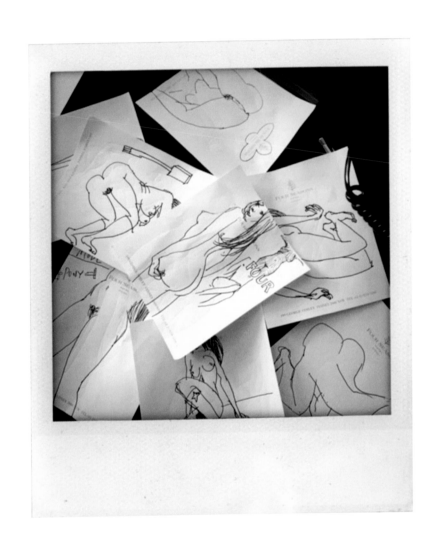

Doodles by Nick Cave
Four Seasons Hotel, 5 and 6 December 2019
For further reading see page 267

212

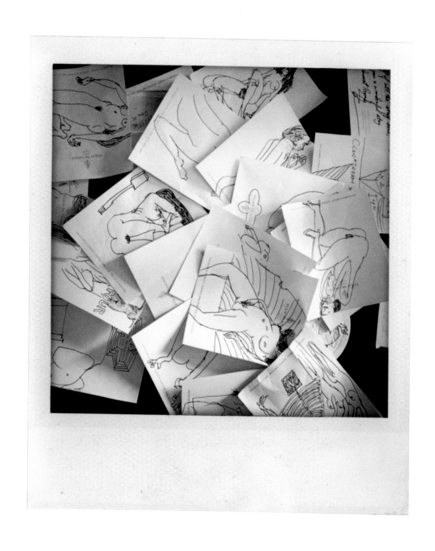

Call me on the phone, my brother
Call me on the phone, my mother
Call me on the phone my lover
Call me on the phone my father

Come on home my brother
Come on home my sister
Come on home my lover
Come on home my father

Call me on the telephone + tell me that your coming home
Call me on the phone

then BOOM! The cops blowing the locks
Like, ah ha, we needed some kind of pro...
I was Mickey Mouse
He was the Big Bad WOOooolf!!!

3 Purple clouds on the horizon
Then the storm passed, all the cameras ran away... gone

There were posters on the airports + the station
I was shivering, I was shivering
We took shelter, we took shelter
Under her body under body shovel
+ We sucked her + sucked her + s...
My brother kissed my cheek + said its o...
goodbye
he said b-b-b-bye b-bye
Ooo W OoooW

Call me on the phone, my brother
"  "  "  "  sister
"  "  "  "  mother
Call me on the telephone + tell

Notebook containing song lyrics
for 'Mickey Mouse and the Goodbye Man'
by Nick Cave, 2009
Released on Grinderman 2 by Grinderman, 2010

214

# MICKEY MOUSE & the GOODBYE MAN

I woke up this morning thought what am ~where am I~
I doing here, yeah what am I doing here

Yeah I woke up this morning I thought where am I +
what am I doing here

I said Hey my
Well my brother! He was ~waking~ shaking
~He starts~ shaking
He starts howling ~howling~
+ he sucked her, sucked her dry ~hanging on the phone~
then bit at me and bit at me + said bye
I was ~pure~ bye
In the woods In the woods

Oooh wooh!!!

---

Well & I been lying there with just my brother
We'd could hear someone outside rattling the rocks
I'd been lying there happily with just my brother
He said I think it may, it might be the cops ~I was happy~
I said I can't take it out there ~anymore~ just do it fit in out there
People always trying to tell me what I ~to~ should
couldn't
I can't take it out there, ~together~ what I should or shouldn't
people always coming around telling me what to
then BOOM! the cops were blowing the rocks ~I said sssh! sssh? to do~
+ we sucked her + sucked her + sucked her
come on home!

Her (a light) is the colour of milk
She got hands like white as milk as she weaves web of
spiders silk that glint

when my baby comes she finds there
while I pray I filled the lost Atlantis, she is crouched like a
antlered praying mantis,
praying

When my baby comes
while I've got your ear
is there anyone out there feel they wasted their lives on
here
booze + drugs + husbands + wives + making mo
they don't do that on the carpet

O, careful of the
carpet

When my baby comes.
They had pistols went pow pow pow
as I staggered from there much giant big mushroom
stupefeel cloud
shadow of I'd about 50 years
a boom boom boom

They had pistols, they had guns, my skirt above m
pulled
head
I emerged much older from under their mushroom
(giant) cloud

When my baby comes

When Just how long you gonna be my baby
Just how long you gonna be my baby
When you come boom boom bom

They had pistols they had guns my skirt twisted all
crawled out In their
I was about nicely when I emerged beneath
mushroom clou
much older from under
maybe one he

Yeah boom boom boom
When my baby comes

(This is better

Notebook containing song lyrics
for 'When My Baby Comes' by Nick Cave, 2009
Released on *Grinderman 2* by Grinderman, 2010

216

# When my baby comes she comes

Thank God we don't get all our hurts at ~~the~~ once ~~time~~,
That'd be a really really bad thing
When my baby comes
Thank God we don't get all our olds at the one time
Listen to me talking practically in ~~my~~ this p_tal gown
Best thing about this place are the showers
The worst thing is the visiting hours — hey don't do
   that on the
      carpet!

   When my baby comes

~~Th~~ Well they had pistols, they had guns, they threw
me on the ground + emptied into me   I was only 15,
when my baby come         yeah bang bang bang

Just How long you gonna be my baby X 4

────────────────────────────────

Hand ~~it is the~~ the   ~~works~~
She got ~~skin   the~~ colour of milk → her hand ~~is~~ like a praying
                        as she weaves   ~~mantis~~
When my baby comes (that glistens)   ~~silk~~ spiders silk
                        while            entered
I pray for the lost city of Atlantis she is crouched like a praying mantis
                        (they crouched of the carpet)   above me
when my baby comes
there any me out there feel they've wasted their lives
      on booze + drugs + husbands + wives + making money?
                              when   hey don't do
                                    that on the carpet!
There is a point you can't help but think ~~are you gonna~~
come out of this ~~one~~ alive ~ When my baby comes
When they threw me on the floor, I was fifteen, skirt around
                                          my head
~~then they emptied into me I~~ emerged I was about
When they ~~finished I was~~ about t hundred ~~+ five~~
~~are~~ ~~close~~         ~~fucking dead~~   boom
                                    with me   I was like about
When my baby comes,         a ~~hundred + dead~~
                              ninety fucking dead

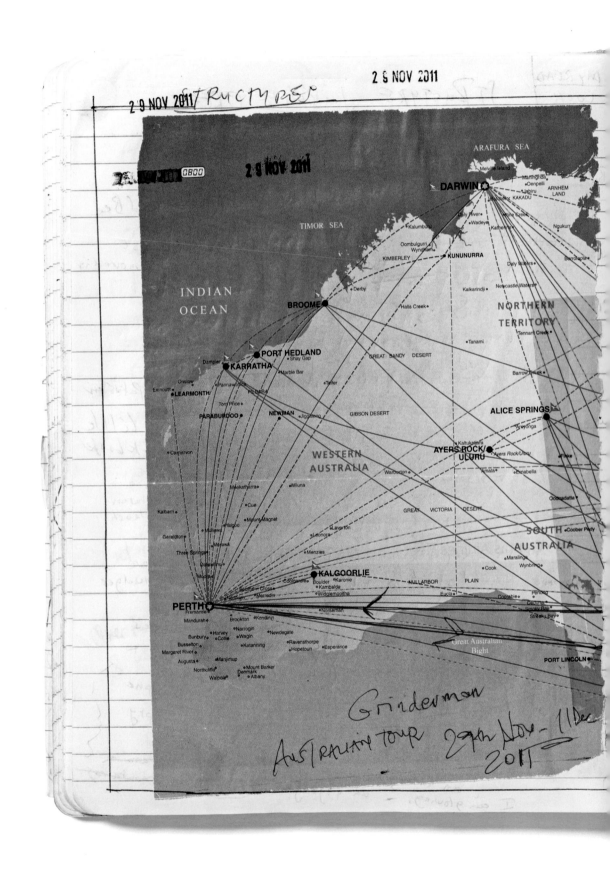

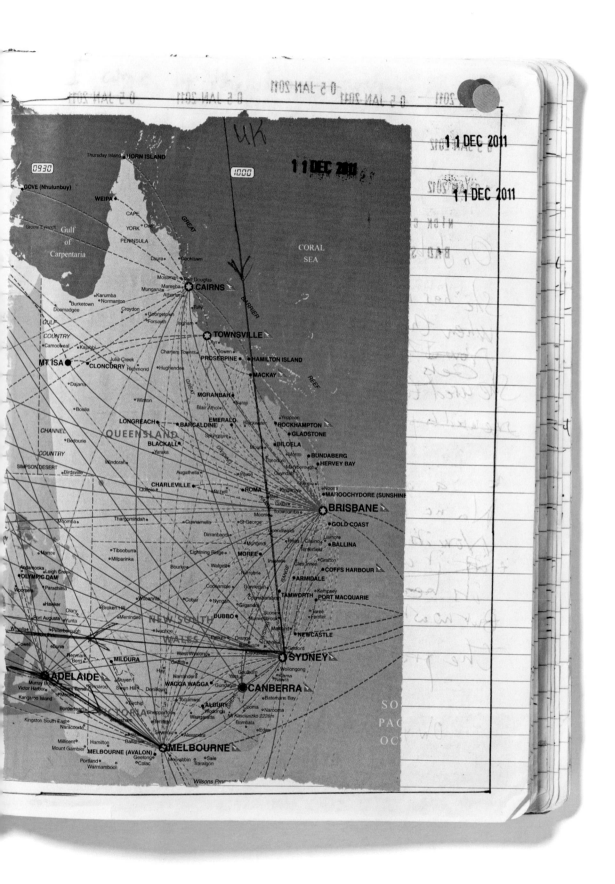

Custom-made notebook
Owned by Nick Cave, 2014
For further reading see page 267

NORTH AMERICAN DIARY

NICK CAVE

09 JUN 2014

NICK CAVE

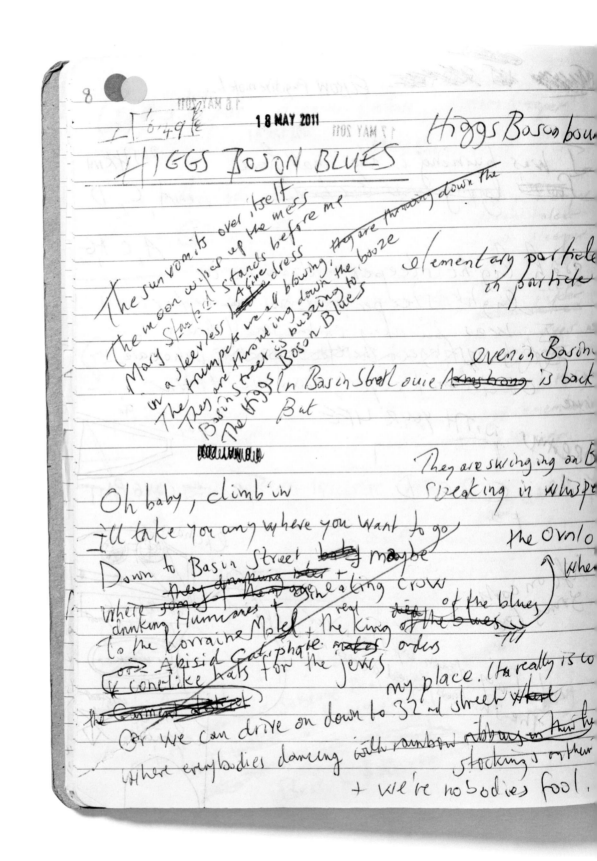

18 MAY 2011

HIGGS BOSON BLUES

Higgs Boson boun

The sun vomits over itself
The moon wipes up the mess
Mary Stands before me
A fine dress
in a sleeveless dress blowing, they are throwin down the
The trumpets really down to booze
Basin street is buzzing to
The Higgs Boson Blues
But

elementary particle
in particle

even in Basin
In Basin Street ouie Armstrong is back

They are swinging on B
speaking in whispe

Oh baby, climb'in
I'll take you anywhere you want to go
Down to Basin Street, baby maybe
they drinking beer +
where some drinking Humans + the healing crow
to the Lorraine Motel + the King died of the blues
ooo Abisid Caliphate makes orders
+ cone-like hats for the jews
the Camel Street
Or we can drive on down to 32nd street there
where everybodies dancing with rainbow ribbons on their h
+ we're nobodies fool.

the Ovnl o
When

of the blues

my place. (it really is to

stockings on their

Notebook containing song lyrics
for 'Higgs Boson Blues' by Nick Cave, 2011
Released on *Push The Sky Away*
by Nick Cave & The Bad Seeds, 2013

NEW ORLEANS ARTHUR LUBIN 1947

Blakeskers  9

Down on Basin Street we collided you + me

## HIGGS BOSON BLUES _Bandar_

There was a collision on _____ Street

You ran into me, I ran into you, too

Something moved from ~~my~~ body into ~~your~~ mine
                         yr.
Something moved from into you
                    my body

~~I wanna love you all night long~~

I wanna feel your beating heart x2

                              yes I do
They are swinging on Basin Street with crows
                                    on their shoes
Speaking in whispers bout the Hi- BOSON Blues

Street with crows in their shoes

bout the HIGGS BOSON Blues

shining shoes

I wanna feel your beating heart
                    kiss your
I wanna kiss your ~~burning~~ lips

                       essential
Can't ~~find atoms~~ find your ~~elementary~~ particles

I want you to shake your hips

~~I wanna~~ old New Orleans Louis Armstrong is taking his cues

from Lucille Bogan and the Higgs Boson Blues.

14 I'm driving my car down to Geneva

~~Passing all~~ the flame trees line the streets

+ I can't remember anything at all

since the storm blew through

I can't remember anything at all

since the storm blew it all away    everything coming up
                                            + an

I've ~~been~~ spent all day in the car park

going round and round

then I hit the exit

Here come the man with rhino~~ceros~~ horn in his han
                                                grease paint
+ the Elephant ~~tusk~~ and white ~~mud~~ smeared all over his
                He looks like hes coming out of some ~ Yeah here he comes  fa
I'd been sitting in my basement patio      with his gone.

it's hot ——————— yeah, so hot for June  lovely strid

Up above the girls walk past with their wide
                                            Come ~~on~~ upon
I watch all their roses in bloom

But I hit the exit, black road, long and ~~hot~~
                                            cross roa

~~Here come~~ Robert Johnstone with a $10 guitar
                                        10
I see
    looking for a ~~killer~~ tune          his wings tucked int
          soul              ~~the strychnine~~        killer
        the man with ~~crocodile teeth~~ + the groove
Here come the^

Robert Johnson + the devil man, ~~dunno who ripped~~ off who
                            can someone tell me              in the lorrain
Can you hear the clock ~~stop~~ ? ~~on the~~ stop.    going T
                  ↓ its too hot ~~I take a~~
I'm tired ~~to room~~ the Lorraine Motel I take a room w
Put my ear to the wall. I hear ~~the~~ man. ~~He's~~ talking a language that
                                        a

Shots ring out and the ~~hot cots cry~~ motel beds cry the H.B. blues

You gotta keep on keeping on.... On the trees 15

Saying If I die tonight, bury me in my favourite yellow
patent leather shoes

with a mummified cat + a cone-like hat      I gotta
that the Caliphate forced on the jews         keep on
                                             keeping
I could lay in this hotel all night but I go to mor  29 JAN 2012 on.
Down on Basin Street they got crow on their shoes
                                                    hot
Can you feel my heart beat? Can you feel my ∧ heart beat

Hannah Montana does the African Savanah     29 JAN 2012
As the monsoon season begins
She curses the queque at the zoo-loo              hot bed
Moves on to Amazonia and cries with dolphins
All over the Amazon the pink dolphins are crying their
In love you cry until you ache                          salt
They are social creatures, its not their fault
As the sob + bob in Toluca Lake

                    I came upon
Im driving my car ~~there's~~ a collision on the side of the road
                    X 2
is suit Here he comes, the man with the rhino horn, 10 foot tall!
                                              + well hung!!
they got the H.B blues right ~~down~~ to their shoes!
hotel Room + its hot + I take a room with a view (Rm 306)

rock + stop!
ng vically
completely
old as it is new.        I could lie here for a hundred years
                              but I gotta move on

18

## HIGGS BOSON BLUES

I can't remember anything at all
Flame trees lined the streets
I can't remember anything at all
I'm driving my car down to Geneva

05 MAY 2012

Been sitting in my basement patio
It was hot
Up above the girls walk past
Their roses all in bloom
You ever heard about the Higgs Boson Blues?
I'm going down to Geneva, baby, gonna teach it
to you

Black road long & I drove & drove
& I came upon a crossroad
The night was hot and black
I see Robert Johnson w/ a ten dollar guitar
Strapped to his back
Looking for a ~~killer~~ tune
Here comes Lucifer with his canon law
& 100 black babies running from his jaw
He got the real killer groove
Robert Johnson & the Devil, man
Don't know who is gonna rip off who

~~Flame trees on fire~~
~~Sucking on the fumes~~
Sitting and singing the Higgs Boson Blues
Driving all night
I'm tired, I'm looking for a spot to drop
All the clocks have stopped in Memphis
In the Lorraine Motel it's hot
It's hot, that's why it is called a hot spot!
I take a room with a ~~point of~~ veiw
Hear a man preaching in a language that is new
completely

Making the hot cots in the flophouse bleed
While the cleaning ladies sob into their mops
And the bell hop hops & bops
& a shot rings out to a spiritual groove
Everybody bleeding to the Higgs Boson Blues

306

CONTINUED

Notebook containing song lyrics
for 'Higgs Boson Blues' by Nick Cave, 2012
Released on *Push The Sky Away*
by Nick Cave & The Bad Seeds, 2013

226

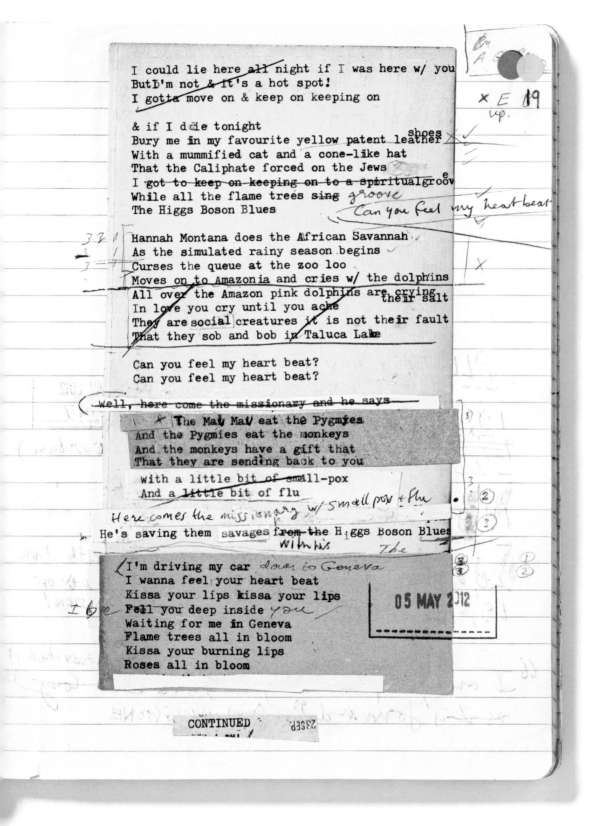

I could lie here all night if I was here w/ you
But I'm not & it's a hot spot!
I gotta move on & keep on keeping on

& if I die tonight
Bury me in my favourite yellow patent leather shoes ✓
With a mummified cat and a cone-like hat ✓
That the Caliphate forced on the Jews
I got to keep on keeping on to a spiritual groov
While all the flame trees sing *groove*
The Higgs Boson Blues          *Can you feel my heart beat*

Hannah Montana does the African Savannah
As the simulated rainy season begins
Curses the queue at the zoo loo
Moves on to Amazonia and cries w/ the dolphins
All over the Amazon pink dolphins are crying
In love you cry until you ache          *their salt*
They are social creatures it is not their fault
That they sob and bob in Taluca Lake

Can you feel my heart beat?
Can you feel my heart beat?

Well, here come the missionary and he says

The Mai Mai eat the Pygmies
And the Pygmies eat the monkeys
And the monkeys have a gift that
That they are sending back to you

with a little bit of small-pox
And a little bit of flu

*Here comes the missionary w/ small pox & flu*

He's saving them savages from the Higgs Boson Blues
          *with his        The*

I'm driving my car *down to Geneva*
I wanna feel your heart beat
Kissa your lips kissa your lips
Feel you deep inside *you*
Waiting for me in Geneva
Flame trees all in bloom
Kissa your burning lips
Roses all in bloom

05 MAY 2012

CONTINUED  23SEP.

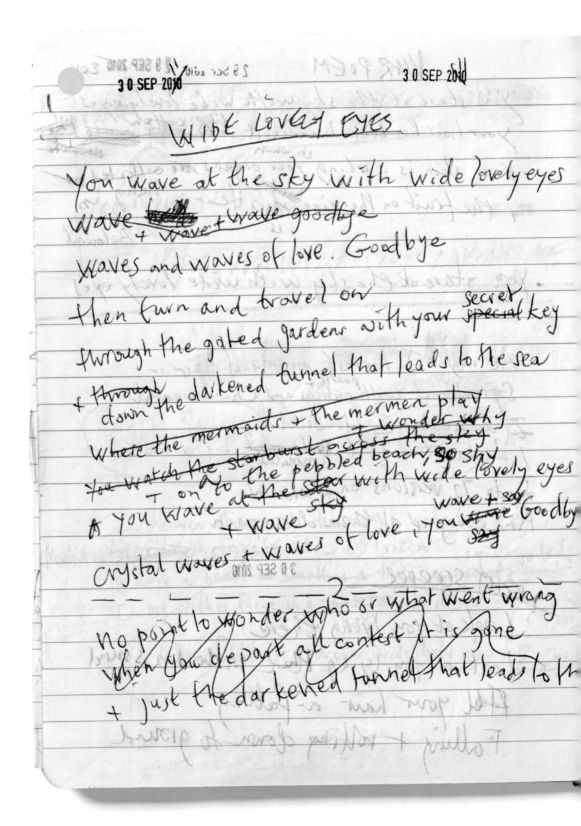

blue

Your dress ~~et waves~~ ~~down the~~ billows with wide, lovely strides
that measure the ~~beat~~ length of a heartbeat ~~+ the rides~~
along the street + lately stories abound
they've ~~taken down~~ dismantled the ~~+~~ + shut down the rides
fun-fair ~~from both sides of the camp~~
they've hung the mermaids from the street lamps
                                        by their hair
+ at night ~~you~~ all I seem to ~~hear their~~ cries.
                    are
melting into mine.

+ with wide lovely, eyes you wave at the sky
at the high window, back n forth + back n forth I glide
waves of ~~pearls of love~~, you wave + say goodbye
      blue + love

_____

The universe expands. I am expanding
~~see~~ watch your hands like butterflies landing

~~we dismantled the fun-fair + shut down the rides~~

all among the myths and legends we create
and all the laughing stories that we tell our friends
Close the window. It's getting late
                 clear up the mess
is dark ~~and~~ + closer to the end
+ through the tunnel and down to the sea
   + on the pebbled beach, so shy
you wave + wave with wide lovely eyes
   mystic waves + waves of love, you wave + say goodbye

2

# GENERAL REPORT        PABLUM

I don't know which was worse
The fact that you left me
Or the fact that you left me first

Kerf — *Verb:* to cut or carve
*noun:* cut in a piece of wood

                                    singing
the mermaids in the Chanel are ~~cry~~ + pining
On Saturday nights we walk on stomach lining
The promenade ~~is painted in bile~~
along

The funfair ~~on the pier~~ breaks free
And floats away, taking the children
                                    with it
Mothers scream from the promenade. They're beyond
                                    their reach
Mermaids wash up on the pebbled beach

~~She~~ was a catch, I was her match    I do parent alertness
                                       I do mermaid alertness
I was the match that fired up her snatch    I do fisherman's ale
But I was no match for her snatch    She was catch
I was fired from her crotch    But she was snatched
Now I sit around and watch
                        English
The mermaids in the Channel pining
                    I
On Saturday night ~~we~~ walk on stomach lining
All Along the ~~Promenade~~. ~~Quite~~ No-one here does anything
~~They're painted the peace statue in bile~~
~~Everyone round her does~~ mean ~~obscene~~ I'll say it ag...

Notebook containing song lyrics
for 'Mermaids' by Nick Cave, 2011
Released on *Push The Sky Away*
by Nick Cave & The Bad Seeds, 2013

I do frighten. I do Brighton. I do bored.
Fred does Wilma with a bowling ball outside the Concorde
I do Shoreham-by-Sea. I do boredom-by-sea

I do speed cameras. I do driver alertness course
I do the floor of the English channel + watch the mermaids rehearse
I do rehearse. I do show. I do rehearse. I do show.
I do hearse. I do horse, I do husband. I do no. I do boo hoo.
I do. I do no. I do come, I do go.
I do, I do. I do divorce. I do boo hoo.
I do I don't know. I don't know which is worse
The fact that you left me I do yabba-dabba-doo
that frighten. I do Brighton.
Or the fact that you left me first pain was no match
Everyone around here does pain has a place to catch
And I will never let that happen again.

English
Down on the floor of the Channel I watch lurk
watch the mermaids on the muck work
I thought one of them was supposed to be little
with starfish on her tits
I do low-brow
Time builds another floor in my forehead
It scares me. It's horrid
I do hi-brow . I do eye-brows
Fred does Wilma with a bowling ball I do boarded-up.
Outside the Concorde. I do bored. Barney does Betty
→ Fred bottles Wilma outside the Concorde, in the tunel
Most Some people round here do bored, obscene + maim
here but obscene Everybody round does pain
No-one does anything around here but maim.

MERMAIDS

0 1 MAY 2012
0 1 APR 2012

She was a catch
And we were a match
I was the match
That would fire up her snatch
But there was a catch
I was no match
And I was famously fired from her crotch
Now I sit around and watch
The mermaids sun themselves out on the rocks
They are beyond our touch I watch
Them wave at me
They wave and slip
Back into the sea

La la la la la la

I believe in God
I believe in mermaids
I believe in seventy-two virgins
On a chain why not why not
I believe in the Rapture
For I have seen your face
On the floor of the ocean
At the bottom of the rain

And all the ones who come
And all the ones who go down to the waters edge
And all the ones who come
And all the ones who go down to the sea

I do rehearse
I do show
I do rehearse
I do show
I do husband
I do I do
I do yabba-dabba do
I do boo hoo
I dance the seabed
I gallop the rain
I sweep the English Channel floor
Fred does Wilma with a bowling ball all along the
Outside the Club Concorde                Old Steine

NICK CAVE & THE
BAD SEEDS

Notebook containing song lyrics
for 'Mermaids' by Nick Cave, 2012
Released on *Push The Sky Away*
by Nick Cave & The Bad Seeds, 2013

And all the ones who come
And all the ones who go down to waters edge
All the ones who come
And all the ones who go down to the sea

I have no worries now I carry on
I run and run and run out of things to say
About this world on which we cannot stay
Ah but Im not that strong to carry on
This way

I do driver alertness course
I do husband alertness course
I do parent alertness course
I do mermaid alertness course
I watch them out on the rocks
They wave at me
They wave at me
Then slip back into the sea

For all the ones who come
For all the ones who go down to the waters edge
For all the ones who come
For all theones who go down to the sea

1.    TURBINE BUCKET WHEEL

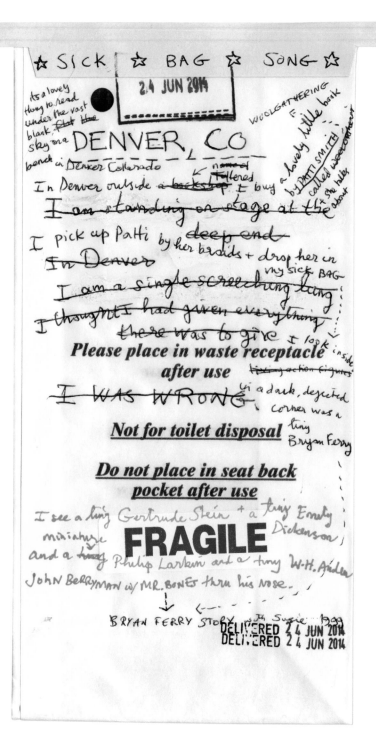

Original sick bags from *The Sick Bag Song*
by Nick Cave, 2014
Published 2015
For further reading see page 267

DELIVERED 2 6 JUL 2014

2 6 JUL 2014

NEW YORK CITY          SICK BAG SONG

Coming up from Philly to NYC, Newark & stuff

*"FOR MOTION DISCOMFORT*

then through the Holland Tunnel, Fast now

Getting faster, up Canal like a shot, and dead straight

INTO MY WIFE.          *AND*

*BABY DIAPER DISPOSAL"*

I button up my MY JACKET

Pull the mist around my shoulders

Where am I going now?

I'm going downtown to get me some

<u>Not for toilet disposal</u>

Later, I throw my Bowery window open
Up in the corner of the sky Elvis' severed head
Cries its salt, All across New York City
It rains curtains and dewdrop jewels
zircons, fugazi + plastic jewels

And rivers of ordinary love songs fill the birdbaths
and the spittoons and the fountains and the swimming pools
Nina Simone pounds the ivories + Karen Carpenter
calls to Roy Orbinson with crystals of sorrowful
sound. We BEGIN TO SEE A PATTERN.

Hank Williams leans to the side in the back of
his cadillac and Lou Reed's face appears on
napkin in a bar in Lower Manhattan.

2 6 JUL 2014     2 6 JUL 2014     2 6 JUL 2014

Let the WORLD know that they died of LOVE

Following page:
Susie and Nick Cave, wedding photograph, 1999

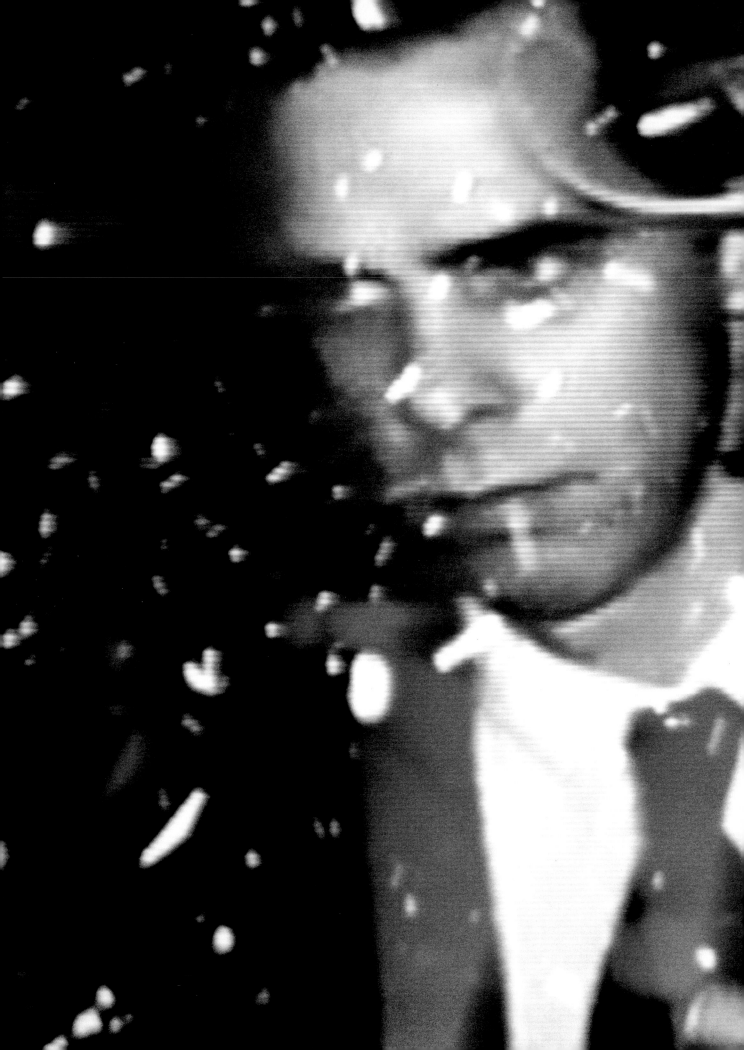

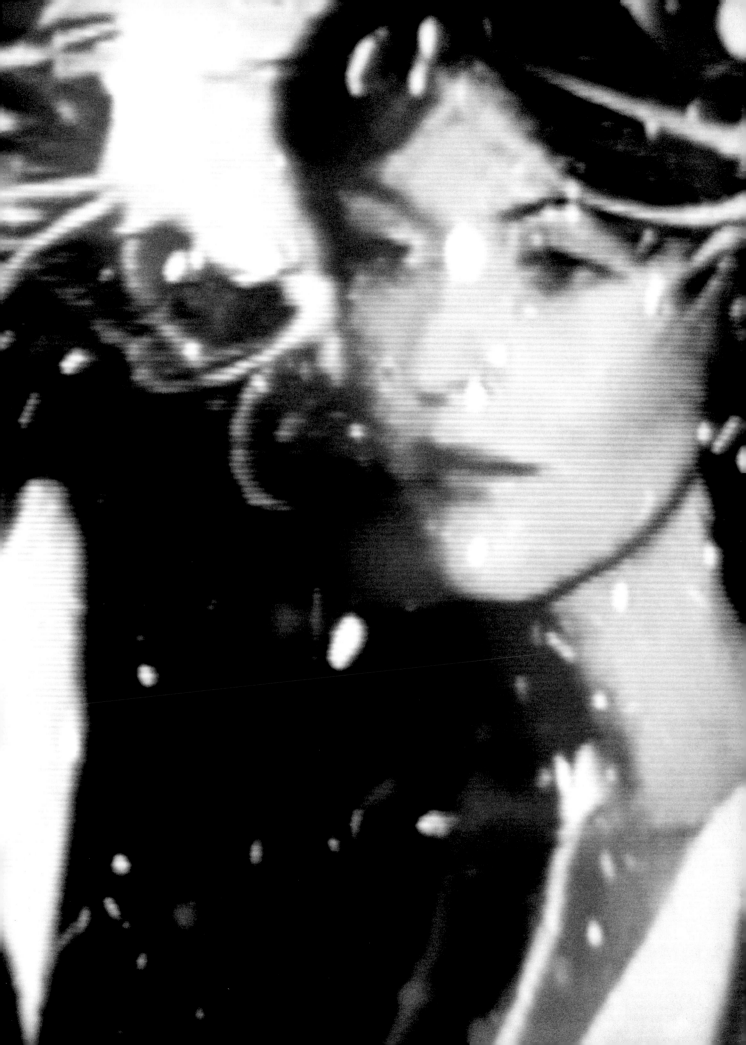

She rolled me deep inside

I kissed the Spider woman, ~~I pushed~~ deep ~~into~~ her silk
I kissed the Spider woman ~~I pushed~~ deep into her silk
                                    she rolled me
Ancient Persia sprang from stream of urine
~~Africa~~ Darkest Africa from a tiny drop of milk
                        tear

Slavery was ~~abolished~~ only for it to raise its ugly head again'
Slavery was abolished only for it to raise its ugly head again
My wife rises from the bed

My wife rises in the dawn, steps over piles of sleeping ch

I call for water, but they are deaf to my demands

I keep to the edges, I do not go inside the towns

~~I am a young man~~ I sleep in a hole beneath the bridge
                          I call for water but they are de

I dug myself a hole beneath bridge, called fo
I called for water thru the cracks, but my de

Notebook containing song lyrics
for 'Jesus Alone' by Nick Cave, 2014
Released on *Skeleton Tree*
by Nick Cave & The Bad Seeds, 2016

238

/k

## JESUS ALONE

I sleep in a hole beneath the bridge. The mist rolls off the sea ~~Steam rises from the water~~

I call for water thru the cracks, but there is no one there to hear me ~~that runs across the River Adur~~

I make figurines from clay. I give them names

You are a ~~sticks~~

There is a new song that ~~gets stuck~~ like a ghost in the throat

You are a fisherman ~~you are a little empty boat~~
on a vast sea in a small boat

You are a song - a ghost song - lodged in a ——— throat

I make

You are a young man, covered in blood. It is not yours

I make

You are a girl in a yellow dress, surrounded by a charm of humming

I make

You are a country doctor ~~leaping over a stile~~ sleeping ~~with~~ in ~~birds~~ ~~a thorn bush~~

I make

You are the mist rolling off the sea ~~beneath a~~ in a field
straw basket

harvesting ~~stealing~~ tearducts + clitores in a

You . You are a African doctor with a pocket full of clitoris's

A I believe in God, but ~~this belief~~ is of no practical use

but I get no special dispensation from this belief

You are a ——— pulling the rain down on the heads of children rafters of my room

am a young man and hung up from the eaves of my home

my demands I am tangled in a web of backwards

You walk into Memory stands on my window ledge & thought

and slept for years cafe in ~~Jerusa~~ threatens to jump

~~ater thru the cracks~~ Tel Aviv ~~with~~ cry the name of
your creator

fell on deaf ears

You are a distant memory in the mind of your creator!

You are an old man sitting around a stone fire with a
wild story

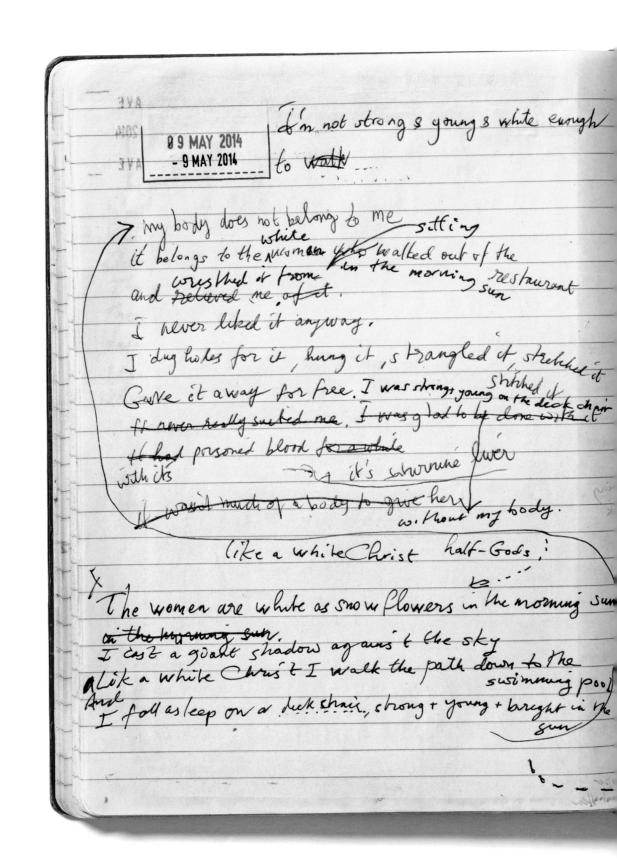

I'm not strong & young & white enough

to ~~walk~~ ...

my body does not belong to me                     sitting
                                white
it belongs to the ~~woman who~~ walked out of the
      wrestled it from    in the morning    restaurant
and ~~relieved me of it~~.                          sun

I never liked it anyway.

I dug holes for it, hung it, strangled it, stretched it

                                       stitched it
Gave it away for free. I was strong, young on the deck chair
~~It never really suited me. I was glad to be done with it~~

~~It had~~ poisoned blood ~~for a while~~
with its                        it's saturnine liver

~~It wasn't much of a body to give her~~
                                without my body.

            like a white Christ    half-Gods,
X                                to ....
The women are white as snow flowers in the morning sun
~~in the morning sun~~.
I cast a giant shadow against the sky
a~~Lik a white Christ~~ I walk the path down to the
And                                      swimming pool
I fall asleep on a deck chair, strong + young + bright in the
                                          sun

Notebook containing song lyrics
for 'Jesus Alone' by Nick Cave, 2014
Released on *Skeleton Tree*
by Nick Cave & The Bad Seeds, 2016

240

JESUS ALONE

You fell from the sky
Crash-landed in a field near the River Adur

Flowers sprang from the ground
Lambs burst from the wombs of their mothers

In a hole beneath the bridge you convalesced
You fashioned masks of clay & twigs & gave them names

You are a fisherman on a vast sea in a small boat
You are a ghost song lodged in the throat of a mermaid

You r a yng manwaking covered in blood that is not yours
You are a girl in a yellow dress surrounded by a charm
                                    of hummingbirds
You are a country boy asleep in a barn
You are a heroin addict in a hotel in the Zona Norte

You are an African doctor harvesting tear ducts
You believe in a God but get no special dispensation for
                                    this belief
You are an old man sitting by a stone fire
You are the mist rolling in off the sea

You are a distant memory in the mind of your creator
You are a distant memory in the mind of your creator

Let us wait together in the dark until the moment comes
With my voice I am calling you

Let us wait together in the dark until the moment comes
With my voice I am calling you

BLUE RINGERS→

I'm a desert island in the sea with a palm tree

My cock sticks out like a sore thumb

08 MAY 2014
- 8 MAY 2014

Space goes on forever & stars are only memories
And much love has gone into their creation
Saturn with its rings of love, the lovely Milky Way
There we fly, ~~look at us~~. All of us. Searching for love
There she is and here she comes...
~~Here she comes~~ + inside out          on all eights, like a ff
Upside down like a funnelweb      the suns coming down
Skinny high haunches skyward + ~~coming down~~ + getting late
                    breasts + ~~black~~ hair      her pale haunches
                                    + the sun hanging  Skyw
~~like a spider~~                    + fuck it's getting ) down +
Through her hair, her eyes like great      my now or it's too fucking,
                        giant green cracks      ↗
                    two sound holes with the light
                                    buckling + rushing in

+ I'm breathing on  and breathing out
two tongue-tied to think

and dangle herself like a dream      She eats her mates mates
    from the rings of Saturn      when the sun goes down

    and now shes up + jiggling + stepping over piles of
then disappearing up + further up to hang herself   sleeping children
    from the rings of Saturn      up down, up
                    then further up to hang herself

Notebook containing song lyrics
for 'Rings of Saturn' by Nick Cave, 2014 (left page)
Released on *Skeleton Tree*
by Nick Cave & The Bad Seeds, 2016
Unreleased song lyrics for 'Decoration Day' by Nick Cave,
2014 (right page)

242

## DECORATION DAY

Come in, I have seen you stretched
Across the world a thousand fold

Come in, I have seen you in Africa by the lake
With a blackchauffer and a snake wand

Come in, I have seen you step from the vehicle
An elephant of woe, onto Bryan Ferry's driveway

Come in, I have seen you at the kitchen table
Smiling and ~~laughing~~ and eating the children
                    waving

Come in, I have seen you march across the desert
And bleed into the waterhole

Come in, I have seen you backwards and upside down
Stop at the edge of my blood and drink

Come in, I have seen you curled in my palm asleep
The air around you inscribed with tiny animals

Little Cat, Little Bear, Little Firehorse, Little Sheep
I have seen you curled in the palm of my hand asleep

And I think if I could do nothing, just do nothing
Not move, not breathe, would it stay this way forever?

Come in, sit down and smile that smile that smiles
And smile that smile and smile that smile that smiles

And decorate this day
And decorate this day
And decorate this day
And decorate this day

Ain't that what you came for.?

All the women I've loved have been good at flyin
~~their~~ chemotrail ~~stripes~~ ~~crisscross~~ the sky air
~~scars~~ across )
(skid marks)

SPAWN OF ........

09 JAN 2014
BRIGHTON

RISE OF THE ANTHROCENE

And so we go searching ~~searching~~ for things to love
Your chemotrail skidmark across the sky
All the women I fell for were all good at flying
I hang out in the o-zone, that's probably why

Rise of the ANTHROCENE

Hang in there, heart, I am flying not falling
And I'm landing on an island of pink polished ~~stone~~ cre
                                              falling
The ~~Rise of the~~ anthrocene age is calling
+ sucking like a bee from its raspberry seam

12 JAN 2014
LONDON
        ~~animals~~
And the ~~trees~~ pull the night across their shoulders
the weight of the air grows more monstrous each day
I walk to the mouth of the cave and I listen

Notebook containing song lyrics
for 'Anthrocene' by Nick Cave, 2014
Released on *Skeleton Tree*
by Nick Cave & The Bad Seeds, 2016

244

a pirate patch of fur + dew                    enfold her  rolled her
                                               b, c, f, g, h, m, o,
                                                         s, told her,
I slide my little songs out from under you =|  wielder

I heard you been out finding things to love

13 JAN 2014
BRIGHTON  THE RISE OF THE ANTHROCENE

All the animals have pulled the night across their shoulders
And the trees fall softly to their naked knees
                                    the planets
And the raincloud cries it's salt, ~~the~~ getting older
Years of tears in the Age of the Anthrocene

Stand ~~back~~ Stand back, people,
~~Hang in there~~, ~~heart~~, Stand back I'm gunna blow ~~over~~ her
with my strap-on blood bomb, poled into the ~~ocean~~ seam
the animals are leaping off the cliffs of Dover
~~water in the morning find you gone~~
Falling ~~in the rise in~~ the Rise of the Anthrocene
the seal pups pull the night cross there shoulders
                          night
the impossible ~~out~~ to heavy to bare
+ the island it rises out of the ocean
                                          set on fire
I heard you've been out looking for things to love
~~I see it in your eyes just~~
~~I won't~~ ~~let~~ + ~~wonder~~ where you've been
   not gonna ask you
                                     the sea,
The flowers, the birds, the trees + the sky ~~above~~ entire

This is our time in the Age of the Anthrone

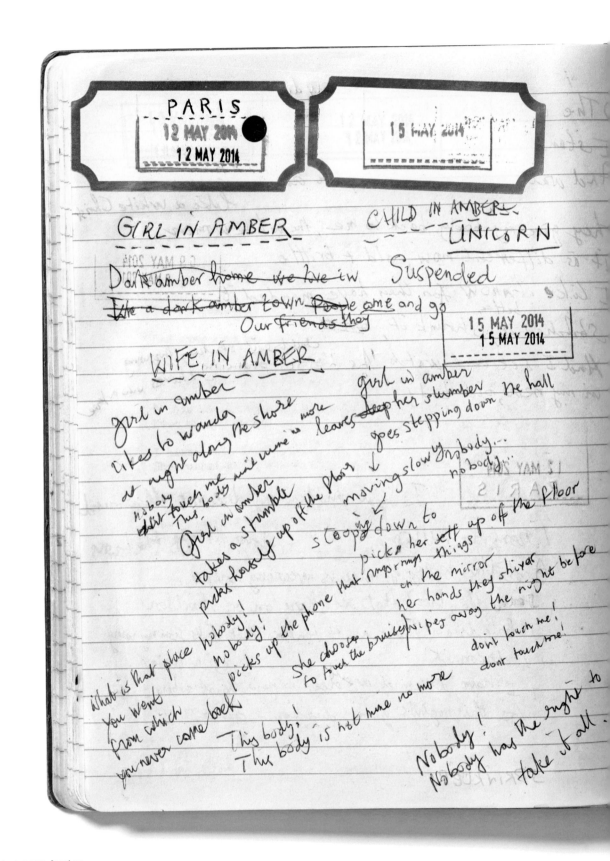

GIRL IN AMBER          CHILD IN AMBER
                              UNICORN

Dark amber home we live in  Suspended
Like a dark amber town People come and go
              Our friends they

WIFE, IN AMBER

girl in amber                girl in amber
likes to wander             her slumber  the hall
as night along the shore    leaves deeper goes stepping down
nobody will come more
didn't touch me             moving slow    nobody...
This body                              nobody...
Girl in amber
takes a stumble        stoops down to    up of the floor
picks herself up off the floor  picks her self up of the floor
                        on the mirror
What is that place nobody!  the phone that rings rings things  her hands they shiver
You went       no body!  picks up  She chooses the bruise wipes away the night before
from which       to touch            don't touch me!
you never come back                  don't touch me!
              This body!
              This body is not mine no more  Nobody!
                              Nobody has the right to
                                        take it all.

Notebook containing song lyrics
for 'Girl in Amber' by Nick Cave, 2014
Released on *Skeleton Tree*
by Nick Cave & The Bad Seeds, 2016
For further reading see page 267

246

Mark Foster - Fos Heron

When I came to see you
you were sitting
quietly in the chair

girl in amber
stuck forever
memory . . . . . . . . . . Dont touch me. Dont touch me
Dont touch me Dont touch me

girl in amber

Sometimes when you slumber

some of us go on                cant remember
some stay behind
some never move at all    how the world it got so
                                                     small
Girl in amber   like a unicorn
held forever                          white + rare
frozen at the door                 + all alone
                        Girl in Amber
nobody            Held in Slumber
    nobody        Goes stepping down the hall

Late night T.V . . . . .
Same old movie                        your stopped life

the phone, the phone, the phone, the phone
aint spoke to her for years

She floats, she floats, she floats   Girl in amber
Away now on her tears               sometimes wanders
                                                   late late late at night along
Girl in amber                                             the shore
suspended float forever  the moon it glows, it glows
                                     she stands alone, it glows alone
                                     she stands alone + rare + white
in the sap of her    memory prison          as a unicorn.
    our recall   → I could not have her
              The girl in Amber
              some never move at all

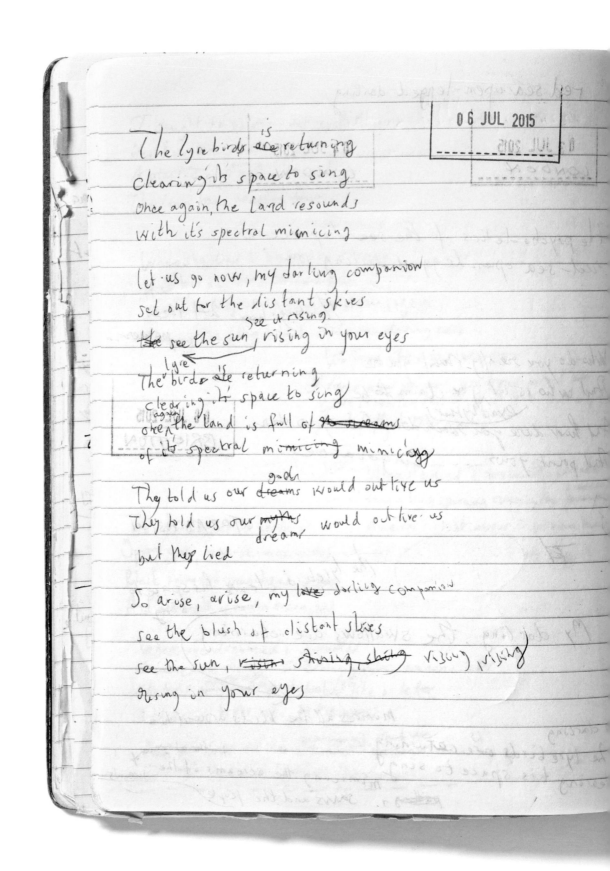

Notebook containing song lyrics
for 'Distant Sky' by Nick Cave, 2015
Released on *Skeleton Tree*
by Nick Cave & The Bad Seeds, 2016

Let us go now, we have ~~had~~ done enough
Call the gasman, turn the power off
Set out for the painted skies
the sun shining in our eyes

Leave the humming bird to the honeysuckle
the metallic green bottle fly
Sally forth like true ~~heroes~~ (believers)     True love never dies
~~Heroes to the end, you and I~~     Our heads held high ...
                                to colonize the stars,

They told us us our Gods would outlive us
the told us our dreams would outlive us
~~I don't know~~ They lied
The told us our _____ would out lives us
The told us our children would forgive us
But they lied ~~I don't know why~~. Soon they rise
                                    I don't know why.

  let us go
So ~~arise~~, arise, my dearest companion
See the blush of the ~~distant~~ skies          Our children
                    coming                      are rising
see the sun, rising rising                go
Rising in your eyes                  Let us ~~make taste~~ haste, my darling companion
                                                        hurry now
Our children ~~are~~ will be rising ~~rising~~     ~~hurry~~ Soon the children will be
This is not for our eyes.                    Rising + remembering  rising
                                             This is not for our eyes

06 JUL 2015

Custodians

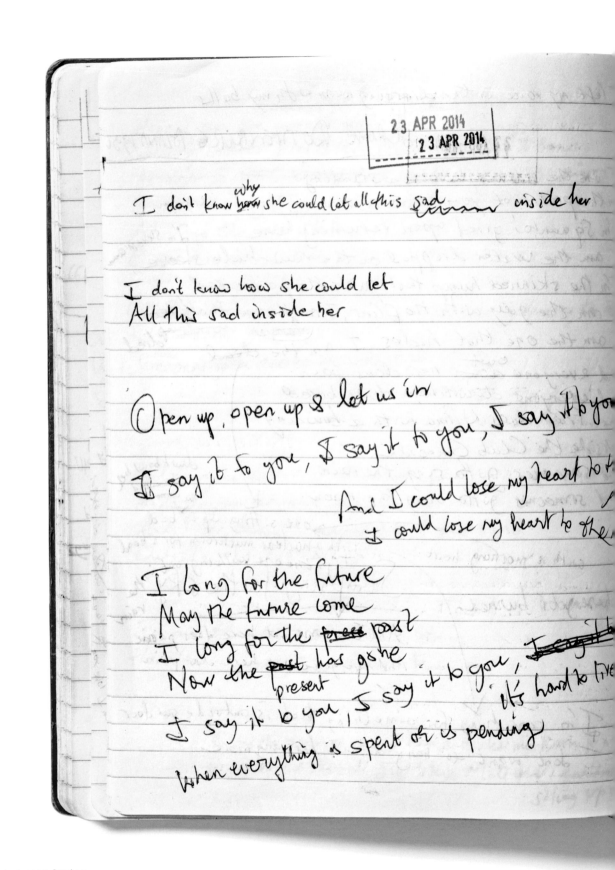

23 APR 2014
23 APR 2014

I don't know how *why* she could let all this sad ~~inside~~ inside her

I don't know how she could let
All this sad inside her

Open up, open up & let us in

I say it to you, I say it to you, I say it to you

And I could lose my heart to t~~~~
I could lose my heart to the~~

I long for the future
May the future come
I long for the ~~pres~~ past
Now the ~~past~~ has gone
present

I say it to you, I say it to you, ~~I say th~~
it's hard to live

When everything is spent or is pending

Once upon a time there was a song
The song started to sing
The song was full of ~~blue~~, full of sad
The song was about Elvis the King

The king was first a prince
The prince was a boy, the boy was the best
with his plukoed crown + he crashed on to stage
with ten pounds of dynamite strapped to his chest

The king had Queen
The queen had hair that went to the sky
The king died in a graveyard, so did the Queen
The graveyard had a tree
Sing the graveyard tree

The graveyard tree was a black train
~~with many~~ branch with sixteen branches high
And on that ~~tee~~ branch there was a black nest
And in that nest, a oily black bird.
Sing the black bird nest
The nest had a ~~black~~ bird
The ~~bird~~ bird ~~sang a song~~ had a wing
The wing had a feather
Sing the feather, sing the wing

The King had to die
The Queen's heart broke like a train
The graveyard tree was absorbed into the earth
But the feather floated, up it went, up and higher, black feather blue blue feather, black bird

SPINNING SONG CYCLE

Once there was a song
The song yearned to be sung
It was a spinning song
About a king named Elvis

The king was first a young prince
The prince was the best
with his jet jelly hair
He crashed onto a stage in Vegas

The king had a queen
The queen's hair was a stairway
She tended the castle garden
And in the garden planted a tree

The garden tree was a stairway
It was sixteen branches high
On the top branch was a nest
Sing the high cloudy nest

In that nest there was a bird
The bird had a wing
The wing had a feather
Spin the feather and ssing the wind

The king in time died
The queen's heart broke like a train
The tree was absorbed into the earth
With the nest and the bird

But the feather spun upward
Up it spun and higher still
Way beyond and spinning up
Forever spinning forever up

NICK CAVE

23 APR 2014

NICK CAVE

07 7 MAY 2014
- 7 MAY 2014

NICK CAVE
23 APR 2014

NICK CAVE

23 APR 2014

NICK CAVE

Notebook containing song lyrics
for 'Spinning Song' by Nick Cave, 2014 (left page)
Released on *Ghosteen* by Nick Cave & The Bad Seeds, 2019
Unreleased song lyrics for 'Baboon Rising' by Nick Cave, 2014 (right page)
For further reading see page 268

# BABOON RISING

It's all right now
And it's all for the best in the end
It's all right now
And it's all for the best in the end

Let's go home            to light our way
While there's still a moon to light our way
Let's go home
                & what goes thru your head

When you're sure that you're alone

            I'm your husband + your a
                        jelly-baby
    And though you tried
        You couldn't go home

You put a record in my heart...

        I don't know the me step
It took me a life time to fall out of that infintile
                              wait            dream
Only to fall back in it again We must stand here in the darkness
            + fight for what we love

● FAILING SONG CYCLE

253

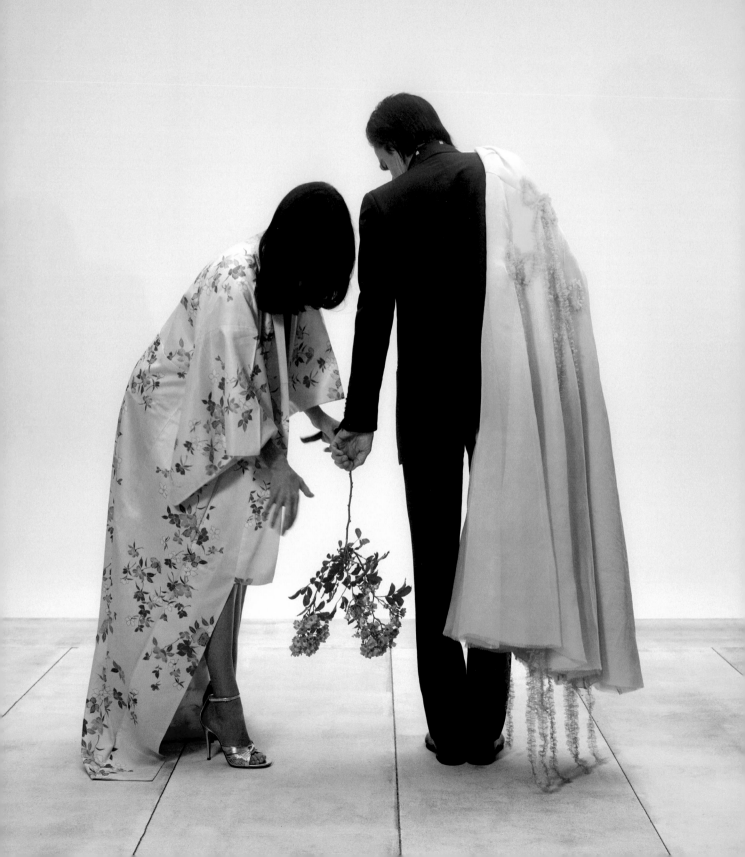

# WIFE WITH EYES CLOSED

She sleeps and dreams to be before
She seems to go there more and more
She turns her back but not with any malice

She says she dreams of beasts run wild
That circle around a rainbow child
Cavorting through a many-roomed palace

And sometimes a black witch flies by
With a wrath that blackens the entire sky
The beasts all watch through a special telescope

And in time I leave her there and go
To the world clawing against the window
Hey, I'm not saying there isn't any hope

For I can see a moment in between
The waking horror and the sleeping dream
Where the world and she are breathless beautiful
Where the world and she are breathless beautiful

# CONTEXTUALISATION

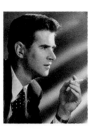

**COLIN CAVE**
**PAGE 18**

Nick Cave's father, Colin Cave, was a handsome and ambitious intellectual, who made a deep impression on people wherever he went. Remembered as an inspirational teacher of literature and drama, Colin Cave established the Wangaratta Adult Education Centre, and wrote the introduction to a book about Australia's legendary bushranger called *Ned Kelly: Man or Myth*, receiving the Wangaratta Citizen of the Year Award in 1971.

Moving to Melbourne with his family, Colin Cave became the Director of the Victorian Council of Adult Education in 1972, a position he held until his untimely death in a car accident in 1979. Throughout his life, Colin Cave shared his love of literature with his children, reading *Lolita* to son Nick, and writing several unpublished manuscripts. Cave was twenty-one when his father died. Cave left Melbourne for London shortly afterwards with The Birthday Party.

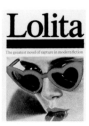

**LOLITA**
**PAGE 19**

When Nick Cave was nine or ten, his father sat him down and read him the first paragraph of Nabokov's *Lolita*. 'Lolita, light of my life, fire of my loins.' His father, Cave has written, 'deconstructed each sentence'. It was a lesson in how to write and how to read. Cave watched his father expand and dilate. 'I could tell by

the way it empowered him that he felt he was passing on forbidden knowledge.' It was instructional but also meaningful. 'In many ways, it was the most intimate moment I ever spent with my father.'

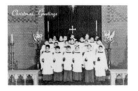

**THE CHOIR**
**PAGE 20-21**

Nick Cave was in the Wangaratta Cathedral Choir for three years, attending church two or three times a week. It was there that he became familiar with the stories of the Bible. These stories had a profound effect on him and became the basis of many of his songs, continuing up to the present time.

'I have never considered myself a Christian as such, but the Bible has always spoken to me in a way that other religious texts don't. I don't know how much this has to do with nostalgia and reliving my childhood, or just the sheer majesty of the actual texts themselves. I don't know, but the Christian stories just captured me and never really let me go.'

**WANGARATTA**
**PAGE 22-23**

Nick Cave's childhood in Wangaratta was idyllic. He lived with his loving parents and his siblings Tim, Peter and Julie Cave. In the morning, his mother Dawn Cave would let them out of the house barefoot and they'd only return at teatime. The landscape in Cave's memory remains Edenic: 'The eucalyptus trees, the willows drooping over the muddy river, the smell of rain on the bitumen, rabbit-shooting, the cathedral, the slaughter house.'

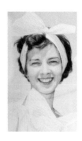

## DAWN CAVE
## PAGE 24

Raised as an Anglican, Nick Cave's mother, Dawn Cave, is a role model of how to live a kind and generous life. Dawn Cave was a school librarian first at Wangaratta High School, and then Firbank Girls School in Melbourne where she fostered the value of education with her students. Along with husband Colin Cave, she appeared on stage with the Warracknabeal Dramatic Society, and as a violinist played on the track 'Muddy Water' from *Kicking Against the Pricks*, released by Nick Cave & The Bad Seeds in 1986.

From a young age, Dawn Cave encouraged and supported her son Nick through piano lessons, choir practice, art classes, appearances at local Eisteddfods and his transition to Caulfield Grammar as a boarder. When Cave moved to London in 1980 and then West Berlin in 1982, Cave and his mother corresponded regularly, their letters keeping them in close contact in between his trips back to Australia. When in Melbourne, Cave lives with his mother, now aged ninety-three, talking, reminiscing and solving the problems of the world.

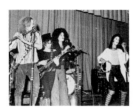

## KOROWA GIRLS' SCHOOL
## PAGE 26

Influenced by David Bowie and The Sensational Alex Harvey Band, Nick Cave in costume and make-up, prancing on stage, was joined by his more subdued friends Phill Calvert, Chris Coyne, John Cocivera, Howard (last name unknown), Mick Harvey and Brett Purcell in a group established while students at Caulfield Grammar. Performing at school socials such as those hosted by Korowa Girls' School, along with church halls, the band – then unnamed and driven to gigs by members' parents – performed covers and some original material.

After completing their Higher School Certificates and launching themselves into art school, hairdressing and the public service, Cave, Calvert and

Harvey came back together and were joined by Tracy Pew, and later Rowland S. Howard, to form The Boys Next Door in 1977.

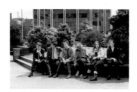

## ART SCHOOL
## PAGE 28-29

In 1976, Nick Cave enrolled at Caulfield Technical College to study painting and to pursue his love of art. 'All the things I loved,' Cave has written, 'found their voice in art school.' After going to an all-boys private high school where he and his friends were regularly called 'fags', art school thrilled him. 'I was suddenly in a world of young artists full of ideas.' Art school radicalised Cave. He savoured conversations with other students and loved working beside them in the studio. He remembers one young woman who painted detailed mythological paintings only to deface them the next day with angry-looking male genitalia. 'I learned not just about art but how to question, how to be.' Cave was 'horrified' to fail his second year because 'all I ever wanted to be was a painter'.

The influence of this intense period of his life resonated far further. From his first days in London writing to his mother Dawn Cave about the wonder of visiting the National Gallery, all the way to his room in Berlin, with walls covered with prints of famous works of art by Piero Della Francesca, Matthias Grünewald, Stefan Lochner and El Greco, to his own practice – seen in the creation of collages and album covers – and his ongoing interest in the art of outsider Louis Wain, Cave's is a creative life informed by art.

Cave's time at Caulfield introduced him to lifelong friends and colleagues including artist Tony Clark, photographers Polly Borland and Peter Milne, and most significantly, his future girlfriend and artistic collaborator, Anita Lane.

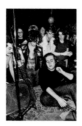

## THE SAINTS
## PAGE 31

'The Saints,' Nick Cave said, 'were kind of God-like to me ... they were just so much better than

everybody else.' In 1977 The Saints came down from Brisbane to Melbourne and Cave and his friends saw them at the Tiger Room. The band's first single '(I'm) Stranded' was released a few months before The Sex Pistols' 'God Save the Queen'. The Tiger Room went on to host Blondie, The Stooges and eventually The Birthday Party, as well as other punk-rock royalty. 'They changed everything,' Cave recalls, 'there was no going back after witnessing The Saints.'

## THE BOYS NEXT DOOR
## PAGE 32

The Boys Next Door was a rehearsal for The Birthday Party, the group they were to morph into. The band developed musically with an awkward confidence as they began performing regularly at inner-city venues such as the Seaview Ballroom in St Kilda, a suburb of Melbourne.

Influenced by post-punk and new wave, and wearing op-shop suits, bow ties and occasional eye-liner, the release of a cover version of 'These Boots Are Made For Walking' in 1978 and Rowland S. Howard's song 'Shivers' the following year defined their early pop-styled angst. By this time, most of the band members had moved out of their suburban homes with the exception of Cave, whose attic bedroom in Airdrie Road, Caulfield, became a regular haunt.

In an attempt to understand his son's burgeoning musical career, Colin Cave secretly attended one or two gigs, telling his son enigmatically that he 'looked like an angel'. Colin Cave's death in an accident happened soon after this, when Cave was just twenty-one. His father never had the chance to see Cave's career as a musician, songwriter and author fully realised. Cave later said that his father's death had come 'at a point in my life when I was most confused'. Following the release of *Hee-Haw*, The Boys Next Door played their last Melbourne show in February 1980 before moving to London and making their transition to The Birthday Party.

## ANITA
## PAGE 34-35

Anita Lane and Cave wrote 'From Her to Eternity' together. 'Ah wanna tell you about a girl', Cave begins. A girl who haunts the song's speaker. 'The desire to possess her is a wound'. Cave met Lane in 1977, when they were both at art school in Melbourne and Lane

lived with her progressive parents and older brother. Besides 'Stranger Than Kindness' and 'From Her to Eternity', Lane also contributed lyrics to 'A Dead Song', 'Dead Joe' and 'Kiss Me Black', using the exquisite corpse method, by passing a piece of paper back and forth, trading lines. The couple split in 1983 but they continue to keep in touch.

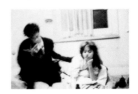

Post-Cave, Lane released two solo albums: *Dirty Pearl* (1993) and *Sex O'Clock* (2001). She also contributed to both Mick Harvey's Serge Gainsbourg tribute albums *Intoxicated Man* (1995) and *Pink Elephants* (1997). Lane sings the parts originally sung by Jane Birkin and Brigitte Bardot. Lane has never spoken about Cave except to say to a reporter, 'I wish I never met the guy.'

## THINGS I'M NOT HAPPY WITH
## PAGE 36

Asked to comment on the list, Nick Cave has said, 'I wrote that when I was very young ... and confused. I'm very glad I didn't implement some of those changes. Mick, for example, became my chief collaborator, completely indispensable, for twenty years, and Phill, well, I always had a real soft spot for Phill, he was a lovely guy, but his drumming was ultimately at odds with what the band wanted to do, I think.'

## LISTS
## PAGE 37

Nick Cave has always been a list-maker. 'Things I'm not happy with, within The Boys Next Door' features the existential items '2. The synth as an instrument' and '5. 50% of our material'. In the later 'Shopping List', Cave reminds himself to buy floral shirts,

hair dye and a crucifix. He also lists the books he asked his publisher Black Spring Press to buy for him while he worked on his first novel *And the Ass Saw the Angel*: Decent Dictionary, Encyclopedia, Book of Mythological Gods. Later, when Cave saw that the cost of the books had been taken out of his royalty statement he was 'more than aggrieved'.

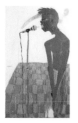

## HORN OF PLENTY
### PAGE 38-39

This painting of Nick Cave by Anita Lane was done in 1977. It is called *Horn of Plenty*. Anita once claimed that if 'Nick was hit by a bus he would be compelled to write about it in his own blood before he died.'

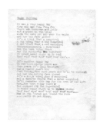

## THE BIRTHDAY PARTY
### PAGE 41

When The Birthday Party arrived in bleak and cold London in 1980, Nick Cave, Phill Calvert, Mick Harvey, Rowland S. Howard and Tracy Pew were in for a shock. Well-known around Melbourne, the band initially struggled to get any kind of confident foothold in this much larger music scene.

After going back to Australia to record *Prayers on Fire*, The Birthday Party had some success which led to extensive touring throughout the UK, Europe and the USA, and developed a reputation for scary, violent and confrontational live shows. No longer living in accommodation with other band members, Cave and Rowland S. Howard resided in squats, beginning a lifestyle increasingly dependent on drugs which accelerated as The Birthday Party reached its artistic climax and collapse.

In 1982, tired of the relentless grind of living in London, The Birthday Party moved to West Berlin, the year that Tracy Pew was jailed back in Melbourne and Phill Calvert was kicked out. German musician Blixa Bargeld recorded some tracks on *Mutiny!*, then the tension between Cave and Rowland S. Howard became

unworkable and Mick Harvey departed, bringing to a close the five years of artistic mayhem known as The Birthday Party.

## NICK THE STRIPPER VIDEO
### PAGE 46-47

The 'Nick the Stripper' video was shot illegally in a rubbish dump in the middle of a hot Melbourne night. The Birthday Party invited friends and associates to come to a party and recreate their version of Hell. People turned up in bunny outfits, carrying pigs' heads; there was a goat, hangman's hoods, Klan costumes; a man brought a crucifix and hung from it the entire night. There was a large cesspit, which they filled with gasoline and set on fire. The 'party' raged through the night and the legendary Birthday Party video of 'Nick the Stripper', directed by Paul Goldman and edited by John Hillcoat – who would become a longtime Cave collaborator – was born.

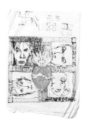

## SWASTIKA
### PAGE 50

Nick Cave was criticised by certain members of the press for using the swastika design on the cover of The Birthday Party's album *The Bad Seed*. Cave always maintained that this was unintentional. This early draft of the cover shows that perhaps Cave was not being entirely truthful.

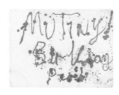

## BLOOD DRAWING
### PAGE 74-75

In the mid-Eighties Nick Cave sometimes drew with his own blood. 'When you're an intravenous drug user,' Cave said, 'blood plays a big part of your life.' This particular drawing was done after a long day in the studio recording The Birthday Party's last album.

The Bad Seeds had the music for a song called 'Mutiny' but Cave had yet to write lyrics. Cave stayed up all night shooting up amphetamines and heroin, writing the words. 'What can I say,' Cave said, 'it was fucked-up.'

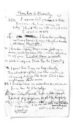

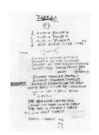

## THE BAD SEEDS
## PAGE 80

On a musical odyssey, Nick Cave & The Bad Seeds inhabit a world of creative transformation and discovery.

Rising from the wreckage of The Birthday Party, original members Nick Cave and Mick Harvey were joined by Blixa Bargeld, Barry Adamson and Hugo Race to form Nick Cave & The Bad Seeds. Their first album, *From Her to Eternity*, was released in 1984. The band's body of work now numbers seventeen albums.

Bringing together individual musicians known independently for their own output and lineage, Nick Cave & The Bad Seeds is a story of collaboration, artistic tension and friendship, as members have joined and departed the line-up. The family tree has included Martyn Casey, Warren Ellis, James Johnston, Ed Kuepper, Larry Mullins, Kid Congo Powers, Conway Savage, Jim Sclavunos, George Vjestica, Roland Wolf and Thomas Wydler.

According to Nick Cave, 'If the band is defined by anything it is the absence of past members. This loss is the engine that drives The Bad Seeds.'

## STATUE OF CHRIST
## PAGE 82

This porcelain statue was given to Nick Cave by Victoria Clarke, the wife of his close friend Shane MacGowan, on his fortieth birthday. Cave has kept it beside his bed ever since, as 'a form of protection'.

## TUPELO
## PAGE 85

'Tupelo' is a song that draws together two of Nick Cave's heroes, Elvis Presley and John Lee Hooker. It tells the story of the storm of Tupelo, which is the theme of the John Lee Hooker song of the same name and conflates it with the story of Elvis Presley and his dead twin, born in Tupelo. It also steeps the whole song in dark religion.

Cave has said about John Lee Hooker: 'I first heard John Lee Hooker on a cassette I had bought at the Camden Market. I had an old beat-up car and I slipped in the tape not knowing what to expect. The first song that came on was "It Serves You Right to Suffer". When John Lee begins the song with that beautifully phrased and liquid first couplet I was entranced. I had to pull the car over to the side of the road. I have never heard a voice like it, with such a powerful, misanthropic and brooding lyric, and that raw, expressive, improvised guitar. My heart just *melted*. It changed my life: how I sang, how I wrote lyrics, how I phrased songs. It was like hearing Elvis for the first time. A sublime beauty, impossible to endure.'

## HOMEMADE DICTIONARY
## PAGE 86-87

Nick Cave remembers the contact high he got from words even as a child. At ten, reading Edgar Rice Burroughs' *Tarzan* he thrilled to the lion that waved its tail 'spasmodically' and leafing through a detective novel he found the phrase 'a wicked little gun'. As Cave created the voice for Euchrid, he would read the dictionary and list words that gave off 'a sort of vibration'. Using these words, he created his own dictionary. 'The words I liked were obscene or just plain groovy. I had several of these dictionaries.'

## EUCHRID'S CRIB
## PAGE 92-93

Nick Cave wrote his first novel *And the Ass Saw the Angel* in a series of small rooms around Berlin.

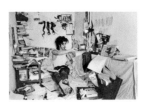

This room, a former maid's chamber, had to be crawled up into. The ceiling was too low for Cave to stand. Miscellaneous items lined the walls: three locks of hair, possibly from sisters, found inside an old box of chocolates; pages from the Bible; a picture of Elvis and one depicting faith, hope and charity. Cave found himself as he wrote, over-identifying with Euchrid, his novel's main character. Euchrid is also a collector; in his beloved swamp he gathers animal skulls and skins. In his clapboard shack beside a sprawling junk-heap, he collects ephemera from his own body: used bandages in a box labelled 'strips' and his scabs in a tobacco tin 'lined with cotton wool'.

## HANDMADE BOOKS
## PAGE 97-121

While the church is heavy on rules, on doctrine, no place has been made in conventional religion for the human body. In these notebooks Nick Cave gathers images of burlesque, Christ and Mary found in flea markets, as well as drawings and even his own blood, to develop a unique theology that encompasses both sexual desire and desire for divinity. God may be dead, but this means we have to work, as Cave does, to create our own God, one who will sustain and nourish us. 'Despite what's gone on in my life,' Cave told an interviewer who asked what the presence of God felt like, 'I've always felt it. I just had a different concept of what *IT* was.'

Asked about his 'art' works done through the Eighties, Cave has said, 'I don't see these things as "art" works at all. They feel to me like fetish objects, or religious artefacts, the terrible residue of an over-stimulated mind. The pictures themselves are made from blood and hair and glue and found objects, such as pornographic photographs, religious prayer cards, kitsch lenticulars, lyrical ideas and so on. They were often the springboards for the songs themselves. The drawings came first.'

Cave collected religious pictures, cutting them from art books found in second-hand bookshops and flea markets. Two images seemed to dominate – The Blessed Virgin Mary holding the infant Christ and the devotional image of Mary holding the dead Christ. When asked about this, he said, 'To me the image of the mother with child and the grieving mother bookend history – the conception of the world and its ultimate destruction. It is the story of the world itself.'

## AND THE ASS SAW THE ANGEL
## PAGE 123

Nick Cave's first novel *And the Ass Saw the Angel* centres on Euchrid Eucrow, a deaf mute born into a swampy backwoods world of drunks and religious zealots.

Writing a novel, which started as an extra-curricular activity, became an obsession. In Berlin, Cave often worked on the book for days without sleeping. Written on a series of borrowed typewriters, Cave carried the manuscript around in a plastic shopping bag. Twice it was lost, once in Berlin and again in London, and as it was his only copy he had to start writing all over from scratch. The novel's prose is intense, gothic, poetic. 'As the storm thickened Abie Poe held high the spirit lamp, waving it wraith-like beside him and allowing its light to fire up his gaunt skull and catch the maddened glint within his eyes.'

## HANDMADE BOOK OF FOUND IMAGES
## PAGE 127-133

This handmade book is the magnum opus of Nick Cave's Berlin years, constructed entirely from found images. It contains hyper-real postcards of flowers, puppies, Brigitte Bardot and Louis Wain cats along with tiny early-twentieth-century sepia portraits of long-forgotten people, female saints from The Children's Miniature Book of Saints and 1950s German pornographic postcards. All these treasures were taken back to his room in Kreuzberg and forensically assembled over many months. This fragile book offers us a glimpse into Cave's obsessions, contradictions and state of mind.

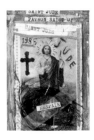

## SAINT JUDE COLLAGE
### PAGE 134-135

Nick Cave wrote in 2007: 'I'd bought a complete version of Butler's *Lives of the Saints* in the mid-1980s and so I was pretty clued up with the saints and the various things they endured. St Jude was beaten to death with a club and then beheaded in Persia in the first century. He is the patron saint of desperate situations and lost causes and is "the Daddy of the Blues". I found the prayer card, or whatever it is, most probably in the flea market in West Berlin, where I found much of my stuff. I've stuck some hair onto it because, well, I have a thing about hair and stamped it with the date 1985, because I have a thing about date stamps. So it is, in the end, a rather pleasing conjunction of things I like – decapitated saints, hair and date stamps.'

## THREE LOCKS OF HAIR
### PAGE 137

Nick Cave found a box of hair in a Berlin flea market in 1985, a place he frequented regularly. Asked about the hair, Cave wrote: 'Small, seemingly insignificant pieces of information become the driving motivation for the final work. An insect trapped within a paper-weight becomes the impetus for "Girl in Amber"; a misreading of the old jazz standard "Basin Street Blues" triggers "Higgs Boson Blues"; a Catholic prayer card suggests the voyeuristic "Watching Alice"; a hedge full of sparrows becomes the motivating force behind "And No More Shall We Part". So it was with the box of hair I found in a flea market in Berlin. Inside the box were three locks of auburn hair, stitched at the top, and kept in tissue paper in a chocolate box. The secret story of the three locks of hair became infinitely important and propelled a cascade of ideas that wove their way through my novel *And the Ass Saw the Angel* and various songs. It remains one of my most treasured possessions.'

## STRANGER THAN KINDNESS
### PAGE 138-139

In the mid-Eighties, Anita Lane wrote the lyrics for 'Stranger Than Kindness'. Nick Cave has said that Lane's 'radical, unorthodox way of seeing' influenced him and The Birthday Party. 'We escorted each other into the creative world. She had the ideas. I had the application.' Written near the close of their time together, Cave calls the song an 'autopsy' of the end of a relationship, and 'an extremely uncomfortable song to sing'. Blixa Bargeld wrote the music. Of all his songs, 'Stranger Than Kindness' remains Cave's favourite.

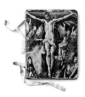

## HANDMADE BOOK WITH BLUE TIES
### PAGE 141-143

Amongst Nick Cave's notebooks, collages and tresses of hair collected from flea markets in Berlin is this larger handmade book with El Greco's *The Crucifixion* pasted on the cover, its contents kept together with blue crepe fabric ties. Replicating the dissonance of Cave's inner world in portable form, the book contains manuscript pages from *And the Ass Saw the Angel*, religious iconography including a print of Christ's feet nailed to the cross with drips of Cave's own blood, and a West German print of the virtues of faith, hope and charity. There is a photograph of Anita Lane and one of Lane's distinctive sketches of Kewpie dolls, this one nailed to a cross, along with collages of Marilyn Monroe for *Your Funeral … My Trial* and other stuff cut out of magazines for future use.

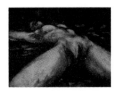

## THE PAINTING OF THE GREEN WOMAN
### PAGE 148-149

The painting of the green woman was Nick Cave's favourite painting and he hung it in his Berlin office. When asked about it he said, 'The painting was done by a guy called Frederic Wall or something. I think this was the only painting he ever did, I'm not sure,

but when I saw it I was instantly drawn to it. Some months later he kicked in my office door and with a carving knife slashed a picture I had above my desk of the Virgin Mary ascending into heaven. I have no idea why he did that. Berlin was like that, though. I sort of stopped being friends with him after that.'

**THE TYPEWRITER**
**PAGE 150-151**
Nick Cave has used a typewriter on and off throughout his writing career. In Berlin he could not afford his own so he wrote both songs and his first novel *And the Ass Saw the Angel* on a variety of borrowed machines.

**DEANNA**
**PAGE 152-153**
Nick Cave has said that the songs he has written about relationships have 'become those relationships themselves'. Deanna, the song's namesake, was not happy to have a song written about her. She felt exposed and called the song, when it was at the height of popularity in the late Eighties, 'the bane of my existence'. Nevertheless, Cave feels drawn to writing love songs. 'Through the writing of the love song, one sits and dines with loss and longing, madness and melancholy, ecstasy, magic and joy with equal measure of respect and gratitude.'

**THE MERCY SEAT**
**PAGE 154-155**
In 2000, Johnny Cash covered 'The Mercy Seat'. For Nick Cave this was momentous, Johnny Cash being a fundamental component of Cave's development as a performer and a songwriter.

Cave said of 'The Mercy Seat': 'Songs are ingenious devices that have their own demands. They find their way, whether you like it or not. In the early Eighties I was fully engaged in the writing of my novel *And the Ass Saw the Angel*. I sat in a small room in Berlin, typing away, day and night, sleeping little. When I reached an impasse with the novel, I would scrawl the odd lyric line on a scrap of paper beside me, ostensibly a song about a man going to the electric chair. The song was at best a distraction, a doodle, a song I never looked fully in the eye, or thought much about. But songs have their own yearnings and in time assert their sovereignty. "The Mercy Seat" was such a song. Even when I was singing it I had no idea that the song was important or that I would play it at every gig for the next thirty-five years, or that my hero Johnny Cash would one day record it. It was, as far as I was concerned, an afterthought. I often find that when it comes to song-writing I am the last to know. The songs hold within them a far greater understanding of their potential than I do.'

**'KYLIE' BAG**
**PAGE 156-157**
Nick Cave wrote in 2007, 'I was on tour in Manchester in 1992 and somebody had given me this drug that made me like people and I was walking through the streets on my own, really late and somebody took me into a small, dark room and there hanging on the wall of the room was this little shoulder bag – pink and baby blue with the words KYLIE MINOGUE printed on the side. And there was something about that little bag that spoke to me. I don't know, it held such promise, sent shivers up my spine – and I asked the guy if I could have it and he very kindly gave it to me, saying rather unnecessarily that he had a JASON one too, somewhere. I kept that little pink bag with me for years, had it in Japan, across the States, across Europe. I felt I'd kind of rescued it.'

**O'MALLEY'S BAR**
**PAGE 158-163**
'O'Malley's Bar' is a forensically detailed and very violent epic about a psychopath murdering a bunch

of people in a bar. It was initially recorded at the *Let Love In* sessions in 1993. As the song was too long to fit on this record, Nick Cave decided to make an album of murder ballads, so that 'O'Malley's Bar' could have a home. Asked about the unrelenting violence of 'O'Malley's Bar', Cave has said, 'I don't know, sometimes you write a song, and you've just got to kill a whole lot of people'.

'"O'Malley's Bar" was written over many months, presenting itself in stages, verses piling up, as they do, endlessly, but the initial idea and preliminary writing was done lying on my back, in my suit, on a banana lounge, around the hotel pool in one of those faceless German cities. It was incredibly hot, I remember, and early in the morning, and I had a hangover you would not *believe*, and nearby there was a group of holiday-makers who were having a good time, or something, so I began, one by one, to describe them (in verse), then name them, and finally and systematically, execute them, on the page. Wonderful things, hangovers, a great creative tool (any artist will tell you), sadly denied to me these days.'

## PAPA WON'T LEAVE YOU, HENRY
## PAGE 165

'Papa Won't Leave You, Henry' was one of several songs composed over the crib of Nick Cave's newborn son, Luke. Cave has said, 'They were essentially nursery songs, lullabies, designed to get Luke to sleep: "Papa Won't Leave You, Henry", "The Weeping Song", "Foi Na Cruz". This is the reason something like "Papa Won't Leave You, Henry" is so long and verbose. It was tough getting him to sleep. Maybe I was singing him the wrong song.'

## RED RIGHT HAND
## PAGE 166-167

Many artists, chiefly due to it being the theme of the hugely popular TV series *Peaky Blinders*, have covered 'Red Right Hand' including P.J. Harvey, Jarvis Cocker, Laura Marling and Iggy Pop. At an In Conversation event, Nick Cave said, '"Red Right Hand" follows

me around like a stray dog. For many casual listeners, "Red Right Hand" has come to define The Bad Seeds. However, it may be the one of my songs I am least attached to. To my great delight, however, Snoop Dogg recently covered it. He did it playfully and irreverently and with a lot of humour. I was very pleased. Finally, hip-hop has embraced The Bad Seeds!'

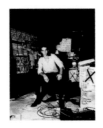

## LET LOVE IN
## PAGE 173

Following recording of the basic tracks for the album *Let Love In* at Townhouse Studios in London in 1994, Nick Cave & The Bad Seeds returned to Metropolis Audio in Melbourne to mix and overdub the album. Polly Borland took photographs of the band, family and friends at work and play including detailed images of Nick Cave surrounded by copious amounts of paper such as daily schedules and chord sheets and notes to cleaners not to move 'my stuff'. On closer inspection, Cave appears to be sitting still in a staged environment belying the slightly erratic, ever-changing process involved in recording and producing an album. Polly Borland went on to take the dramatic and electrifying photographs of the band that were used on the cover of *Let Love In*.

## FAR FROM ME
## PAGE 174

'"Far From Me" took four months to write, the duration of the relationship it describes. The first verse was written in the first week of the affair, and is full of the heroic dreams of the new love. It sets the two lover-heroes against an uncaring world – "a world where everybody fucks everybody else over" – and brings in the notion of physical distance suggested in the title. Verse 1, and all is well in the garden. But "Far From Me" had its own agenda, and was not about to allow itself to be told what to do. As if awaiting the inevitable "traumatic experience", it refused to let itself be completed until the catastrophe had occurred. Some songs are tricky like that, and it is wise to keep

your wits about you when dealing with them. More often than not, the songs I write seem to know more about what's going on in my life than I do. I have pages and pages of final verses for this song, written while the relationship was sailing happily along. One such verse went: "The Camellia, the Magnolia/Have such a pretty flower/And the bell from St Mary's/Informs us of the hour". Pretty words, innocent words, unaware that any day the bottom was about to drop out of the whole thing. As I wrote the final verse, it became clear that my life was being dictated by the largely destructive ordinance of the song itself, that it had its own in-built destiny over which I had no control. In fact, I was an afterthought, a bit player in its sly, mischievous and finally malicious vision of how the world should be.'

Taken from Cave's 1999 essay, 'The Secret Life of the Love Song'.

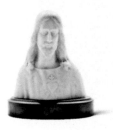

**JESUS BUST**
**PAGE 175**

Nick Cave found this marble bust of Jesus at a flea market in Buenos Aires while on tour and carried it all over Europe under his arm. 'Christ,' Cave has written, 'spoke to me through his isolation, through the burden of his death, through his rage at the mundane, through his sorrow.'

**THE SORROWFUL WIFE**
**PAGE 182-183**

In The Red Hand Files, Nick Cave wrote, 'I remember lying under the old yew tree in Kew Gardens with my wife, Susie, in a vast field of bluebells. It was the year 2000 and we would visit the gardens often that spring. It was a magical time, full of excitement and promise. Susie was heavily pregnant with the twins and we could barely contain ourselves, as we lay there in the shade of the ancient tree, with the children growing inside her, as the momentary bluebells looked on.' Around this time Cave wrote 'The Sorrowful Wife'.

**WEATHER DIARIES**
**PAGE 186-187**

The Weather Diaries began in 2000 as an 'antidote to British weather'. In their concentrated detail, the diaries are an act of deep attention. As Nick Cave laments and describes the elements, the weather becomes embodied, complex, nuanced. 'The weather is getting interesting, cloud is interesting, wind is interesting, rain and thunder and lightening [sic] are interesting...'

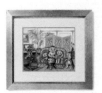

**LOUIS WAIN**
**PAGE 188-189**

Nick Cave learned about the cat paintings of Louis Wain from artist, teacher and friend, Tony Clark. When he first got to England, Cave saw a Wain in a second-hand shop for fifty quid but was 'in no position to buy it'. Later, the musician David Tibet, another Wain enthusiast, sold Cave several paintings. Since then he has acquired many more. Cave admires Wain's development from naturalistic cats to humanised cats sitting in living rooms and around dinner tables to the 'psychedelic' cats Wain painted while in a mental hospital for schizophrenia. 'Apart from their extraordinary spiritual energy,' Cave writes, 'the Wains, in some kind of way, keep me anchored to my past in Melbourne.'

**BUNNY MUNRO**
**PAGE 198-203**

The story of Bunny Munro, a salesman and unrepentant letch, began as a screenplay which Nick Cave later turned into a novel. The main motivation behind the book was Valerie Solanas's 1967 *SCUM Manifesto*, a work of strident feminism. 'Every man deep down,' she wrote, 'knows he is a worthless piece of shit.' Bunny is a comedic character, profligate and poetic. After his wife's suicide, he takes his young son Bunny

Junior on a road trip defined by grief's denial. Cave credits the gospels as 'ghost stories' for the novel's form and also the idea of 'resurrection through your children' as the driving force of the novel.

## GRINDERMAN
## PAGE 204

Grinderman is Nick Cave's creative reset button. Born out of the behemoth that Nick Cave & The Bad Seeds had become around the time of recording the complex double album *Abattoir Blues/The Lyre of Orpheus*, Grinderman was the antithesis of The Bad Seeds. The band was small with a shared, organic and collaborative approach to producing music. Working with Warren Ellis, Martyn Casey and Jim Sclavunos, and with the pressure of being the primary songwriter gone, Cave and his Grinderman colleagues were free to set out in new directions performing pure, raucous and untamed garage rock.

So far, Grinderman have recorded two albums, *Grinderman* (2007) and *Grinderman 2* (2010), and left fans wondering and speculating when, or if, Grinderman will return.

## DOODLES
## PAGE 210-213

When asked about his compulsive habit of doodling naked women, Nick Cave said, 'Well, Queen Victoria doodled horses, Mark Twain doodled whales, Claude Monet doodled paintbrushes, I doodle naked women. Mostly, I draw them sitting at a desk in hotel rooms on hotel stationery. They are a compulsive habit I have had since my school days and I have thousands of them floating around. They have no artistic merit: rather they are evidence of a kind of ritualistic and habitual thinking, not dissimilar to the act of writing itself, actually; I simply sit down each day and write. I have conditioned my brain to behave in this way. It is the applied mind that simply does its work regardless of inspiration. So it is with the doodles of naked women. I am compelled to draw them.'

## NOTEBOOKS/SONGWRITING
## PAGE 221

Nick Cave uses notebooks, created especially for him in Australia by Jillian Burt, to make notes for his songs and also the letters he writes in response to fans' questions on The Red Hand Files. Songs develop at various speeds. A song from his most recent album *Ghosteen* (2019) was found in a notebook from 2013. The notebook pages reveal the anatomy of songwriting, how the lyrics come together, are negated and migrate. When the song is done, Cave types the lyrics and glues them into the notebook. The books are taken into the studio and the lyrics are reworked again as he improvises with his band.

## THE SICK BAG SONG
## PAGE 234-235

In 2015, Nick Cave published what would be a highly personal and heroic saga of his trip around North America and Canada, written partly on aeroplane sick bags. Cave has said, at an In Conversation event, that '*The Sick Bag Song* is the best thing I ever did, as far as I'm concerned.'

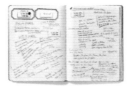

## GIRL IN AMBER
## PAGE 246-247

The film director Andrew Dominik claimed recently that Nick Cave was extremely difficult to work with through the filming of *One More Time with Feeling*. Dominik has intimated that Cave was deeply suspicious of the whole premise of the film and was afraid the film would turn out to be 'mawkish and depressing and exploitative of his son's death'. Dominik suggested that Cave was determined not to appear victim-like. While Dominik was filming 'a beautiful shot of Susie Cave walking along the beach in Brighton',

Cave (who was not there) rang his wife and asked her what she was doing. Susie Cave told Cave she was being filmed walking by the sea. Cave demanded the shoot stop and his wife return home. He accused Dominik of making grief-porn. Months later, upon seeing a rough cut of the film, Cave wanted the whole thing scrapped. The story is that he rang Warren Ellis, who had also seen the film, and that Warren Ellis had told Cave 'to step away from the film and allow it to be'. It was not until Cave saw the audience reaction to the film and the positive effect that it had on other people that he embraced it. He now sees the film as a 'beautiful gift from a dear friend'. The piece of footage of Susie Cave walking along the beach became an important and iconic feature of the *Skeleton Tree* live shows, accompanied by the song 'Girl in Amber'.

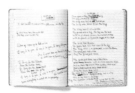

**GHOSTEEN NOTEBOOK**
**PAGE 250-253**

Nick Cave has used the same bespoke notebooks to write his lyrics in since 2012, beginning with the *Push The Sky Away* album. He has called them 'objects of devotion'. Recently he lost his *Ghosteen* notebook. He said this: 'My notebooks, which are predominately a collection of failed ideas, nevertheless hold great value to me. They are proof of life, and I am never far from one. My notebook for *Ghosteen* was full of songs and it disappeared. I have looked everywhere for it. I sometimes think maybe someone stole it, or destroyed it, or there was some kind of cosmic erasure of it, I don't know, but in the end I probably just left it in a hotel room somewhere, or on a train, or in the back of a car or something. It wouldn't be the first time. Mostly I remain composed and think that it will come back, these things have a way of turning up. I hope so.'

# LIST OF ILLUSTRATIONS

**PAGE 42-43**
Wallet owned by Nick Cave,
c. 1985
Nick Cave private collection

**PAGE 44-45**
Lists by Nick Cave, c. 1979
Nick Cave private collection

**PAGE 46-47**
Still image from the music
video for 'Nick the Stripper',
1981
Directed by Paul Goldman
Reproduced by kind permission
of The Birthday Party Pty Ltd

**PAGE 48-49**
Lyric for *Prayers On Fire*
by Nick Cave, c. 1981
Acrylic paint on paper
Gift of Nick Cave, 2006,
Australian Performing Arts
Collection, Arts Centre
Melbourne

**PAGE 50**
Design sketch for *The Bad Seed*
by Nick Cave, 1982-83
Ink and pastel on paper
Gift of Nick Cave, 2006,
Australian Performing Arts
Collection, Arts Centre
Melbourne

**PAGE 51**
Song lyrics for 'Wild World'
by Nick Cave, 1982-83
Gift of Nick Cave, 2006,
Australian Performing Arts
Collection, Arts Centre
Melbourne
Reproduced by kind permission
of Mute Song Limited

**PAGE 52**
Song lyrics for 'Dead Joe' by
Nick Cave and Anita Lane, 1982
Nick Cave private collection
Reproduced by kind permission
of Mute Song Limited

**PAGE 53**
Song lyrics for 'Sonny's
Burning' by Nick Cave, 1982
Gift of Nick Cave, 2006,
Australian Performing Arts
Collection, Arts Centre
Melbourne
Reproduced by kind permission
of Mute Song Limited

**PAGE 54**
Song lyrics for 'Swampland'
by Nick Cave, 1983
Gift of Nick Cave, 2006,
Australian Performing Arts
Collection, Arts Centre
Melbourne
Reproduced by kind permission
of Mute Song Limited

**PAGE 55**
Song lyrics for 'Jennifer's
Veil' by Nick Cave, 1983
Gift of Nick Cave, 2006,
Australian Performing Arts
Collection, Arts Centre
Melbourne
Reproduced by kind permission
of Mute Song Limited

**PAGE 74-75**
'Mutiny!, The Birthday Party'
Drawing in blood by Nick Cave,
c. 1983
Nick Cave private collection

**PAGE 76**
Song lyrics for 'Mutiny in
Heaven' by Nick Cave, 1983
Gift of Nick Cave, 2006,
Australian Performing Arts
Collection, Arts Centre
Melbourne
Reproduced by kind permission
of Mute Song Limited

**PAGE 78-79**
Box of cassettes owned
by Nick Cave, 1982-85
Nick Cave private collection

**PAGE 80**
Song lyrics for 'From Her
to Eternity' by Nick Cave and
Anita Lane, 1983
Gift of Nick Cave, 2006,
Australian Performing Arts
Collection, Arts Centre
Melbourne
Reproduced by kind permission
of Mute Song Limited

**PAGE 81**
Postcard from handmade
book by Nick Cave, 1985
Gift of Nick Cave, 2006,
Australian Performing Arts
Collection, Arts Centre
Melbourne

**PAGE 82**
Statue of Christ, c. 1860
Staffordshire Pottery
Slip cast religious
figurine with painted glaze
Nick Cave private collection

**PAGE 83**
*The Penguin Dictionary of
Curious and Interesting Words*
by George Stone Saussy III, 1986
Gift of Nick Cave, 2006,
Australian Performing Arts
Collection, Arts Centre
Melbourne
Courtesy © Penguin Books

**PAGE 84**
Postcard from handmade
book by Nick Cave, 1985
Gift of Nick Cave, 2006,
Australian Performing Arts
Collection, Arts Centre
Melbourne

**PAGE 85**
Song lyrics for 'Tupelo'
by Nick Cave, c. 1984
Gift of Nick Cave, 2006,
Australian Performing Arts
Collection, Arts Centre
Melbourne
Reproduced by kind permission
of Mute Song Limited

**PAGE 86-87**
Handwritten dictionary of
words by Nick Cave, 1984-85
Gift of Nick Cave, 2006,
Australian Performing Arts
Collection, Arts Centre
Melbourne

**PAGE 88**
*The Firstborn Is Dead* drawing
by Nick Cave, 1985
Gift of Nick Cave, 2006,
Australian Performing Arts
Collection, Arts Centre
Melbourne

**PAGE 89-91**
*The Gospel According to St John*,
1980s
Annotated by Nick Cave
King James Version, American
Bible Society, New York
Nick Cave private collection

**PAGE 92-93**
*Euchrid's Crib 1*
Nick Cave in Yorkstraße,
West Berlin, 1985
Photograph by Bleddyn Butcher
Black and white photograph
Reproduced by kind permission
of Bleddyn Butcher

**PAGE 94**
Collage entitled *Sad Waters*
by Nick Cave, 1986
Ink and acrylic paint
on printed card
Gift of Nick Cave, 2006,
Australian Performing Arts
Collection, Arts Centre
Melbourne

**PAGE 95**
Barbary Ape, Souvenir of
Gibraltar, date unknown
Ceramic figurine
Nick Cave private collection

**PAGE 97-121**
Handmade book by Nick Cave,
1987
Gift of Nick Cave, 2006,
Australian Performing Arts
Collection, Arts Centre
Melbourne

**PAGE 122**
Map of Ukulore for
*And the Ass Saw the Angel*
by Nick Cave, 1985
Nick Cave private collection

**PAGE 228-229**
Notebook containing song lyrics
for 'Wide Lovely Eyes' by Nick
Cave, 2011
Nick Cave private collection
Reproduced by kind permission
of Mute Song Limited

**PAGE 230-231**
Notebook containing song lyrics
for 'Mermaids' by Nick Cave,
2011
Nick Cave private collection
Reproduced by kind permission
of Mute Song Limited

**PAGE 232-233**
Notebook containing song lyrics
for 'Mermaids' by Nick Cave,
2012
Nick Cave private collection
Reproduced by kind permission
of Mute Song Limited

**PAGE 234-235**
Original sick bags from *The Sick
Bag Song* by Nick Cave, 2014
Nick Cave private collection

**PAGE 236-237**
Susie and Nick Cave,
wedding photograph, 1999
Nick Cave private collection

**PAGE 238-241**
Notebook containing song lyrics
for 'Jesus Alone' by Nick Cave,
2014
Nick Cave private collection
Reproduced by kind permission
of Kobalt Music Publishing Ltd

**PAGE 242-243**
Notebook containing song lyrics
for 'Rings of Saturn' by Nick
Cave, 2014
Nick Cave private collection
Reproduced by kind permission
of Kobalt Music Publishing Ltd

**PAGE 244-245**
Notebook containing song lyrics
for 'Anthrocene' by Nick Cave,
2014
Nick Cave private collection
Reproduced by kind permission
of Kobalt Music Publishing Ltd

**PAGE 246-247**
Notebook containing song lyrics
for 'Girl in Amber' by Nick
Cave, 2014
Nick Cave private collection
Reproduced by kind permission
of Kobalt Music Publishing Ltd

**PAGE 248-249**
Notebook containing song lyrics
for 'Distant Sky' by Nick Cave,
2015
Nick Cave private collection
Reproduced by kind permission
of Kobalt Music Publishing Ltd

**PAGE 250-252**
Notebook containing song lyrics
for 'Spinning Song' by Nick
Cave, 2014
Nick Cave private collection
Reproduced by kind permission
of Kobalt Music Publishing Ltd

**PAGE 254**
Susie and Nick Cave, 2019
Photograph by Casper Sejersen
Colour photograph
Reproduced by kind permission
of Casper Sejersen Studio and
The Vampire's Wife

**OBJECT PHOTOGRAPHS BY:**

Anders Sune Berg
for Royal Danish Library:
pages 19, 41, 42-43, 78-79, 97,
98-99, 100-101, 102-103, 104-105,
106-107, 108-109, 110-111, 112-
113, 114-115, 116-117, 118-119,
120-121, 123, 137, 138, 139,
142-143, 180-181, 182-183, 191,
192-193, 194-195, 198-199, 200-
201, 202-203, 214-215, 216-217,
218-219, 221, 222-223, 224-225,
226-227, 228-229, 230-231, 232-
233, 238-239, 240-241, 242-243,
244-245, 246-247, 248-249, 250-
251, 252-253

Tom Breakwell
for Arts Centre Melbourne:
pages 25, 27, 32, 33, 40, 44-45,
48-49, 52, 53, 54, 55, 74-75, 81,
84, 85, 94, 122, 126, 128-129,
130-131, 152, 154, 174, 176-177

Dan Magree
for Arts Centre Melbourne:
pages 36, 37, 50, 51, 76, 80,
82, 83, 86-87, 88, 89, 90-91, 95,
124-125, 127, 132-133, 134, 135,
141, 145, 146-147, 150-151, 155,
156-157, 158-159, 160-161, 162-
163, 165, 166-167, 175, 186-187,
188-189, 204, 208-209, 210, 211

# ACKNOWLEDGEMENTS

Published in association with
Stranger Than Kindness: The Nick Cave Exhibition
Royal Danish Library, Copenhagen
23 March–3 October 2020

Developed by Nick Cave and Christina Back

Editors: Jamie Byng, Francis Bickmore, Simon Thorogood
Authors: Nick Cave, Darcey Steinke and Janine Barrand
Copy editors: Leila Cruickshank, Juliane Hartsø Lassen,
Georgina Greer
Proofreader: Lorraine McCann
Production: Caroline Gorham, Megan Williams, Chrissy Chan

Design: Hingston Studio
Layout: Rasmus Koch Studio
Image retouch: Eli Lajboschitz

Cover: Painting entitled *Ink and Solace* by Ben Smith, 2019

Special thanks to Dawn Cave, Susie Cave, Rachel Willis,
Suzi Goodrich, Brian Message, Molly Cairns, Beth Clayton

Every effort has been made to locate the owners of
copyrighted material appearing in this publication.
We welcome any further information pertaining to copyright
ownership, which may have been inadvertently overlooked.

nickcave.com

Stranger Than Kindness: The Nick Cave Exhibition
The exhibition was developed and designed by Christina
Back, Royal Danish Library and Janine Barrand, Arts Centre
Melbourne in collaboration with Nick Cave for The Black
Diamond, Copenhagen. It was curated and produced by
Royal Danish Library in collaboration with the Australian
Music Vault at Arts Centre Melbourne.

**SUPPORTED BY**          **COLLABORATORS**

GUCCI

MAIN SPONSOR